The complete paintings of

Bruegel

Introduction by **Robert Hughes**

Notes and catalogue by **Piero Bianconi**

Harry N. Abrams, Inc. *Publishers* New York

Classics of the World's Great Art

Editor
Paolo Lecaldano

International Advisory Board
Gian Alberto dell 'Acqua
André Chastel
Douglas Cooper
Lorenz Eitner
Enrique Lafuente Ferrari
Bruno Molajoli
Carlo L. Ragghianti
Xavier de Salas
David Talbot Rice
Jacques Thuillier
Rudolf Wittkower

The Classics of World Art are published in Italy by Rizzoli Editore, in France by Flammarion, in the United Kingdom by Weidenfeld and Nicolson, in the United States by Harry N. Abrams, in Spain by Editorial Noguer and in Switzerland by Kunstkreis

Standard Book Number 8109—5502—4
Library of Congress
Catalogue Card Number 78—84184
© Copyright by
Rizzoli Editore, 1967
Printed and bound in Italy

Table of contents

Robert Hughes Introduction 5

Piero Bianconi An outline of the artist's critical history 9

 The paintings in color 15

 List of plates 16

 The works 81

 Basic bibliography 82

 Outline biography 83

 Catalogue of works 87

Appendix Bruegel's drawings 116

Indexes Subjects 119

 Titles 120

 Topographical 120

Photographic sources Color plates : Blauel, Munich ; Brenwasser, New York ; Conzett-Hüber, Zurich ; Dominguez Ramos, Madrid ; Emmer, Milan ; Hessisches Landesmuseum, Darmstadt ; Librairie Flammarion, Paris ; Meyer, Vienna ; Musées Royaux des Beaux-Arts de Belgique, Brussels ; Némerlin, Brussels ; Staatliche Museen, Berlin (Dahlem) ; Witty, Sunbury-on-Thames.
Black and white illustrations : A.C.L., Brussels, Alinari, Florence ; Archivio Rizzoli, Milan ; Bayerische Staatsgemäldesammlungen, Munich ; Bibliothèque Royale, Brussels ; Blinkhorns, Banbury ; Christie, Manson and Woods Ltd, London ; Kunsthandel de Boer, Amsterdam ; Descossy, Montpellier ; The Detroit Institute of Arts, Detroit ; Duca Collection, Milan ; Fein, Rainham ; The Frick Collection, New York ; Hessisches Landesmuseum, Darmstadt ; Librairie Flammarion, Paris ; The Johnson Collection, Philadelphia ; Giraudon, Paris ; Kronacker Collection, Brussels ; Kunsthistorisches Museum, Vienna ; Musée Calvet, Avignon ; Musée des Beaux-Arts, Bordeaux ; Museum Boymans-van Beuningen, Rotterdam ; National Gallery, London ; National Gallery of Art (Samuel H. Kress Collection), Washington ; Philadelphia Museum of Art, Philadelphia ; Photo Studios Ltd, London ; Reinhart Collection, Winterthur ; Staatliche Graphische Sammlung, Munich ; Statens Museum for Kunst, Copenhagen ; Steinkopf, Berlin ; Stockholms Universitet, Stockholm ; Von Pölnitz Collection, Ansbach ; Wolfrum, Vienna.

Introduction

One of the most misleading nicknames ever applied to a painter was given to Pieter Bruegel: "The Peasant." It has passed on the image of Bruegel as a salty bumpkin, literate only at brushpoint, deeply proletarian in his loyalties, rejecting the luxury art of the courts and the involved *concetti* of Mannerism in order to make paintings about peasants that peasants could understand. It tempts one to suppose that Bruegel paid for his sympathies when his work seemed – as Friedländer put it – "merely an undercurrent" to his contemporaries in Antwerp, and when the seventeenth and eighteenth centuries had no time for him at all. In short, the name "Peasant Bruegel" connects him to two of today's favorite myths: the artist as voice of the People, and the genius as outsider. The image is false, and so are its implications.

We do not know much about Bruegel's life, but we know enough about his friends in Antwerp (Goltzius, Plantin, Ortelius, Coornhert, and the collector Nicolaes Jonghelinck) to presume that so distinguished a circle of scientists, scholars and Erasmian liberals would not have put up with an artist, however gifted, who was not educated to the fingertips. There is little doubt that Bruegel's stance was bourgeois, even courtly; and as for the notion of art for the peasants, this, in a sixteenth-century context, is pious fiction. Illiterate serfs could not buy paintings and seldom looked at them, except in churches, where Bruegel's did not hang. Had a Flemish peasant seen *The Wedding Feast* or *The Peasant Dance*, he would probably have been indifferent to them. (It is much the same today: the rich buy Picasso's *Frugal Meal*, but the poor prefer Annigoni's portrait of Queen Elizabeth II.)

On the other hand, both these paintings by Bruegel were admirably suited to the demands of the aristocratic audience which did, in fact, respond to them. Bruegel produced them in or around 1568. At this time, northern Europe had not emerged from the traumas of messianic hysteria and peasants' revolts.

For fifty years and more, Germany and the Netherlands had been racked by a succession of peasant risings, caused by grinding poverty, taxes, crop-failures and the Black Death, and frequently led by Anabaptist visionaries proclaiming the destruction of the Catholic Antichrist and the coming of a millennium in which all property would be torn from princes and shared out among the people. What patron would wish pictures to remind him of the nightmare of the collectively organized poor? Bruegel did not hate or fear peasants – as Dürer certainly did; but the compassion with which he painted these robust, scrubbed human tubers, fat-lipped and lump-nosed, sticking their thumbs into the soup or clumping out the bagpipe rhythms of a bucolic dance, is not the compassion born of a sense of equality. Compare the scenes of rustic life painted by the Limbourg brothers 150 years before Bruegel for Jean de Berry: tiny serfs tilling their tapestried fields, under the blue pinnacles of the distant fortress, content with their place in a fixed world. Bruegel's peasant scenes wholly accept this convention of jolly, productive, impotent well-being. They are seen from the duke's angle. But they are more "real," because less heraldic. Each face, sly, greedy, replete, or lit by stupefied tenderness, exists *morally*: the distance between the *Très Riches Heures* and *The Peasant Dance* is analogous to that between *The Romaunt of the Rose* and Shakespeare. But Bruegel, unlike Shakespeare, was not interested in the psychological identity of the people his brush called into being. He left no portraits. All his peasants are "types"; and when appetites show on their faces, one can be sure that Bruegel was more interested in the appetite than the person. In this respect, there is something arrested and medieval about Bruegel's approach. Not Shakespeare, but a morality play. When Bruegel's patrons enjoyed his genre scenes as burlesques, they may have been closer to the painter's intentions than the critics who,

centuries later, enthuse over his love for mankind.

But Bruegel's distance from his subjects was not determined by social events. The most one can say is that it suited them, but that it springs from other sources; and in this fact of his imagination lies his immense originality. Bruegel thrust man from the center of the world, where the combined efforts of Renaissance artists had installed him. One never finds in Bruegel what is constant in the paintings of his Italian contemporaries and Northern predecessors (with the exception of Bosch): a figure dominating the landscape, the humanist's hero with nature as a backdrop. In Bruegel, nature is dominant and man must survive in it as best he can. The blackened red silhouettes of *The Hunters in the Snow*, the numb peasants pollarding trees in the foreground of *Dark Day*, exist on not quite equal terms with clouds, rocks, snow, magpies and thatched roofs. "It is not enough to call Man a little Worlde; save God, man is a diminutive to nothing" – so John Donne; Bruegel rebuts this heroic and stylized optimism. At a time when most Italian artists (and Flemish, working *all'Italiana*) were painting monumental figures within a controlled, and usually shallow, pictorial space, Bruegel widened the lens, raised the eyeline, thrust his perspective towards an engulfing horizon and dispensed with the grand manner. His people – ants on the far snow – are barely more than events within nature. In classical art, the movement of a figure emanates from a calm and balanced center, but Bruegel's figures are in constant flux, caught in squat, strained, and (by Renaissance norms) un-dignified postures of workaday life: hopping, tugging and tumbling, invading the edges of the canvas and scurrying out again, they are the ancestors of Impressionist figure-painting, and not until the nineteenth century will one find a group so "casually" trapped in one moment of time as the figures on the right edge of *The Peasant Dance*. When Bruegel paints a crowd, it is a *Gestalt,* a herd organism: the armies in *The Suicide of Saul* wave their lances with a slow, groping rhythm like the spines of a sea-urchin. Even his handwriting is anti-classical. One need only compare Bruegel's *Adoration of the Magi* with any representative Italian treatment of the same theme from the 1560s – let alone an Adoration by Van Eyck or Van der Weyden – to see how the harsh linear scribbles of Bruegel's brush differ from the lucid, continuous modeling of the Renaissance.

The only parallel to Bruegel's sense of a deep and convulsive rhythm in nature, before which men are powerless, is perhaps Leonardo da Vinci's. And so it is appropriate, even though the works of art Bruegel saw during his year's visit to Italy in 1553 are held to have made no impression on him, that his gnawed mountains and toppling seas so resemble the lunar crags behind *The Virgin of the Rocks* and the apocalyptic whorls of Leonardo's deluge drawings. The main figure in *The Birdnester* might be a bucolic parody of Leonardo's enigmatically pointing St John. The snoring yokel around whose sprawled limbs the composition of *The Harvesters* radiates in spokes may be "from life"; on the other hand, his pose, one arm crooked behind his head, may be Bruegel's memory of this classical gesture of defeat and exhaustion seen on a Roman sarcophagus or the ceiling of the Sistine Chapel. Bruegel's debt to the Italian Renaissance has not been fully studied, and no doubt it was not as great as Rembrandt's; even so, it is unlikely that so avid and retentive an eye could have passed a year in Italy without seizing motifs which, transformed, were to poke their muffled outlines through Bruegel's quite unclassical sense of form.

One of the vital areas of Bruegel's imagination had little to do with the Italians and was not understood by them. This was his genius as moralizer. In 1558, Bruegel designed seven plates of the Deadly Sins, for the engraver-publisher Jerome Cock. Giorgio Vasari, confronted by such capering swarms of hybrid freaks, called Bruegel's moralities "fantastic and laughable" – which was as off-center as the fashion for calling them surrealist 400 years later. In Italian art, the grotesque had been sublimated into decoration or comedy by the sixteenth century. Few of its demonic possibilities remained intact, and those left were not exploited. Not so in the north. In these engravings, as in his full-scale "fantasies" like *Dulle Griet*, Bruegel was not trying to be funny. The aim of his disjointed and stupendously energetic piling-up of monsters and portents was to make sin and folly concrete – to give them, in paint, the kind of absolute existence that they possessed in the religious atmosphere of Bruegel's time. Sin is objectified as distortion; the damage it does the soul was bodied forth, for Bruegel's audience, in a zoo of flabby, malevolent horrors. Dante's hell is an ordered place beside the world invaded by sin which Bruegel produced. It is a dreadful world precisely because it is not presented as fantasy. In Bosch's paintings, the spiky leaves and cool crystalline limbs, the stage-lighting of Hell and

the exquisite abstraction of Eden keep one at a certain distance. Not so with Bruegel. His monsters and the landscape they inhabit are painted with the same stolid, documentary conviction("I was there; this is how it looked") as his peasants. To decipher such images in detail today, we need a crib, and despite Bruegel's reliance on popular proverbs in his demon-paintings (as well as in milder works like *The Land of Cockayne* and *Flemish Proverbs*) it is hard to imagine that anyone in Antwerp could have followed the intricacies of *Dulle Griet* without considerable erudition. Bruegel evidently drew on a wide range of sources – Biblical texts, legends of the monsters of India, early medieval apocalyptic like *The Vision of Tundale*, Gothic and Romanesque carvings, local stories of freaks as portents, propaganda woodblocks and, of course, the paintings of his predecessor Bosch. A modern viewer, trying to follow Bruegel into this dark wood of lost references, is at a disadvantage – so would a Yugoslavian be, trying to read Pound's cantos in translation 400 years from now. But a complete understanding of Bruegel's imagery, which we may never have, is not essential to recognize the vitality and inventiveness of this Degas of the Millennium. ROBERT HUGHES

An outline of the artist's critical history

The esteem in which Pieter Bruegel was held and the fame he enjoyed during his lifetime are proved by the fact that he had eminent humanists among his friends, by the eagerness of collectors to acquire his works and the enormous number of copies of them that were made. Among his friends and patrons in Antwerp (see p. 83, Outline biography) were scholars and literary men, including art-lovers like Cardinal Perrenot de Granvelle and Nicolaes Jonghelinck. In 1566 the latter owned sixteen paintings by Bruegel, among these, six panels representing "*The Months*," which the city of Antwerp later presented to Archduke Ernest, who also paid 160 florins for *The Peasants' Wedding*, thus laying the foundations of the magnificent collection of the master's works now in the Kunsthistorisches Museum in Vienna. In December 1572 a cleric named Morillon wrote a letter to Cardinal Granvelle, informing him that there was no longer any hope of tracing the paintings by Bruegel which had been stolen during the sack of Malines, adding that his works "*sont plus requirez depuis son trépas que par avant et s'estiment cinquante, cent et deux cents escus*" (since his death they are more sought after than before and are now valued at 50, 100 or 200 crowns each). During the following century Pieter Paul Rubens – to mention only the most illustrious name – was an enthusiastic collector of Bruegel's works, and from the inventory of his property made after his death (1640) we learn that he owned no fewer than twelve. Another testimony to Bruegel's fame is to be found in one of Robert Herrick's poems (*To his Nephew, to be Prosperous in his Art of Painting*), where he is mentioned together with Holbein, Raphael, Rubens and other great artists.

During the eighteenth century and most of the nineteenth Bruegel was virtually forgotten, or at the best relegated to the category of portrayers of folklore, a peasant who painted peasants. The academic taste of those days saw him as a minor artist, while the critics – with the notable exception of the great P. J. Mariette (see p. 10) – starting with J.-B. Descamps [*La vie des peintres . . .* , 1753] ranked him as inferior, even in this "secondary" genre, to painters such as Brouwer and, in particular the more pleasing David Teniers the Younger, while Waagen [1869] devoted six whole pages to the latter and barely one to the great Pieter. One of the reasons was, obviously, that in those days no one was capable of distinguishing the genuine works of the elder Bruegel from copies. It should, however, be noted that what appealed to most of Bruegel's contemporaries was the amusing or didactic aspect of his works. It was this narrative content which led to his being nicknamed "*Piet den Drol*," the painter who made people laugh. This misapprehension lasted for centuries almost without a break (always excepting Mariette, who perceived his great artistic qualities from the drawings he had seen: these, he said, would not have been unworthy of Titian). Not until the end of the nineteenth century did critics begin to perceive what a great genius Bruegel was. Nevertheless, when we read the celebrated words of Baudelaire [*Curiosités esthétiques*, 1858] (see p. 10), we cannot help feeling that this critic and poet was in reality thinking of Hieronymus Bosch. Denis has rightly pointed out that for a long time the great museums – the Louvre in Paris, the former Kaiser Friedrich Museum in Berlin, and the National Gallery, London – never troubled to acquire any works by the master, and that as late as 1846 the Musées Royaux in Brussels purchased his *Fall of the Rebel Angels* believing it to be by Bosch.

In a brilliant study written in 1884 Riehl assigned to Bruegel a leading place among his contemporaries; in 1890 Hymans noted how original he was compared with other artists of the time, and in 1902 Riegl called him the founder of Flemish non-religious painting. But the real turning-point in the appreciation of Bruegel came in 1907, when Van Bastelaer and Hulin de Loo published their catalogue of his works – not the first, since it had been preceded by Romdahl's [1904–5], but the first to be compiled on a scholarly basis. This catalogue contained far more attributions to our painter than can now be regarded as acceptable – a natural fault when the *œuvre* had been so little scrutinized formerly. For this change, the work of Glück, Dvořák, Michel, Tolnay, Grossmann, and many others, is responsible.

Nowadays, Bruegel is approached with the greatest respect: no trace remains of the old patronizing approach. Much attention has been paid to the subject-matter of the paintings, following Ortelius' remark "*In omnibus eius operibus intelligitur semper plus quam pingitur*" (roughly "there is in all his works more than meets the eye"). As well as this new understanding of the seriousness that underlies much of the painting, there is at last a true appreciation of Bruegel's purely painterly qualities. His brilliance in capturing movement, the natural life of ordinary, unheroic people; his beautiful and delicate coloring, and in particular his deep understanding of the poetry of landscape and of the seasons (cf. the paintings of "*The Months*") – all these qualities make us see in him an artist of unique greatness, both in his time and country, and now.

Pietro Brueghel of Breda, that great imitator of the learning and fantasy of Hieronymus Bosch, for which reason he has also acquired the nickname of the Second Hieronymus Bosch.
L. GUICCIARDINI, *Descrittione de' Paesi Bassi*, 1567.

They also praise as a good painter ... Pietro Breughel of Antwerp, an accomplished master ...
G. VASARI, *Le Vite*, 1568.

> *Quis novus hic Hieronymus Orbi*
> *Boschius? ingeniosa magistri*
> *Somnia peniculoque, styloque*
> *Tanta imitarier arte peritus,*
> *Ut superet tamen interim et illum?*
> *Macte animo, Petre, mactus ut arte*
> *Namque tuo, veterisque magistri*
> *Ridiculo, salibusque referto*
> *In graphices genere inclyta laudum*
> *Praemia ubique, et ab omnibus ullo*
> *Artifice haud leviora mereris.**

D. LAMPSONIUS, *Pictorum aliquot celebrium Germaniae inferioris effigies*, 1572.

... The Flemings, by whom I have seen certain paintings done in oils ... which are wonderful to behold; and those painters who made them deserve no little praise, Gill Mostraert, Pier Breughel ...
G. P. LOMAZZO, *Trattato dell'arte della pittura*, 1584.

... The witty and ingenious Pieter Bruegel, eternal glory of the Low Countries ... Few of his paintings can be contemplated without laughter. Even the grimmest and most austere of men, on beholding them, cannot refrain from laughing or chuckling ... He drew his personages with unfailing skill and was a past master in handling the pen, especially in the numerous little landscapes drawn from nature.
K. VAN MANDER, *Het Schilderboek*, 1604.

... he produced only absurd and ridiculous things, as regards subject-matter and conception, though his coloring and his drawing were ably done and masterly.
P. A. ORLANDI, *Abecedario Pittorico*, 1719.[2]

At Crozat's I saw some drawings by Bruegel the Elder ... they are dated 1553 and as regards the details they are extremely fine ... Pieter Bruegel ... has become famous not only through his fantastic, amusing compositions, but also through his land-

scapes, which are in the grand manner ... There are landscapes painted with a featherlight touch that Titian would not disown.
P. J. MARIETTE, *Abecedario*, 1851–60 Volume I.

... that this age – for whom nothing is inexplicable, thanks to its double nature of incredulity and ignorance – should simply qualify [Bruegel's works] as fantasy and caprice, holds, it seems to me, a kind of mystery ... Now I defy anyone to explain Breugel *le Drôle*'s diabolical and laughter-provoking chaos other than through a kind of special, satanic grace ...
C. BAUDELAIRE, *Quelques caricaturistes étrangers*, Le Présent, 1858.

... Bruegel the elder, a true master whose importance is underestimated.
W. BÜRGER-THORÉ, *Le Musée d'Anvers*, Brussels, 1862.

... he was the first who applied himself to the study of various forms of peasant life, and made it the chief subject of his art. His mode of viewing these scenes is always clever but coarse, and even sometimes vulgar.
G. F. WAAGEN, *Handbook of Painting. The German, Flemish and Dutch schools* (Based on the Handbook of Kugler), London 1869.

... an artist of originality rather than greatness ... In short, he is a painter whom it is very interesting to study, because basically one finds him in all the qualities and all the faults of the peasant school, of which he is in effect the head.
A. SIRET, *Biographie Nationale*, 1872.

In our era, justly proud of having honored such masters as Frans Hals, Adrien Brouwer and Rembrandt, it is fitting that we should see in Pierre Breughel an artistic personality capable of far more than a simple concern with the odd and the unexpected.
H. HYMANS, *Pierre Breughel le Vieux*, in "Gazette des Beaux-Arts," 1890.

Bruegel set out on the road to art without suffering the misfortune of losing by a conventional education the ideas around which his artistic vocation took shape. Without scruple, he subordinated form to meaning, kept it strictly in its original role of expression, neglected, unlike the followers of the Italian school, the constant search for beauty of form for the force of expression and character, and, indifferent to the grace of balanced grouping, built up without difficulty in his compositions the most varied aspects of his subject.

As the logical result of his stubborn ingenuousness he combined also, in the works of the early part of his life, fundamentally popular subjects and means of development ...

But in the second part of his life, things were very different. Bruegel had an innate gift of style, not for a style based on pretensions to elegance and nobleness of attitude which was so quickly to become a mannerism with Barthélemy Spranger, but based on a calm and certain strength which can reduce the means of expression to an abbreviated form, and this he practiced with his figures. By a further development, he applied this gift to composition; he abandoned his all embracing profuseness and his building up of groups disposed in wide

* "Who is this new Hieronymus Bosch who has returned to this world, who has given new life to the fantasies of the master, so skillful in his use of colors and his drawing that he even surpasses his master? Glory be to thee, Peter, glorious in thy art; for thy witty pictures in the style of the master thou art deserving of the highest praise, no less than that which is accorded to any other artists." The English translation gives the sense rather than the literal wording of the Latin epigraph, with a view to making it more easily comprehensible.

ranging general effects, to devote himself to giving the greatest possible force of expression first of all to limited groups, and finally to single groups. This simplification was equally successful in his landscape painting where the artist ended up by characterizing the seasons and the times of day, and in his figure painting; it led him, in his final style of composition, to mingle the two types in balanced works where the countryside, as we have just shown above, is only envisaged in its relationship to humanity.

And in fact one must inevitably attain a certain loftiness of viewpoint to be able to judge the feat achieved by Bruegel to the benefit of art for all time. Before him, the question of customs divorced from any literary connotation hardly existed. After him, this question was henceforth capable of competing in grandeur, in passion, and in power with religious or historical subjects. A man divorced from all literary or moral associations has to meet the demands of art with an almost symbolic anonymity. When taking for his model the peasant of Campine, whom he knew best of all, Bruegel had enlarged his own horizon, and the public for whom he was painting could henceforth be completely human.
R. VAN BASTELAER, *Peter Bruegel l'ancien*, 1907.

An artist of depth and seriousness, a painter of broad effects, with a passion for reality, a lover of nature, a lover of mankind, but one who felt keenly the tragic disproportion between the fragility of the one, and the inescapable laws and the terrible upsets of the other. Without bitterness however, for he loved life in all its manifestations, and he maintained that happiness is possible even in the shadow of the gallows, and he painted this unbridled joy, because it too is a great force; it knows that young and exuberant life is always reborn from death, and this precious certainty makes it, in spite of all, optimistic.

He was Flemish and profoundly so, in his very bones, by extraction, in his surroundings, in that keen vision of the actual, by that sense of the tragic, by that originality and that vigor which enlivens his whole output, but a Fleming who, in order to explain and to express what he felt about things of both great and general moment, learnt a great deal from Italy; not as his contemporaries did, by imitating the outward appearances of southern art, but on the contrary by grasping the essentials of this art, and borrowing from it the innermost secrets of the structure of its language . . . Bruegel, in his basic efforts strives particularly to express man in relation to the universe and to nature, which surpass him with all their grandeur, and man in relation to society, at grips with an oppression, a cruelty and a stupidity which are largely victorious. Let us note that this deep human feeling, which epitomizes for us the true nature of Bruegel, finds its expression in compositions of which all the elements have been taken from reality, and almost always from the countryside and the people whom our Master knew the best, those of his native land.
E. MICHEL, *Bruegel*, Paris 1931.

. . . Like Rabelais and Shakespeare, Bruegel adopted in an ingenious way a rather pretentious fashion of his own times, the often excessively pedantic display of culture, camouflaged in the most unexpected ways. His learned contemporaries had

a passion for discoveries, and Bruegel, with his unusually fertile and fanciful imagination certainly had no difficulty in endowing many of his works, especially during this early period, with the appearance of riddles which he deliberately made more obscure. This does not alter the fact that the master's works are of a popular kind, since it was from the world of workers, especially that of peasants, that he took his most striking male and female types . . .
V. DENIS, *Tutta la pittura di Pieter Bruegel*, 1952.

Into the peacefulness of nature, reminding us of a lost paradise, the evil of this world suddenly erupts, upsetting and destroying everything. This is the hidden message in the art of Bruegel, who was known as "the clown". A clown for those who fail to understand the painter's pessimism, for spectators who cannot see that evil is still making inroads into this world. Children and peasants? Of course, for they are the symbols of serenity! And the painter seems to strike a note of restfulness when he contemplates the simplicity of nature and depicts the games played by children and the dances of the peasants . . . But *The Fall of the Rebel Angels* and *The Tower of Babel* leave no room for doubt as to Bruegel's pessimism.
E. CASTELLI, *Il demoniaco nell'arte*, 1952.

Bruegel was a keen but indulgent observer of his own fellow-countrymen. The faces of his peasants often reveal an obvious brutishness; but it is a brutishness due to poverty rather than to immorality. And the caricatures we find in his paintings are not inspired by any polemical attitude, but by a desire to achieve freedom of expression. It is therefore futile to ask ourselves whether the man Bruegel was superior to, or on the same level as, his fellow-countrymen. His art was neither an indictment nor a moral consensus nor an attempt to exalt. It was an act of human comprehension, and therefore of love. Here Bruegel the man is identified with Bruegel the artist.

As a painter of mankind Bruegel, too, had a mythology of his own. But he did not take it from the world of the classical Renaissance or from Christendom. His myths were autochthonous, born of the soil of his own country, the customs of its people, the proverbs and beliefs of peasant wisdom, the games of children . . .
G. FAGGIN, *Bruegel*, 1953.

Pierre Bruegel the elder is the last in the line of primitive Flemish artists. This painter is the most authentic representative of the humanism of the northern Renaissance, both in its scholarly and in its social aspects. Of all the artists of this century he best of all appreciated and made use of the fruitful innovations of the Italian school, and the lessons of antiquity. One can only discern his genius in this context. Let us forget in Bruegel, Bruegel the droll, let us not imagine in him a Platonic philosopher, but let us get to know the cultured painter eager to bring to bear on the problems of his time a rejuvenated and sensitive local style. He achieved, and always with strength to spare, that synthesis which his contemporaries sought for the benefit of Flemish expression of feeling, but he preserved traditional characters even in his last works . . .
R. GENAILLE, *La peinture dans les anciens Pays-Bas*, Paris, 1954.

. . . he was above all a disciple of Erasmus, less interested in Erasmus's erudite works on the texts of Cicero, or on St Jerome, than in his books of a social character, the most widespread and far reaching: the *Eloge de la Folie*, the *Adages*, the *Colloques*, and without doubt also the *Institution du Prince chrétien* and the *Querela Pacis*. That aspect of Erasmus's thought which relates at one time the traditions of popular Flemish literature with old medieval ideas and the Platonic myth of the cave seems above all to have made its impression on him: the idea of the absurdity of the world, the weaknesses of human nature, and an existence of which we only normally see the appearances and the fictions as if on a theater stage.

R. GENAILLE, *Bruegel l'Ancien*, 1953.

Ever since students of the Reformation have accepted the Italian Renaissance as a factor in the general renewal of European thought and culture, realizing that the relationships between artists in the various countries are a far more complicated matter than the question of influence exercised or felt, the figure of Pieter Bruegel has increased in stature. Max Dvořák was the first to perceive that he was far more than an entertaining and naïve popular painter, bound up with a picturesque peasant tradition. And Dvořák also perceived the outlines of his cultural background, in some ways connected with, and in others directly opposed to, the ideas and history of Italy. In reality Bruegel was the only artist who, in the middle of the sixteenth century, put forward an alternative to the formal ideal which the Italians based on the logical certitude and historical authority of the ancients. It was this alternative that provided art with a means to develop along historical lines, a development which the Italian attitude in these same years tended to deny, since it stipulated that the activities of artists must be based on universal history, on the history of principles, and denied that actual historical events could have any influence whatsoever.

It is evident that the kind of Flemish painting against which Bruegel reacted in such a markedly polemical way was the same as that which Michelangelo, according to Francisco de Hollanda, condemned on the grounds that it was bigoted rather than religious, more likely to bring tears to the eyes of friars and servant-girls than to edify the mind by providing examples of perfection, and also because it devoted too much attention to the copying of details and the creation of a pleasing but useless *trompte-l'œil*. In direct contrast to such painting, Bruegel's has a broad and regular rhythm, the composition is unified and coherent, the colors are subdued and unglazed, and his brushwork is broad and often summary. Bruegel pays far more attention to the character and significance of things than he does to their attractiveness. He disdains the use of ornate language and prefers a robust pictorial "vernacular." Similarly, he disdains to imitate others or to show the traditional reverence for every created thing.

Nevertheless, since he refuses to be devout, his art is never religious, but remains secular, and it is easy to believe that Bruegel's polemical attitude, even if his targets were the same, was quite different from that of Michelangelo. *Reculant pour mieux sauter*, Bruegel goes straight back to Bosch, like Michelangelo, who in his early years went back to the original sources of the Florentine Renaissance, to Donatello and Brunelleschi. Anyone who has studied the reciprocal contacts between Italian and Flemish artists during the last decades of the fifteenth century and the first of the sixteenth, will readily admit that, although each of them remained firmly attached to his own traditions, Bruegel and Michelangelo definitely rejected the type of painting which sought to reach a compromise on the common, though elastic, basis of "naturalism." Their reasons for rejecting this naturalism were, however, different – idealistic in Michelangelo's case and realistic in Bruegel's.

Bruegel was the first painter who drew with his brush . . . And in fact his colors are local colors differentiating between things that are red, blue or yellow, but ignoring the nuances that may result from their being in a setting full of light. These local colors, however, do shade off into tones and are suffused with grays and browns; and each shade of color is the harbinger of the next and finds echoes in the most distant planes. This is a method of composition by means of "dissolutions," in which each image seems to form itself and stand apart from the next, taking the place of the preceding image and drawing the spectator's attention away from it.

G. G. ARGAN, *Cultura e realismo in Pieter Bruegel*, in "Letteratura," 1955.

. . . It can be safely asserted that we owe the discovery of his greatness to modern taste . . . Bruegel . . . is not only one of the greatest, but also one of the most complex figures in the whole history of art, and the interpretation of his works is one of the most arduous tasks a critic can undertake.

Brugel's treatment of space [in *The Wedding Dance in the Open Air*, now in Detroit], thanks to its dynamic nature, achieves the same cosmic spatial absoluteness that we find in the works of Raphael; it is no longer conceived as a geometrical segment of universal space, but as "total space," which, within its own boundaries, becomes a microcosmic reflection of universal space, with the result that even the smallest detail acquires a universal value and becomes a synthesis of the whole of life. In this sense, Bruegel is a Renaissance artist, and in this sense, too, he "absorbed" the teachings of Italian "classical" art. But the universality of Raphael's compositions is due to the harmonization of a whole series of separate harmonies, whereas in Bruegel's pictures the spatial and vital universality is achieved by combining a series of contrasts and discords to form a harmonious whole. Time after time – and especially when he appears to be merely juxtaposing fortuitous elements drawn from life – he follows the compositional principles of the Mannerists; for example, the reversal of corresponding elements and the contrasting of opposites. In this sense, his art could be described, historically, as a brilliant synthesis of the contrasting motifs found in sixteenth-century art.

. . . From his very first works, filled with admiration for the imposing beauty of nature, down to those which depict the lives of men as a futile scurrying of insects and the last works extolling the image of human misery [*The Cripples* and *The Parable of the Blind Men*], Bruegel's art seems to be inspired by the consciousness of the existence of a dramatic gulf between nature, which is truth, and man, who is the incarnation of error. This sense of drama, with its roots in a profound pessimism

which laughter and irony cannot conceal, explains the disconcerting ideological content of his works and the rigorously perfect form in which from one picture to another it is presented, a complex and often obscure way of thinking being translated into simple and crystal-clear poetry.
R. SALVINI, *La pittura fiamminga*, 1958.

Is there . . . any justification for including Breughel among the number of great spirits at the beginning of modern painting? This it seems to us would be to exaggerate his importance. Breughel did not have a comparable breadth. One has only to compare him with such leaders as Hubert van Eyck or Rubens to convince oneself of this.
From what we know about him through his works, Breughel seemed like the incarnation of that sound good sense which one saw flower in Western Europe in the course of that same century in certain outstanding personalities such as Erasmus, Thomas More and Rabelais. He was, like them, the incarnation of it. But in his own particular fashion, because he is a philosopher who originated from peasant roots.
. . . Seen from this point of view, the limited scope which Breughel's spirit confers upon his subjects becomes explicable. And we must be satisfied with that. It makes superfluous any search for enigmas and allusions which the artist never intended to introduce in his works.
. . . Breughel borrowed from Bosch certain representations of the spirit of evil, such as the addled egg, the spider on the harp, the lizard and certain monstrous fish. The important thing to notice is that in this sphere his imagination is sometimes superior to that of Bosch and that his plastic expression has a greater verisimilitude, which should give satisfaction to us all.
L. VAN PUYVELDE, *La peinture flammande au siècle de Bosch et Breughel*, Paris 1962.

The art of Pierre Bruegel the elder is diametrically opposed to the Italian influences of his age, but it passes far beyond the simple painting of peasant customs to which at one time he was assumed to be limited. Bruegel was a cultured artist, in contact with such humanists as Ortelius. He brought about a revival of religious painting, in combining it with the depiction of the Flemish rural scene. He broadened the art of landscape painting, notably in his series of "Months," in which he drew strength from the tradition derived from Patenier, but he surpasses all his predecessors by the breadth of his conception of nature, and

by the manner in which he links living creatures to it. He composed at the same time imaginative visions which perpetuate in a new form the devilish inventions of Hieronymus Bosch. From both his peasant scenes and from his didactic pictures emerges a wisdom which, although deriving its strength from popular sources, attains a serene and stoic outlook worthy of Montaigne. His style still has affinities with the Primitives (bold and strongly contrasting local colors), but also foreshadows modern landscape painting.
G. MARLIER, in *Le siècle de Bruegel*, 1963.

Bruegel brings about the synthesis of the perspective vision of the Italian school and the natural affinity of the Flemish for expansiveness: depth and breadth thus find themselves united in the vastness of a world of infinite size. The emblem which is the most applicable to Bruegel is that of the eagle, now gliding through the air and watching the picture of the universe unroll beneath its wings, and now plunging to earth in a steep dive to grasp its prey.
G. BAZIN, in *Le siècle de Bruegel*, 1963.

With the secularization of the subject on the other hand, when the religious theme disappears or is no more than an insignificant pretext in the case of Peter Bruegel and Joachim Patinier, nature reigns alone, with no share in the life of the spirit; it would be a completely profane vision of nature did it not preserve a powerful mystic reality suggesting the presence of the unseen behind the façade of the visible. In the case of Patinier, occult forces can be discerned when the massing of trees and rocks takes on vaguely anthropomorphic shapes. In the paintings of Bruegel on the other hand the symbolic allusions to certain "elements" which could be of the same essential nature as men and beasts, disappear entirely; one could well say that this Flemish artist was the first painter of modern landscapes, in the sense that the religious theme *The Massacre of the Innocents* or a myth *The Fall of Icarus* occupies a position of very minor importance in the picture, where it is not the subject that counts but the pure representation of an aspect of nature crystallized at a particular time of day or season, in some village of Flanders where winter bears heavily on peasant homes. These landscapes are peopled by peasants already weighed down by that sadness and weariness whose simple dignity Millet too, three centuries later, knew how to express.
MARCEL BRION, in *L'Oeil, l'Esprit et la Main du Peintre*, 1966.

The paintings
in color

List of plates

FLEMISH PROVERBS

PLATE I
Ensemble and detail of left
portion of the middle ground
(for the sayings depicted here
and in Plates II and III, see
pp. 91–3)

PLATE II
Center portion

PLATE III
Detail of upper right-hand
corner

**BATTLE BETWEEN CARNIVAL
AND LENT**

PLATES IV-V
Ensemble

PLATE VI
Detail of Carnival and his
cortège

CHILDREN'S GAMES

PLATE VII
Ensemble and detail of the
top right portion

PLATE VIII
Details: A, B and C, top left;
D, E and F, center, towards the
left; G, H and I, lower portion,
towards the center

PLATE IX
Details: A, B and C, right
center; D, below, on left; E and
F, center, on right; G and H,
below, center; I, bottom
right-hand corner

THE TRIUMPH OF DEATH

PLATE X
Ensemble and detail of top left
portion

PLATE XI
Detail of middle portion,
towards the left

PLATE XII
Detail of lower middle portion

PLATE XIII
Detail of lower portion, left

TWO MONKEYS

PLATE XIV
Ensemble

THE DEATH OF SAUL

PLATE XV
Detail of warriors and
landscape on right

THE LARGE TOWER OF BABEL

PLATES XVI-XVII
Ensemble

PLATE XVIII
Details: A, houses and a
bridge, on left – B, centering of
arch, middle portion –
C, laborers and carpenters,
middle portion, towards the
right – D, stone-breakers,
middle, towards the lower edge
– E and F, hoisting gear,
middle portion, on right
G, plaster kiln, below, left –
H, finishing touches, below, left
I, laborers with ladder, middle
portion, towards the right

PLATE XIX
Details: A, "little house,"
middle portion, left – B, stone-
breakers, near center – C,
hoisting gear, middle portion,
right – D, carts at entrance to
the tower, below, towards the
right – E, carters and stacks of
bricks, below, on right –
F, unloading of bricks, below,
on right – G, tower guarding
entrance to harbor, middle
portion, extreme right –
H, men on a raft, below, on
right – I, sailors in rigging of ship,
extreme right

ADORATION OF THE MAGI

PLATE XX
Ensemble

PLATE XXI
Details of St Joseph and a
bystander

PLATE XXII
Detail of one of the Magi, on
left

PLATE XXIII
Detail of the Virgin and Child
with one of the Magi

PLATE XXIV
Detail of bystanders, on right

**THE PROCESSION TO
CALVARY**

PLATE XXV
Ensemble and detail showing
the crosses, top right

PLATE XXVI
Center portion, showing Christ
falling

PLATE XXVII
Detail of the Virgin and St
John with mourners, on right

HUNTERS IN THE SNOW

PLATES XXVIII-XXIX
Ensemble

PLATE XXX
Detail of landscape with trees
and a bird, in center, above

PLATE XXXI
Detail of the village, below, on
right

THE DARK DAY

PLATE XXXII
Ensemble and detail of trees,
above in center

PLATE XXXIII
Detail of the landscape, with a
shipwreck, on left

PLATE XXXIV
Detail of the village, on left

PLATE XXXV
Detail showing woodmen,
towards the right

THE CORN HARVEST

PLATES XXXVI-XXXVII
Ensemble and details of the
landscape, towards the left

THE RETURN OF THE HERD

PLATE XXXVIII
Ensemble and detail of the
landscape

PLATE XXXIX
Ensemble and detail showing
the trap

**THE NUMBERING OF THE
PEOPLE AT BETHLEHEM**

PLATE XL
Ensemble and detail showing
the collection of the tax

PLATE XLI
Detail of the lower right portion

PLATE XLII
A, detail showing castle and
shed, upper right portion:
B, detail of the Holy Family

PLATE XLIII
Detail of the upper left portion

THE LAND OF COCKAIGNE

PLATES XLIV-XLV
Ensemble

**THE CONVERSION OF
ST PAUL**

PLATE XLVI
Detail showing Saul falling to
the ground, in center

**THE ADORATION OF THE
MAGI IN THE SNOW**

PLATE XLVII
Ensemble and detail of the
lower right portion

PARABLE OF THE BLIND MEN

PLATE XLVIII
Ensemble and detail showing
the blind men falling

PLATE XLIX
Detail of the church in the
background

PLATE L
Detail of the third blind man

PLATE LI
Detail of the blind man on the
point of falling

THE MISANTHROPE

PLATE LII
Ensemble

CRIPPLES

PLATE LIII
Ensemble

THE BIRDNESTER

PLATE LIV
Ensemble

**THE MAGPIE ON THE
GALLOWS**

PLATE LV
Ensemble

THE PEASANTS' WEDDING

PLATES LVI-LVII
Ensemble

PLATE LVIII
Detail showing the bride with
some of the guests

PLATE LIX
Detail showing little girl in the
foreground

PEASANTS DANCING

PLATE LX
Ensemble and detail showing
votive offering on a tree, on
right

PLATE LXI
Detail showing little girls, on
left

PLATE LXII
Detail showing a piper and a
spectator

PLATE LXIII
Detail showing dancers,
towards the right

STORM AT SEA

PLATE LXIV
Detail showing seagulls in the
sky, on left

ON FRONT COVER
Detail from *Peasants Dancing*

*In the captions underneath the
color plates the width (in
centimeters) of the ensemble or
of the detail from it is given*

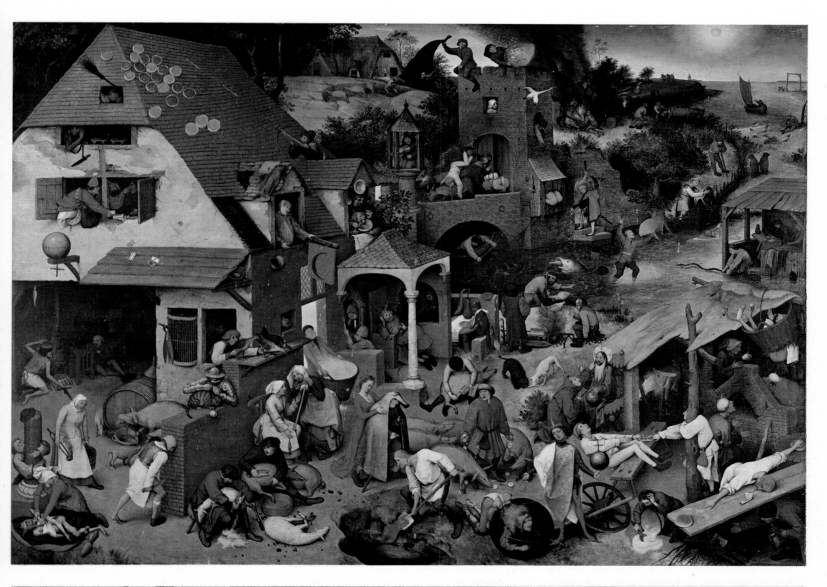

PLATE I FLEMISH PROVERBS Berlin, Staatliche Museen
Whole (163 cm.) and detail (57.5 cm.)

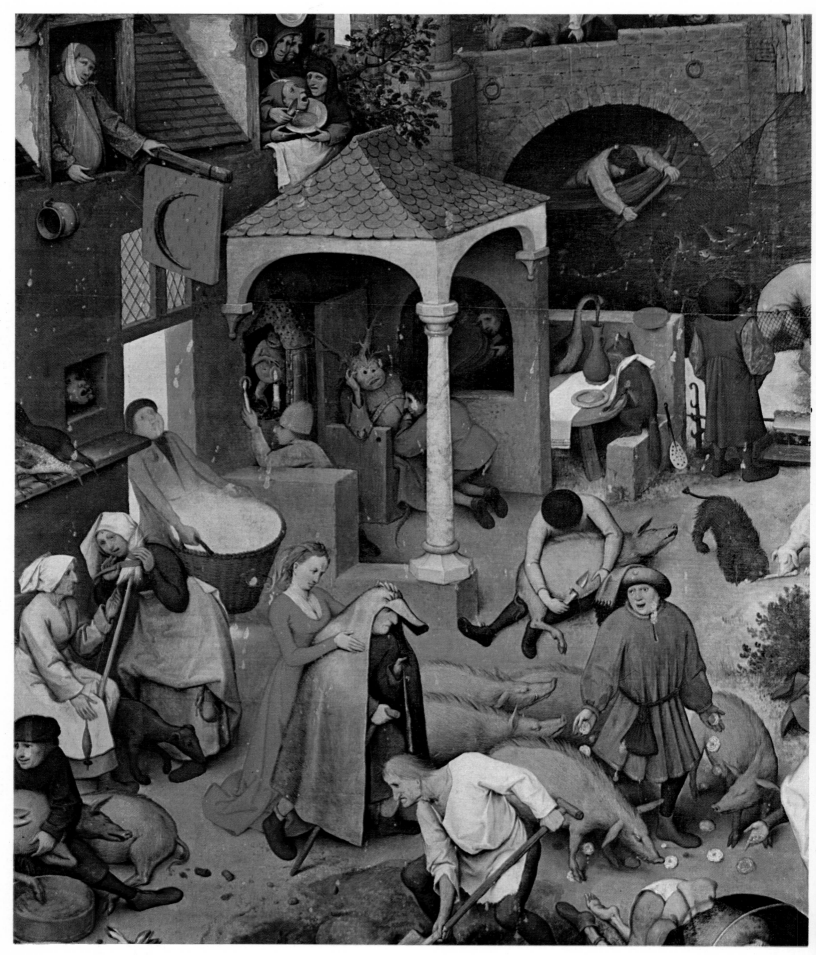

PLATE II FLEMISH PROVERBS Berlin, Staatliche Museen
Detail (57.5 cm.)

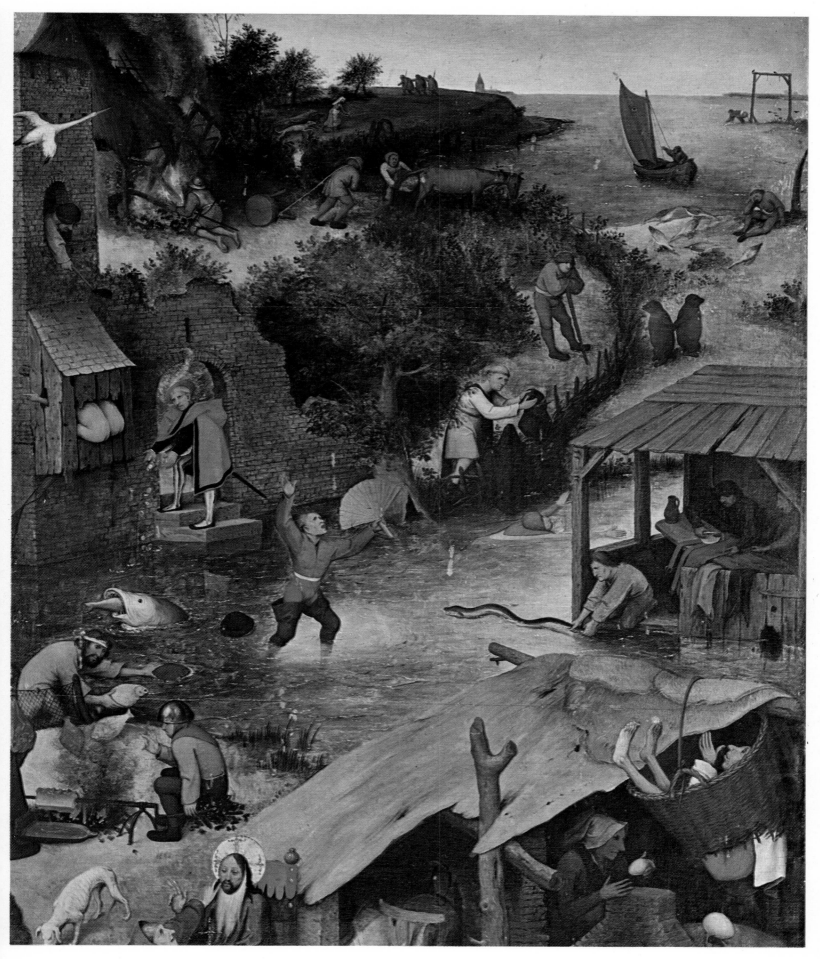

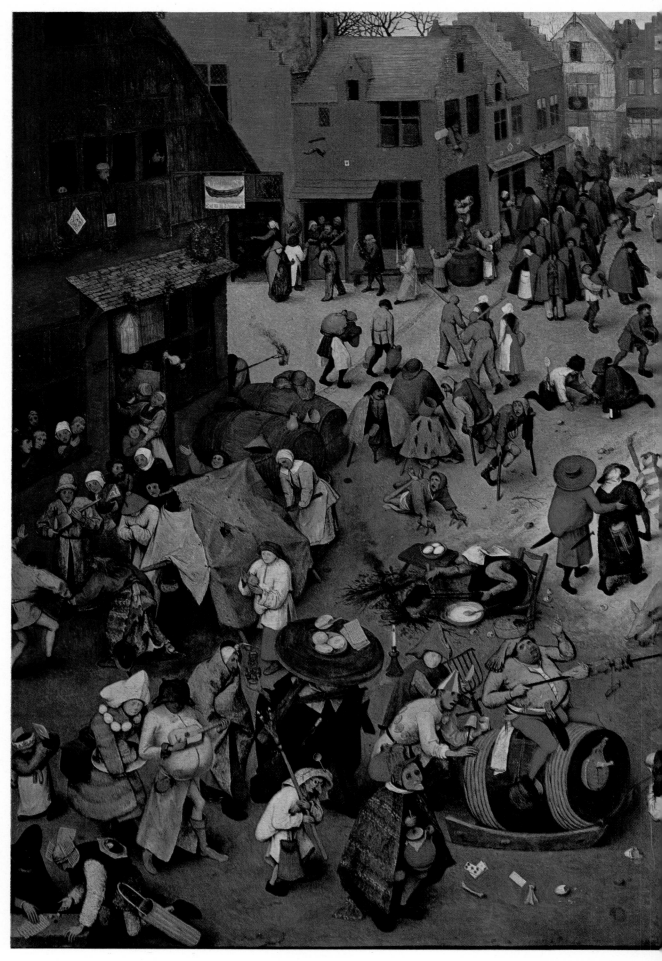

BATTLE BETWEEN CARNIVAL AND LENT Vienna, Kunsthistorisches Museum
Whole (164.5 cm.)

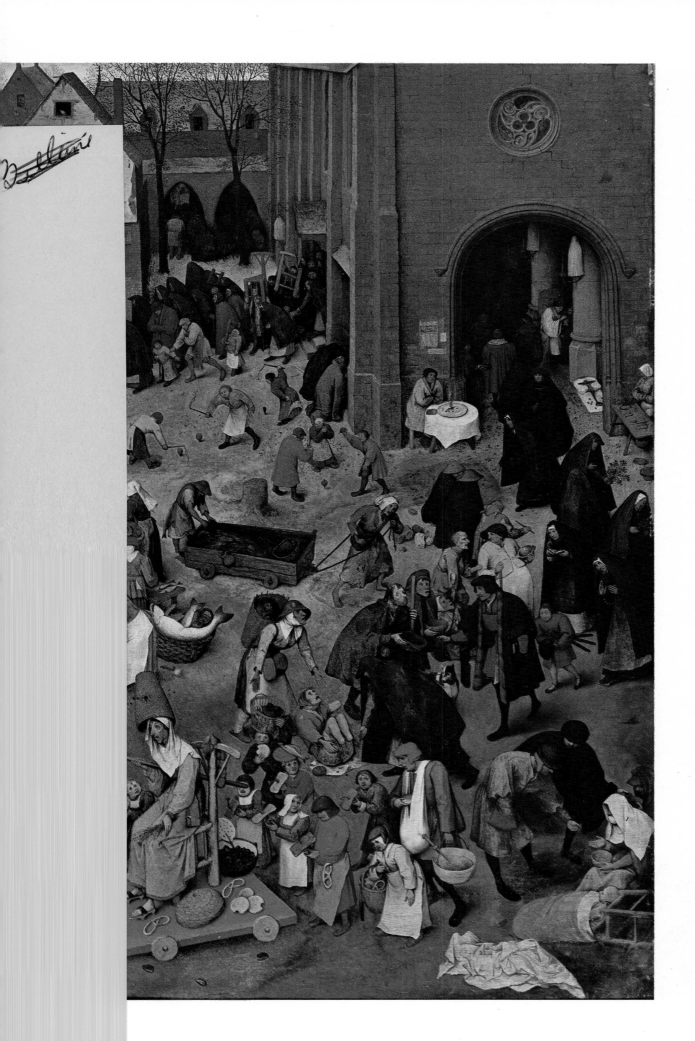

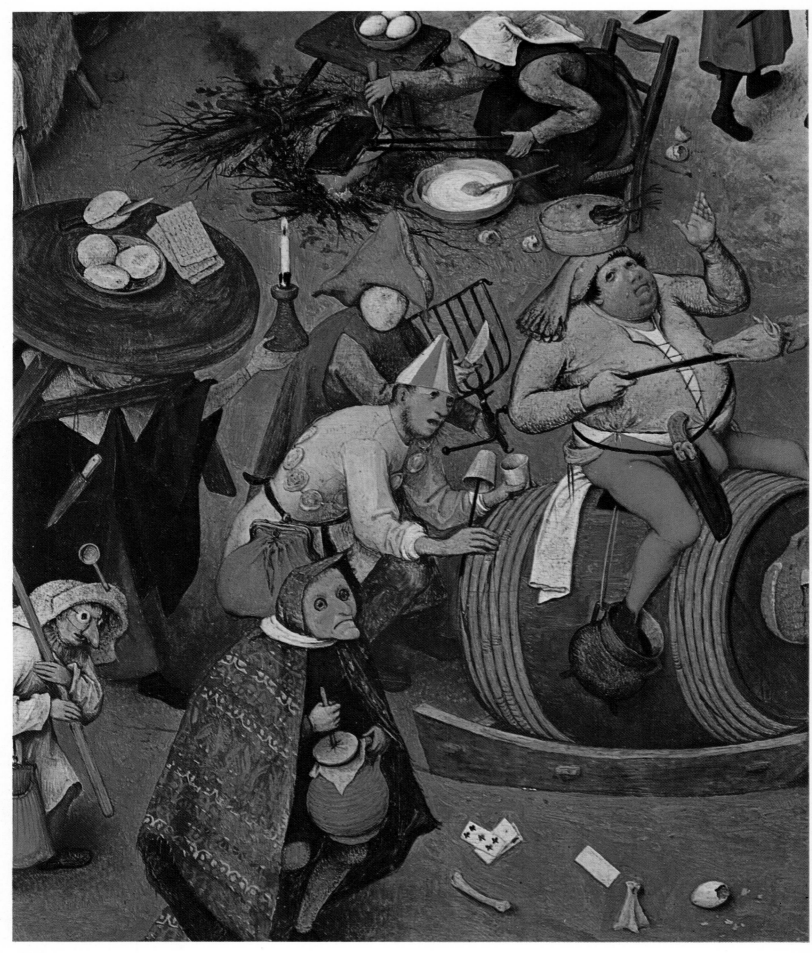

PLATE VI BATTLE BETWEEN CARNIVAL AND LENT Vienna, Kunsthistorisches Museum
Detail (38 cm.)

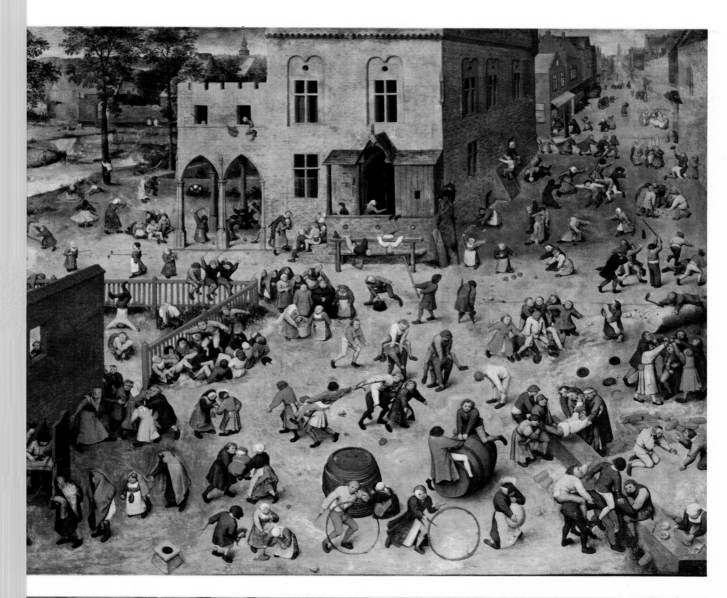

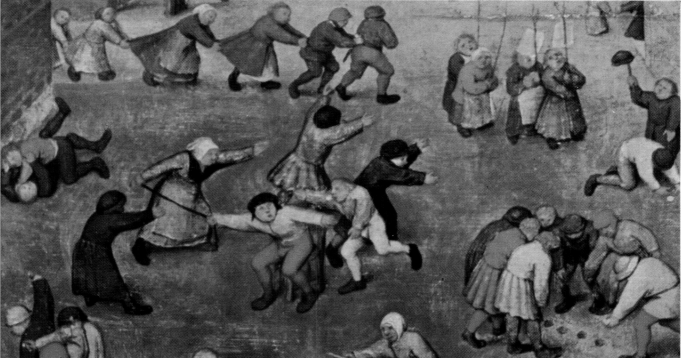

I'S GAMES Vienna, Kunsthistorisches Museum
cm.) and detail (38 cm.)

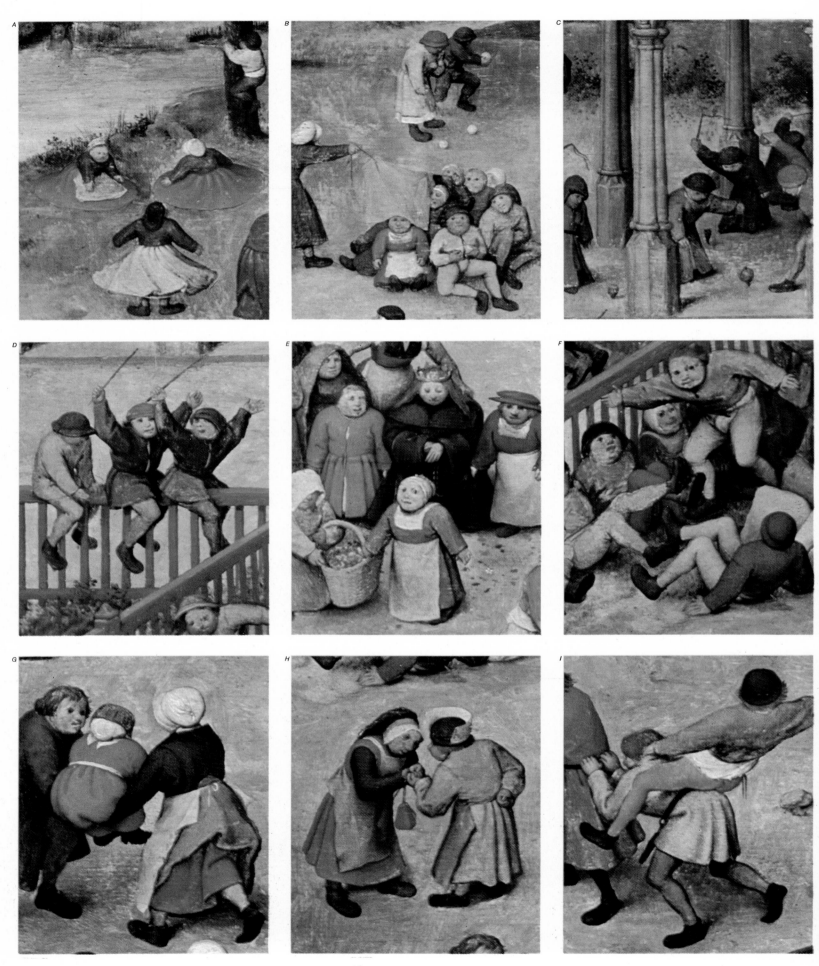

PLATE VIII CHILDREN'S GAMES Vienna, Kunsthistorisches Museum
Details (12 cm.)

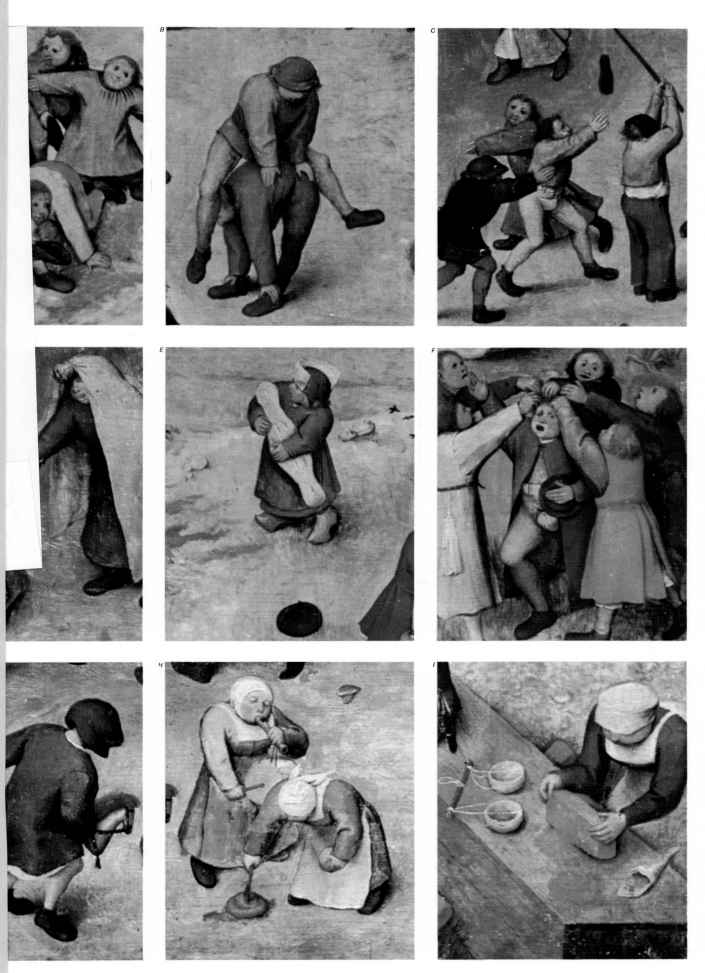

'S GAMES Vienna, Kunsthistorisches Museum
cm.)

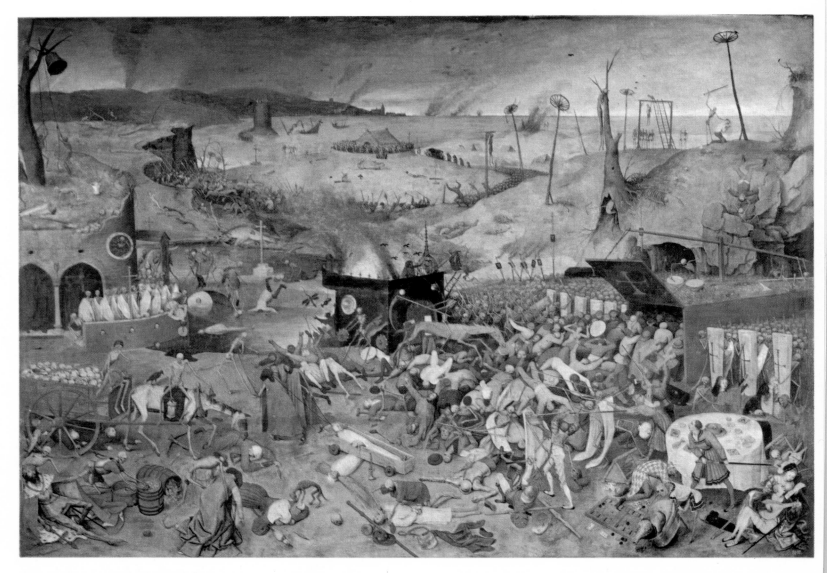

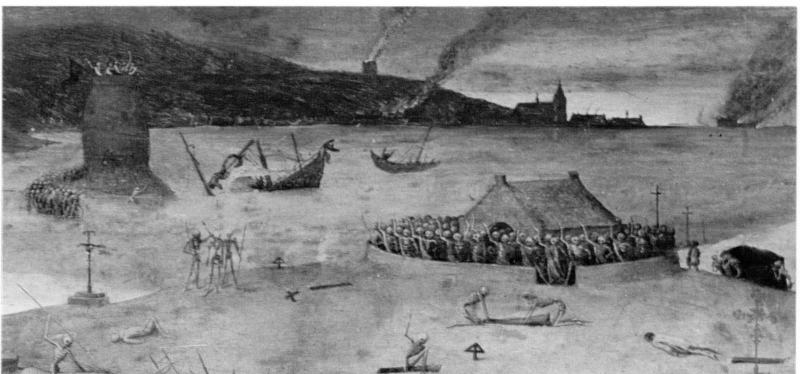

PLATE X THE TRIUMPH OF DEATH Madrid, Prado
Whole (162 cm.) and detail (43 cm.)

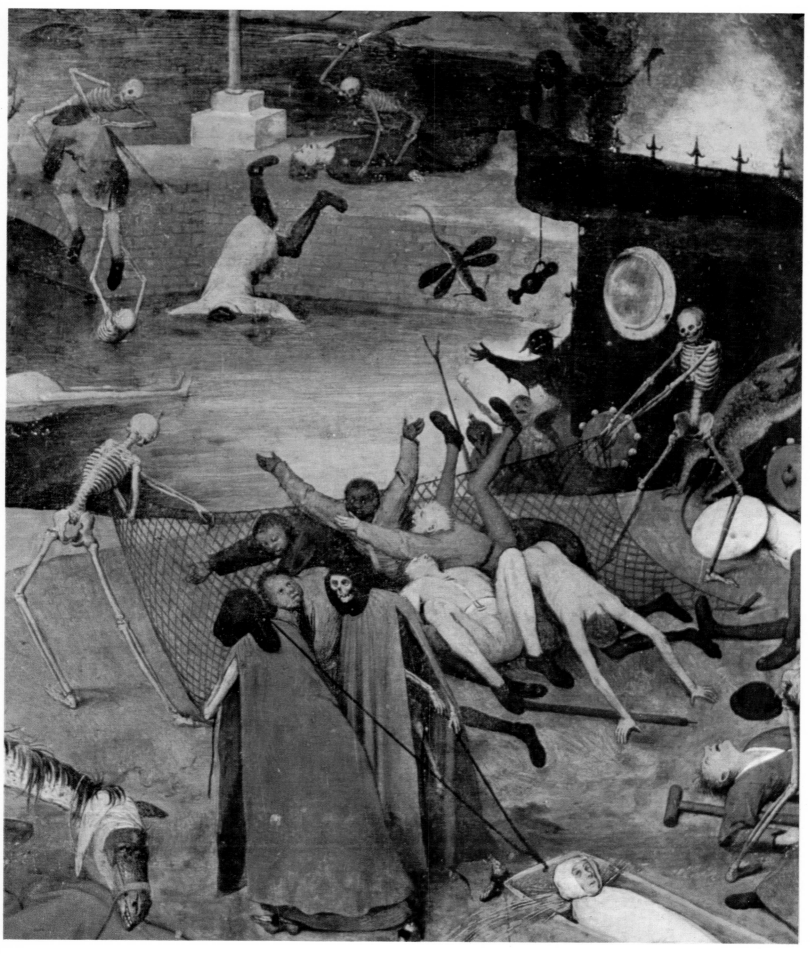

PLATE XI THE TRIUMPH OF DEATH Madrid, Prado
Detail (34 cm.)

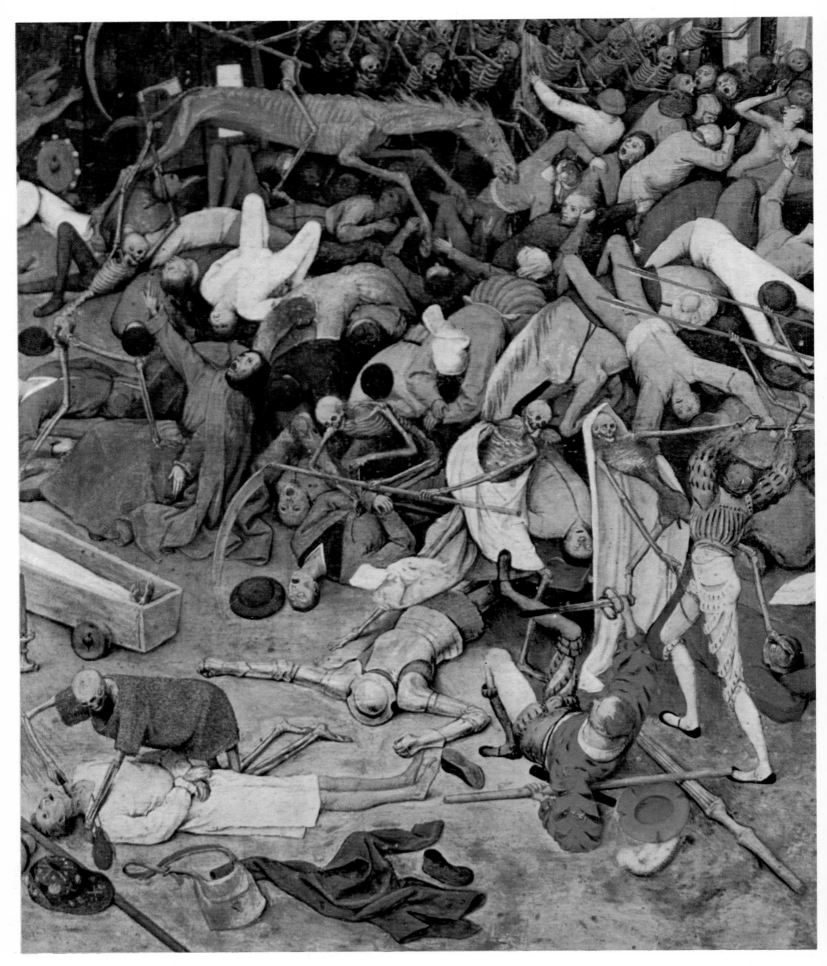

PLATE XII THE TRIUMPH OF DEATH Madrid, Prado
Detail (43 cm.)

PLATE XIII THE TRIUMPH OF DEATH Madrid, Prado
Detail (43 cm.)

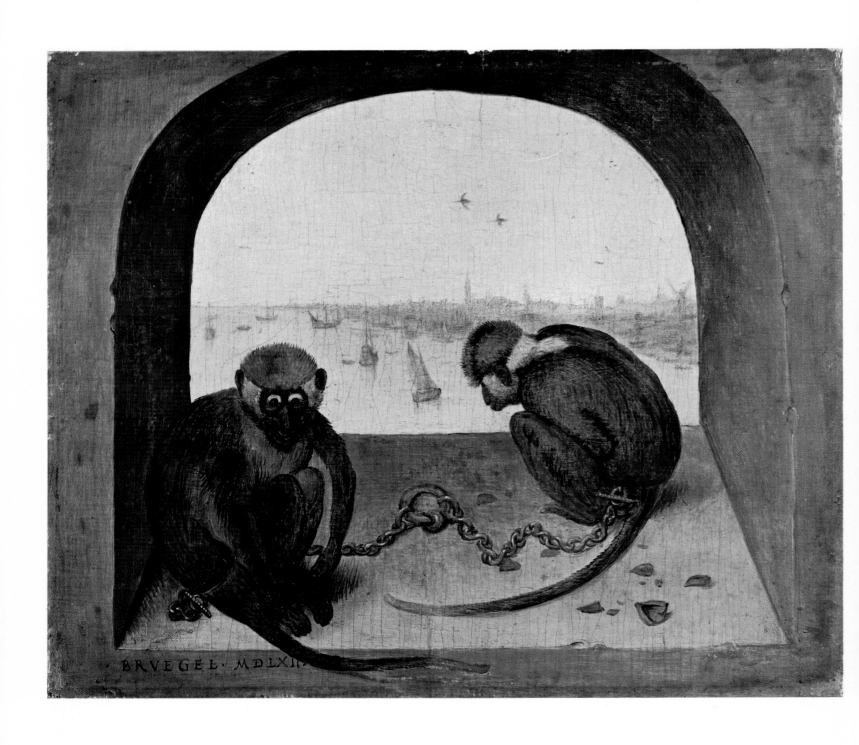

PLATE XIV TWO MONKEYS Berlin, Staatliche Museen
Whole (23 cm.)

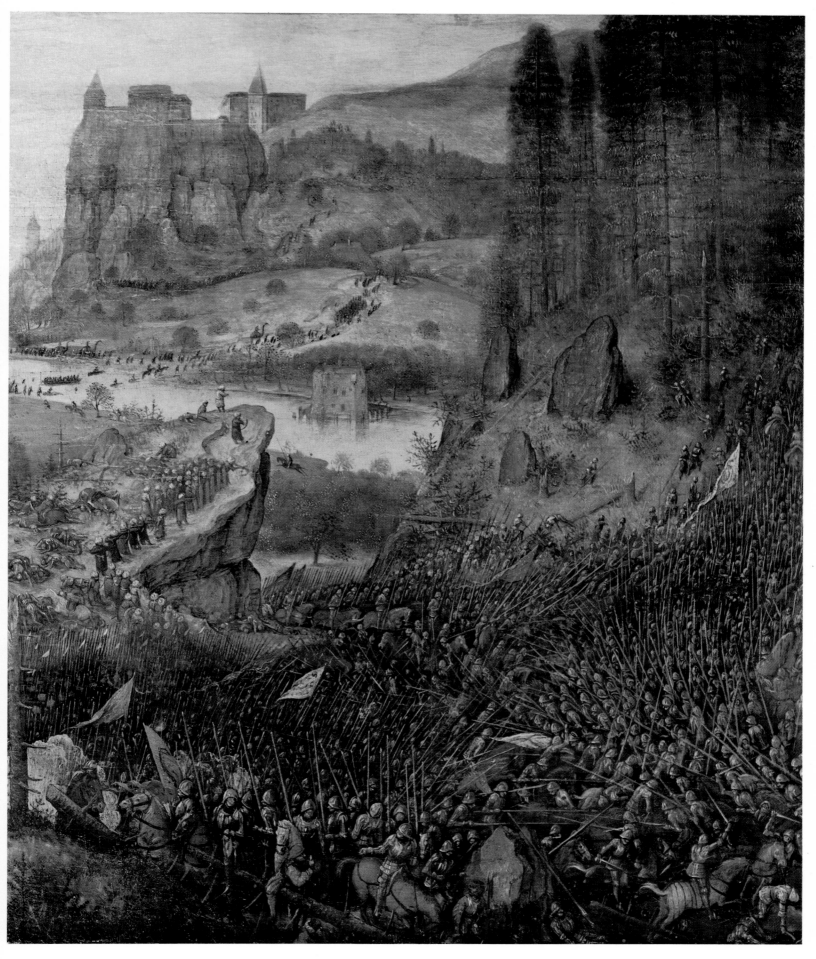

PLATE XV THE SUICIDE OF SAUL Vienna, Kunsthistorisches Museum
Detail (27 cm.)

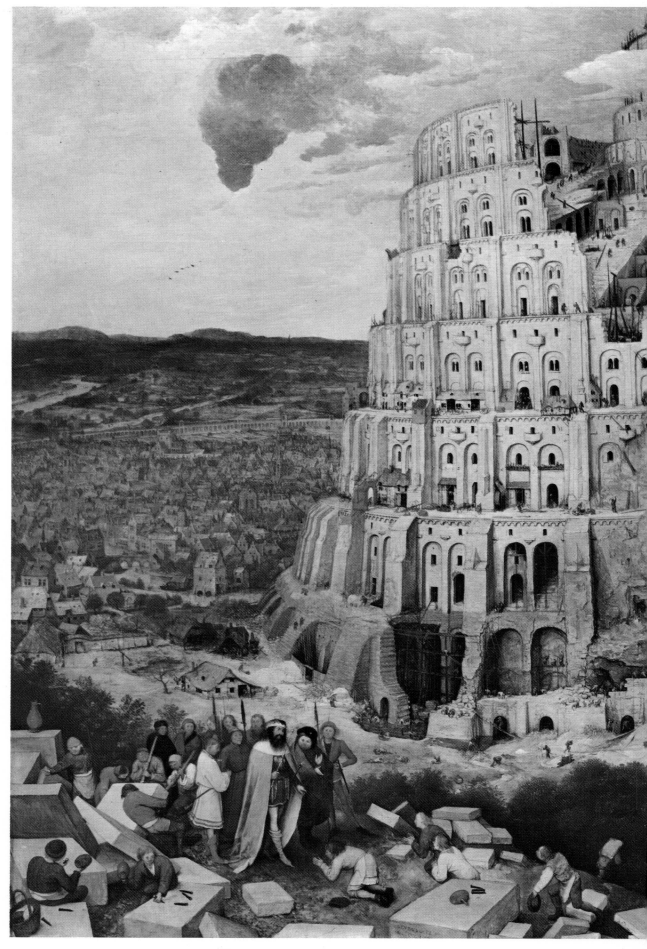

THE LARGE TOWER OF BABEL Vienna, Kunsthistorisches Museum
Whole (155 cm.)

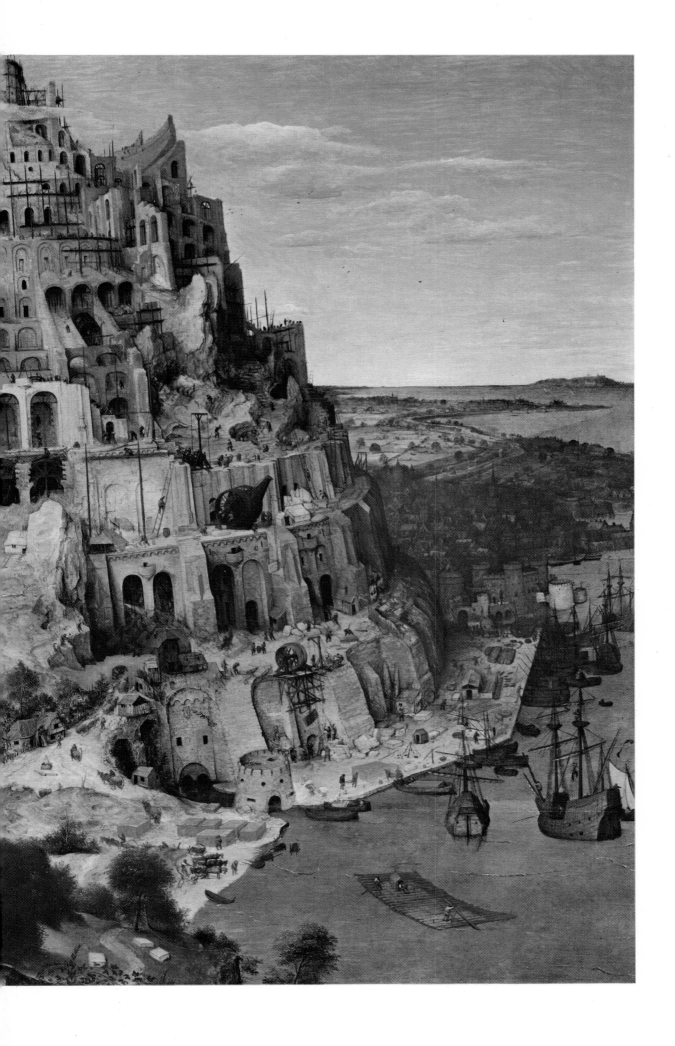

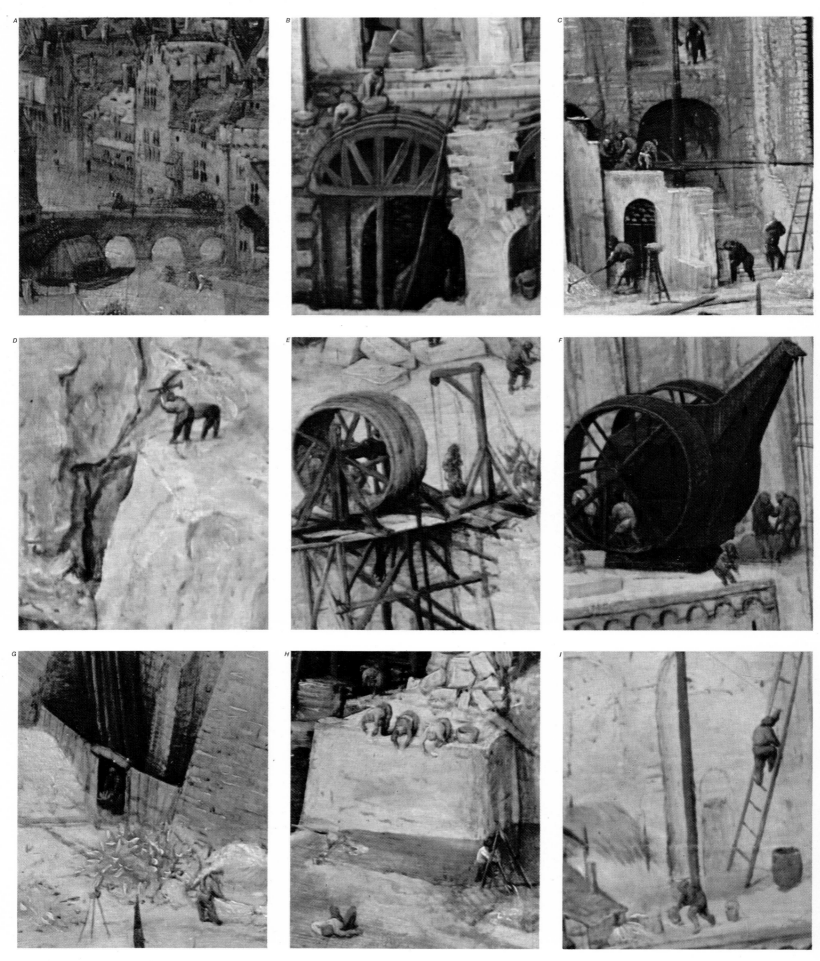

PLATE XVIII THE LARGE TOWER OF BABEL Vienna, Kunsthistorisches Museum
Details (life size)

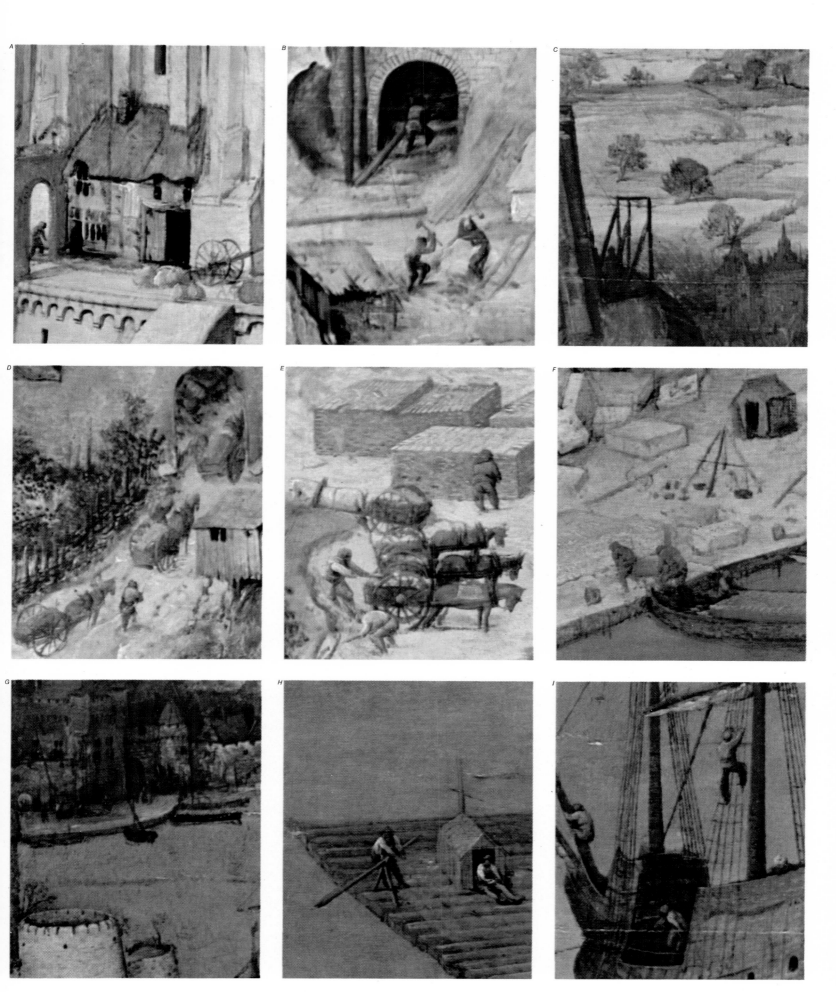

PLATE XIX THE LARGE TOWER OF BABEL Vienna, Kunsthistorisches Museum
Details (life size)

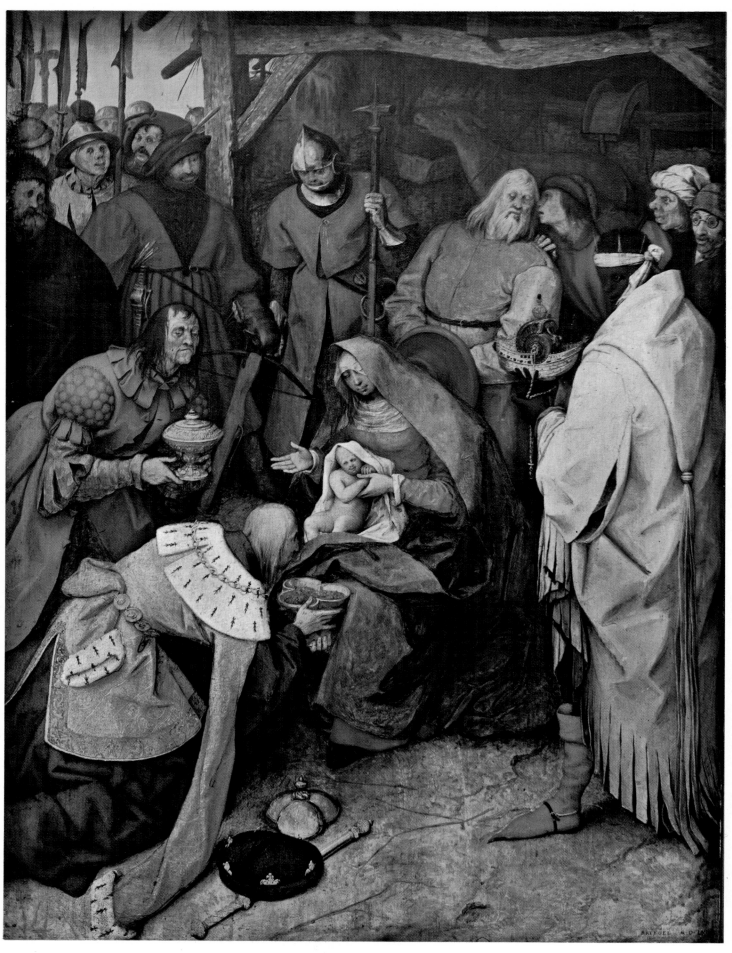

PLATE XX ADORATION OF THE MAGI London, National Gallery
Whole (83 cm.)

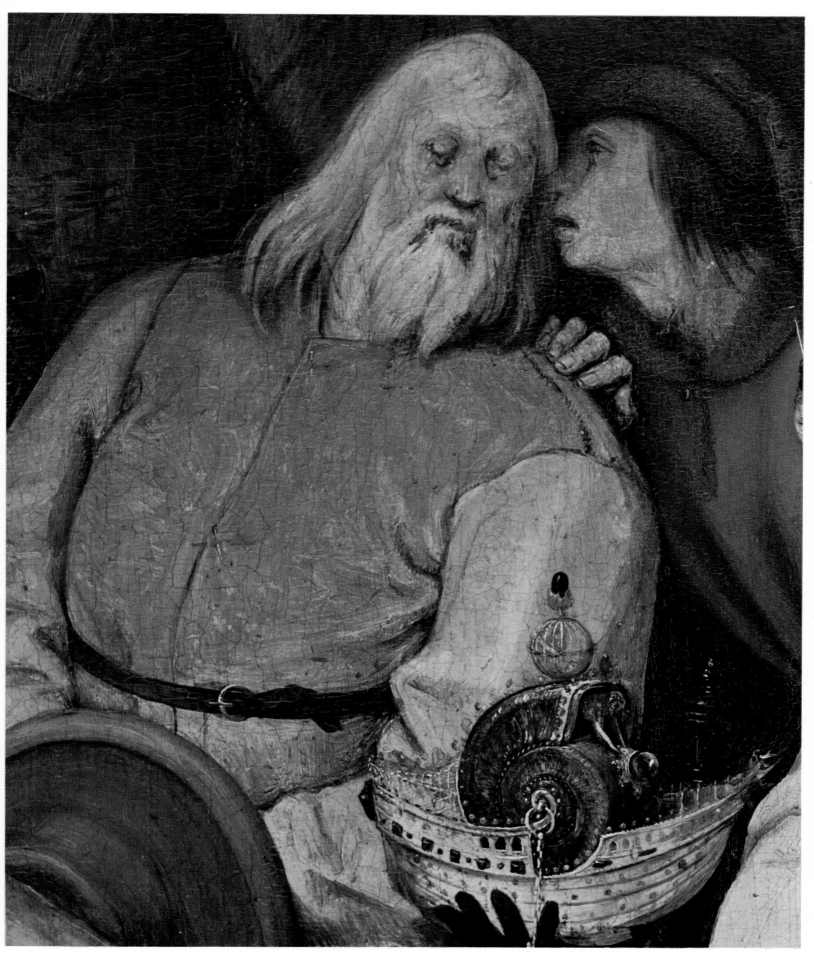

PLATE XXI ADORATION OF THE MAGI London, National Gallery
Detail (life size)

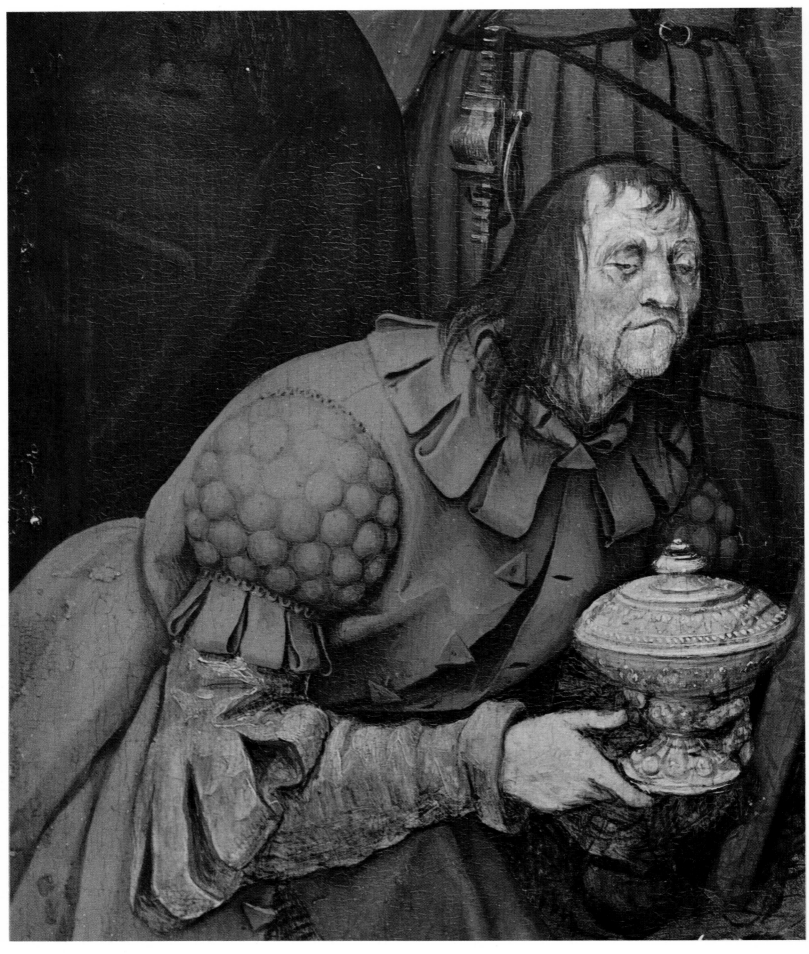

PLATE XXII ADORATION OF THE MAGI London, National Gallery
Detail (26 cm.)

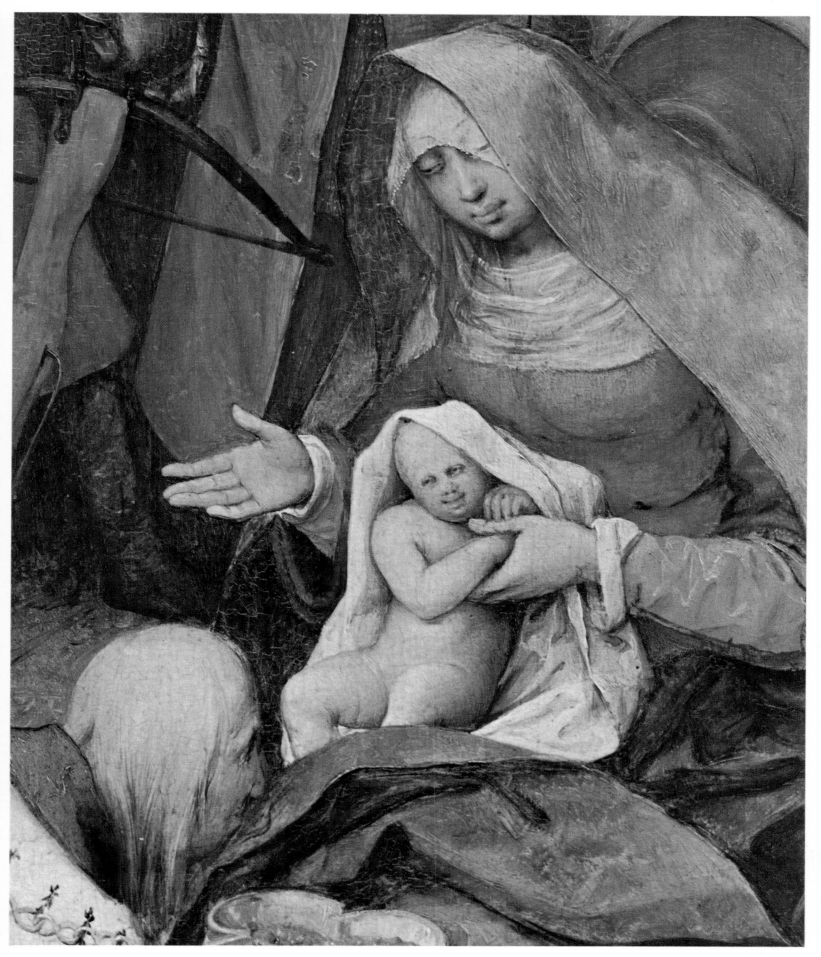

PLATE XXIII ADORATION OF THE MAGI London, National Gallery
Detail (26 cm.)

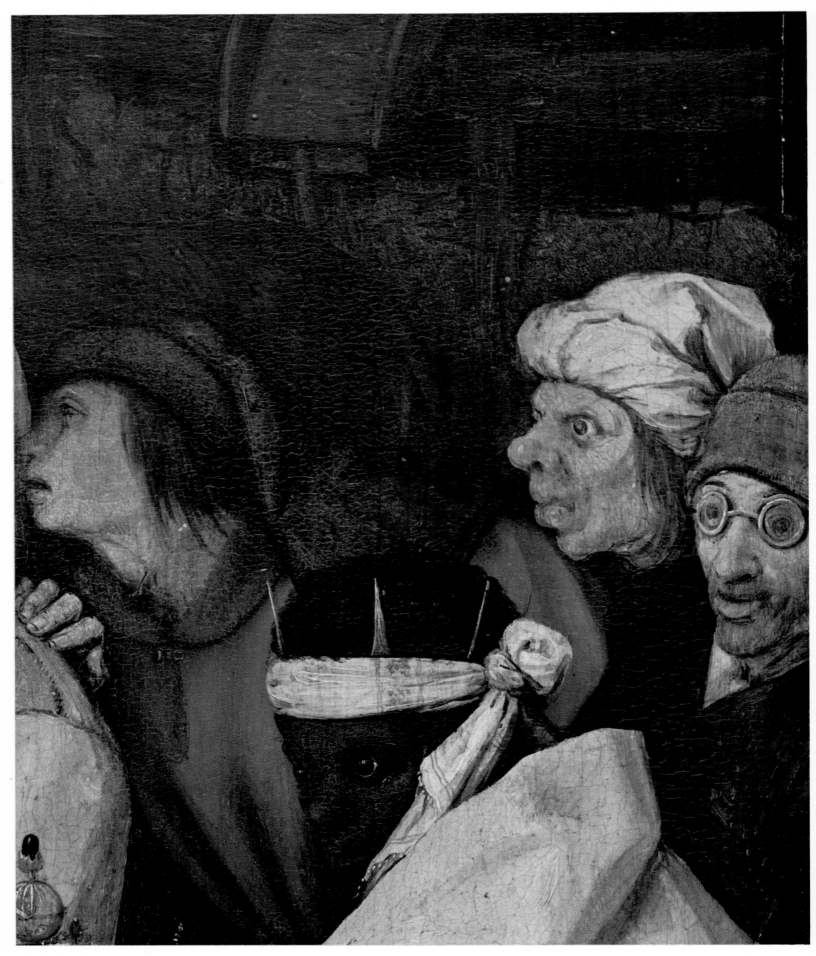

PLATE XXIV ADORATION OF THE MAGI London, National Gallery
Detail (life size)

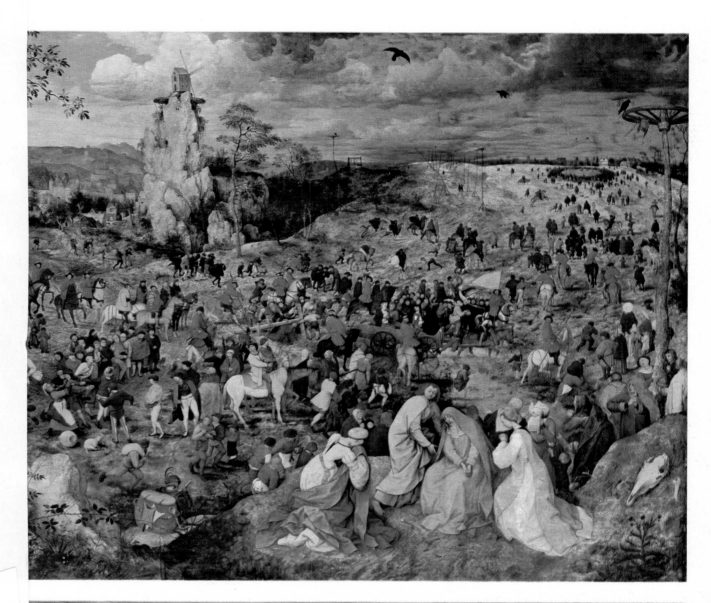

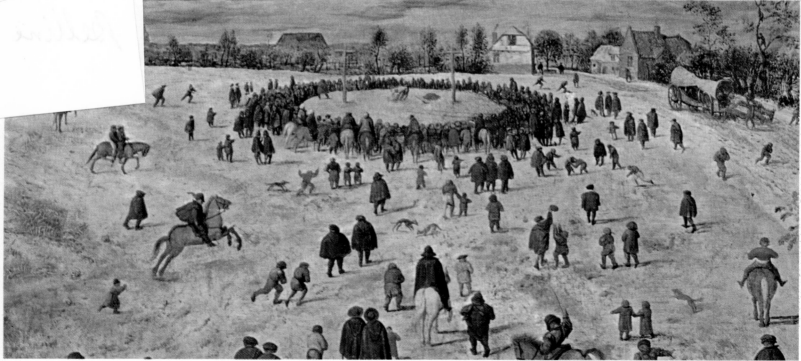

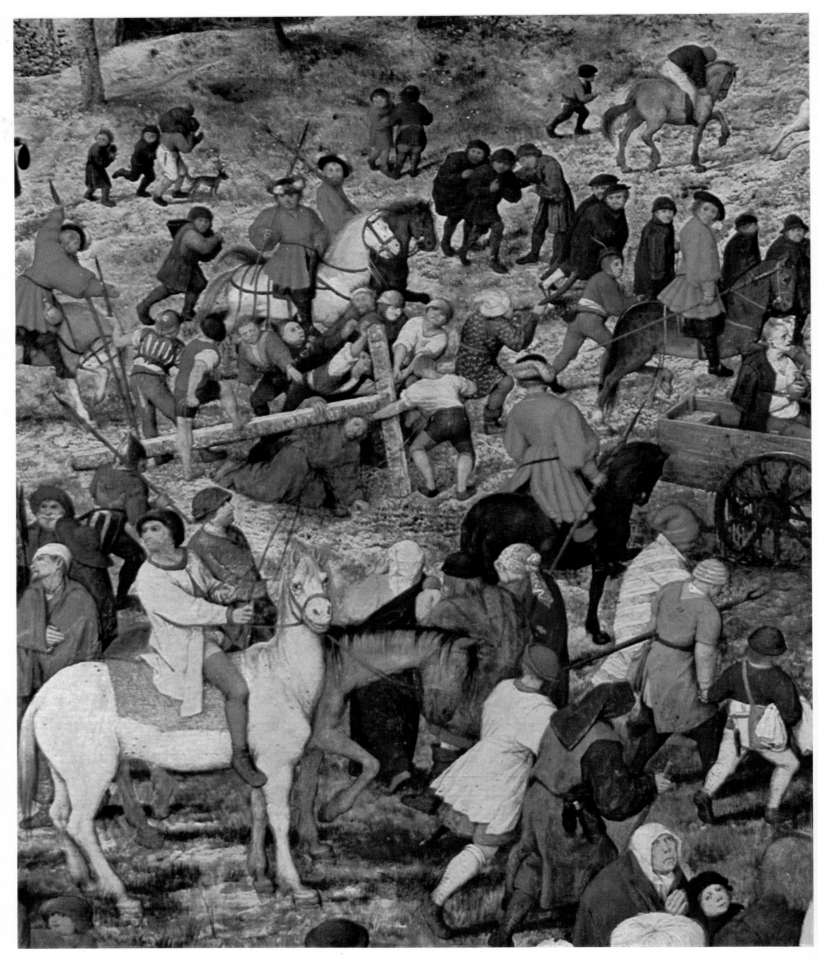

PLATE XXVI THE PROCESSION TO CALVARY Vienna, Kunsthistorisches Museum
Detail (36 cm.)

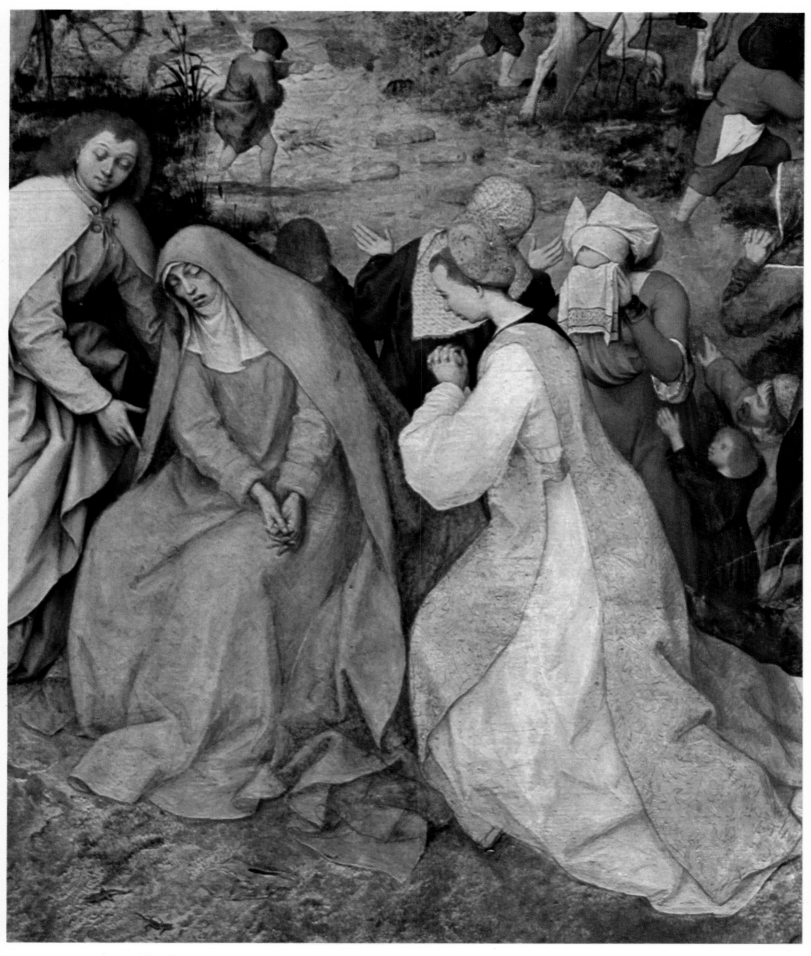

PLATE XXVII THE PROCESSION TO CALVARY Vienna, Kunsthistorisches Museum
Detail (36 cm.)

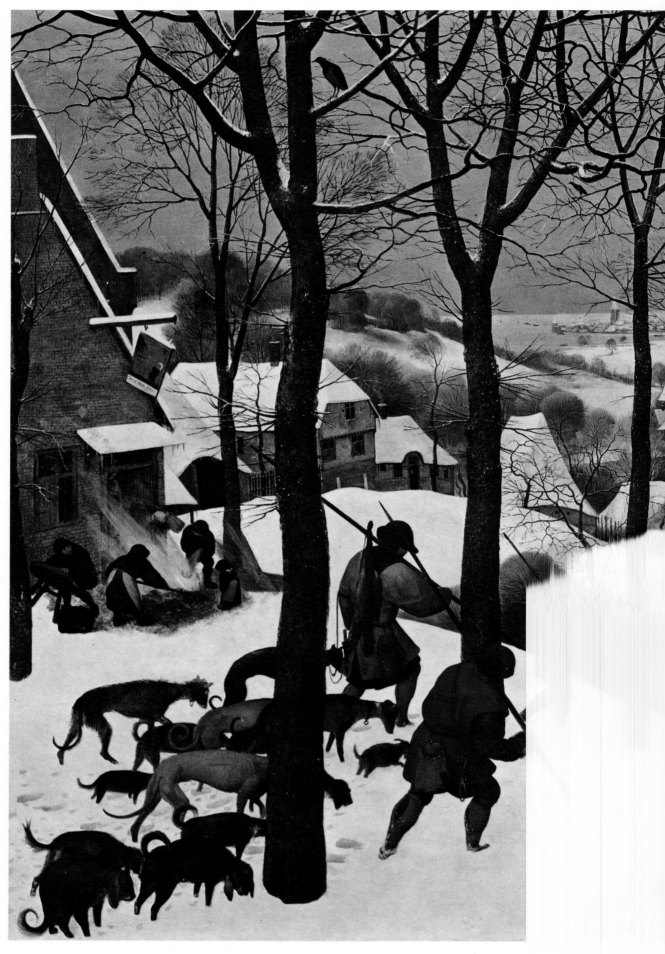

HUNTERS IN THE SNOW Vienna, Kunsthistorisches Museum
Whole (162 cm.)

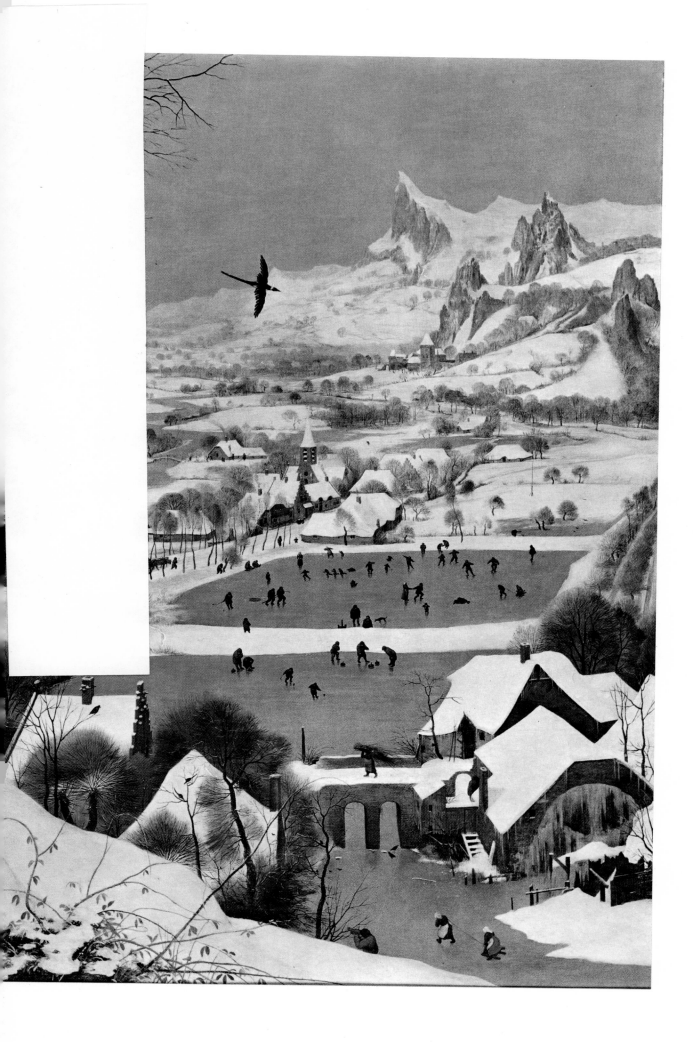

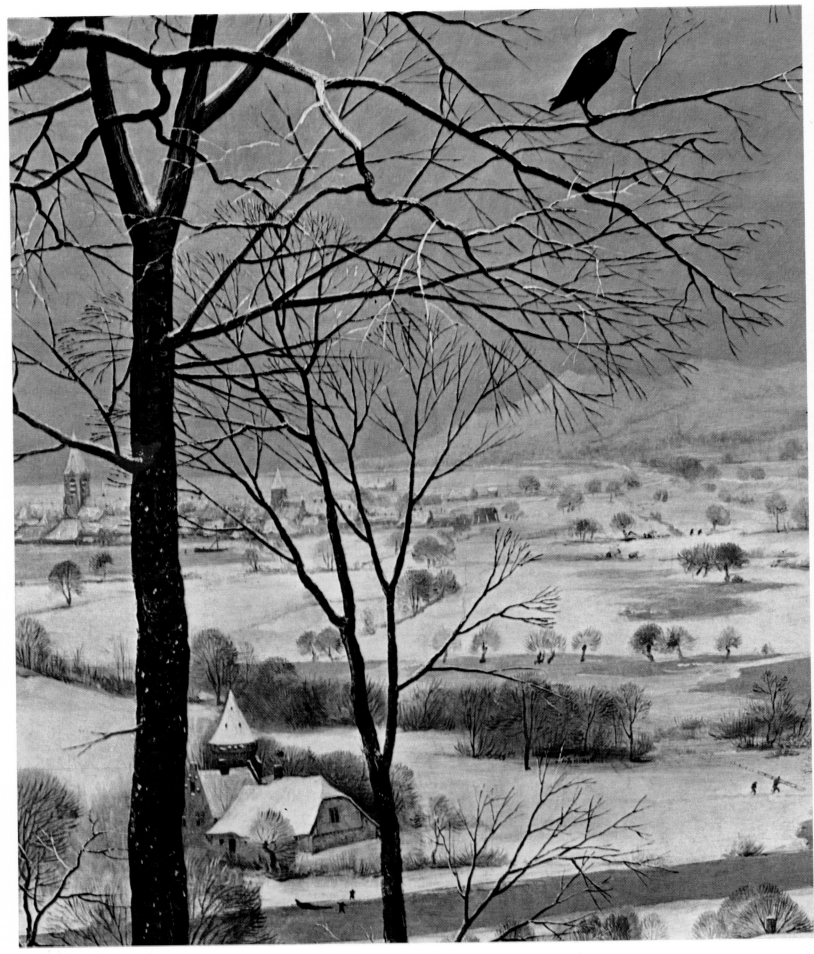

PLATE XXX HUNTERS IN THE SNOW Vienna, Kunsthistorisches Museum
Detail (30.5 cm.)

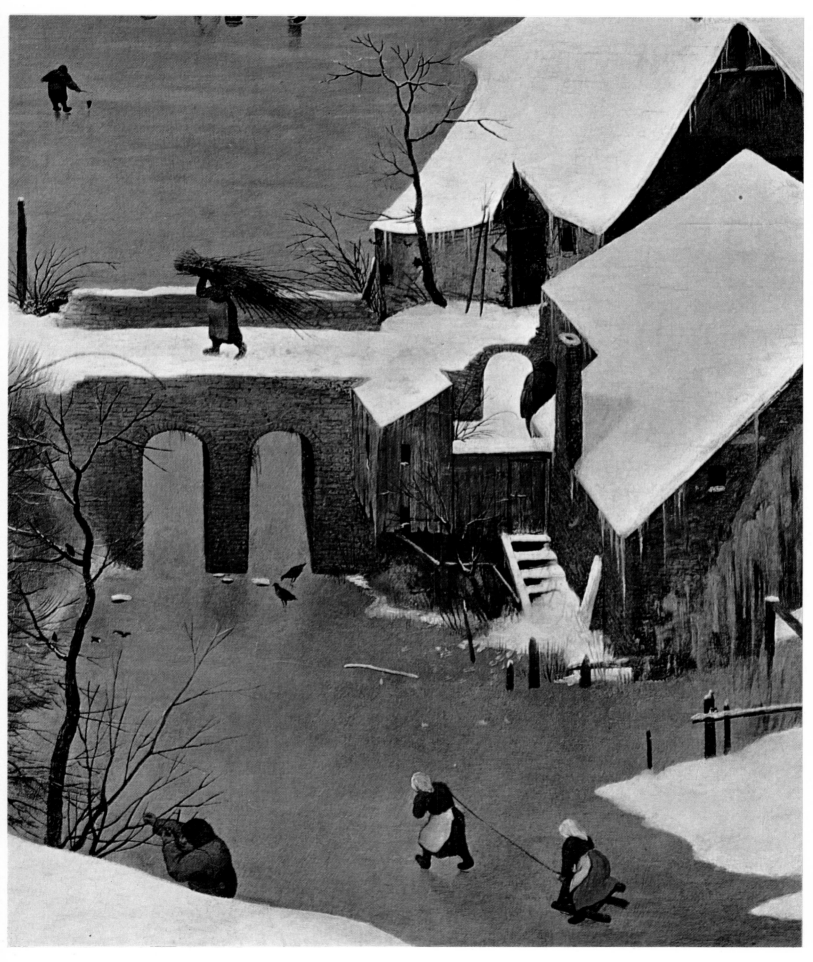

PLATE XXXI HUNTERS IN THE SNOW Vienna, Kunsthistorisches Museum
Detail (30.5 cm.)

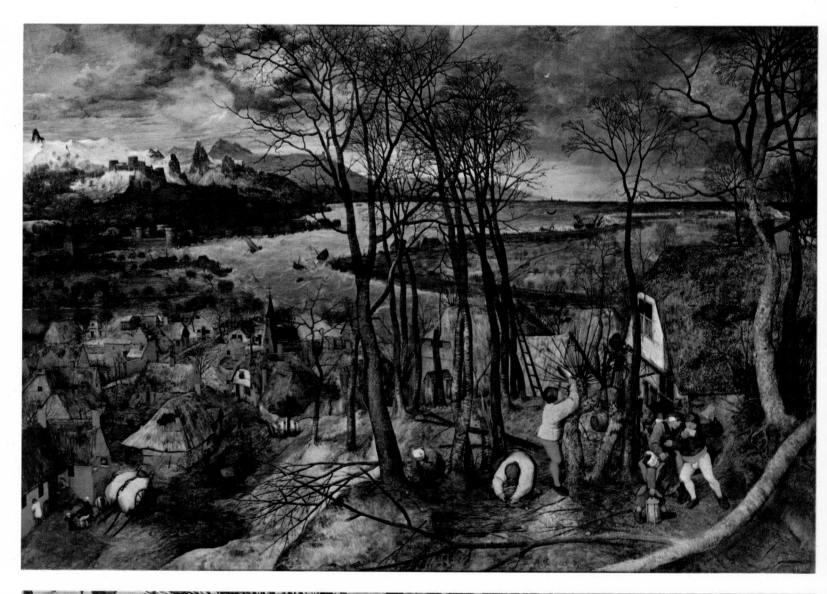

PLATE XXXIII THE DARK DAY Vienna, Kunsthistorisches Museum
Detail (40 cm.)

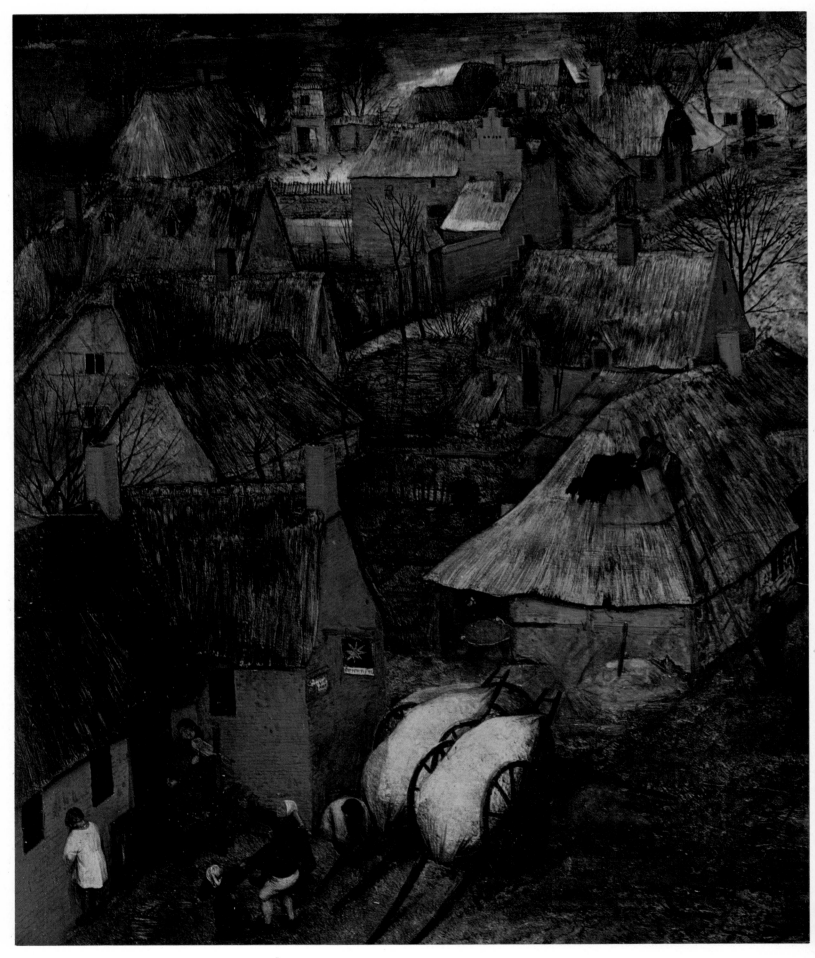

PLATE XXXIV THE DARK DAY Vienna, Kunsthistorisches Museum
Detail (40 cm.)

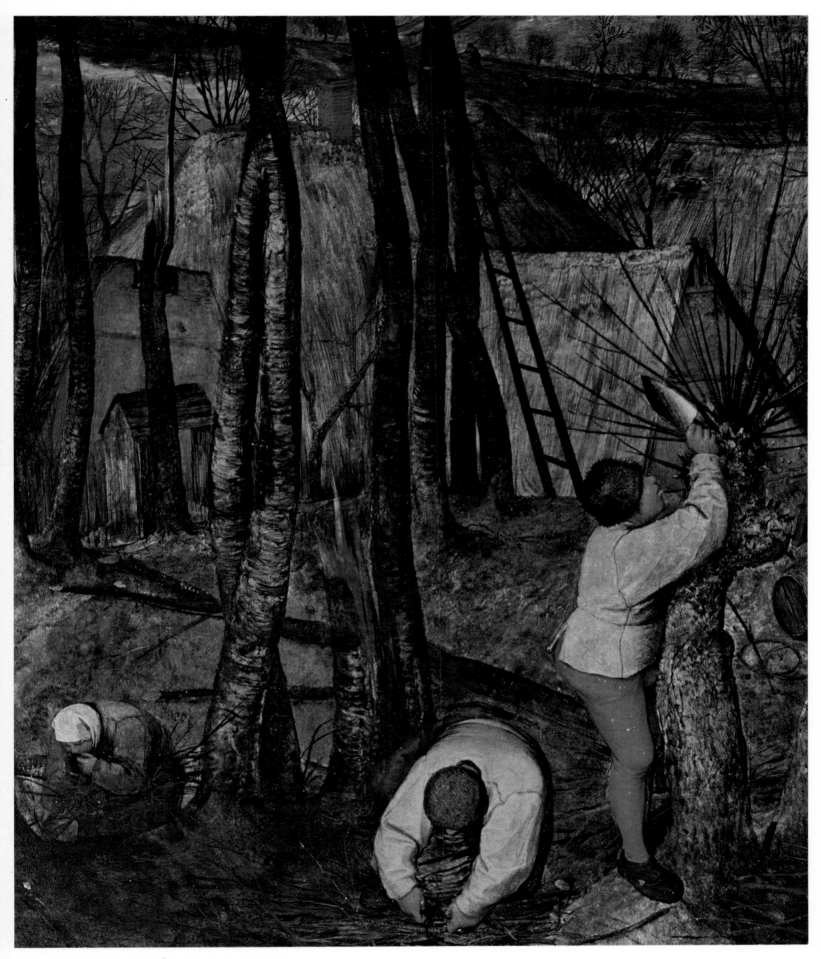

PLATE XXXV THE DARK DAY Vienna, Kunsthistorisches Museum
Detail (40 cm.)

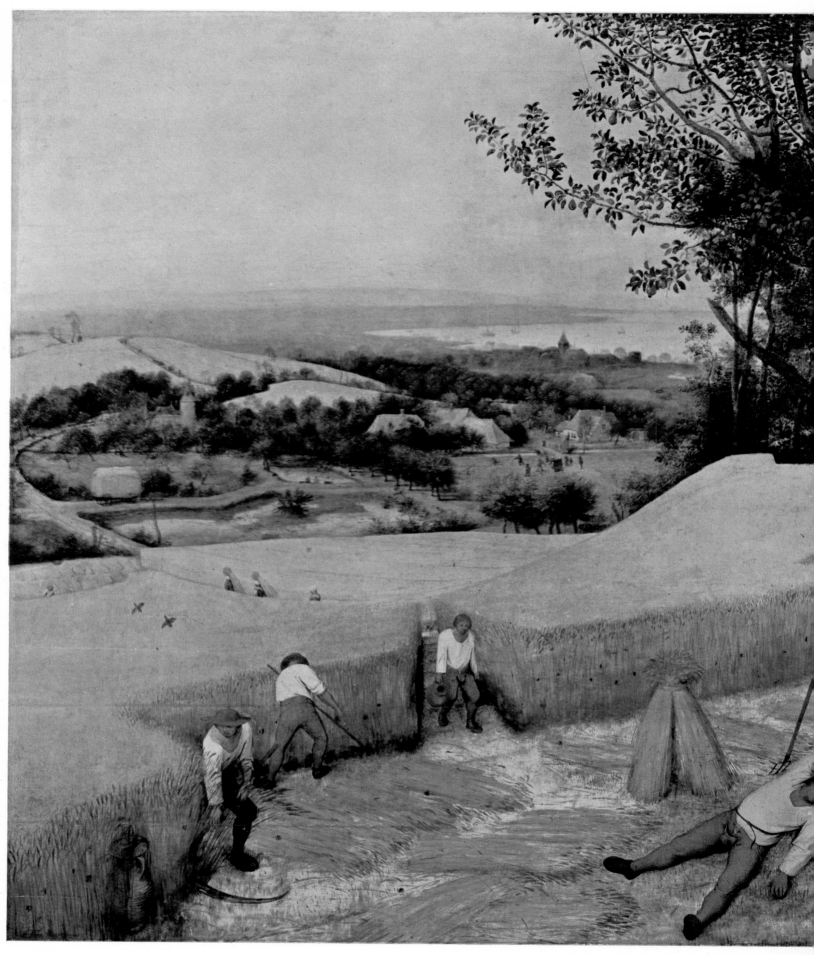

PLATES XXXVI-XXXVII ‘THE HARVEST New York, Metropolitan Museum
Whole (163 cm.) and details (20 cm.)

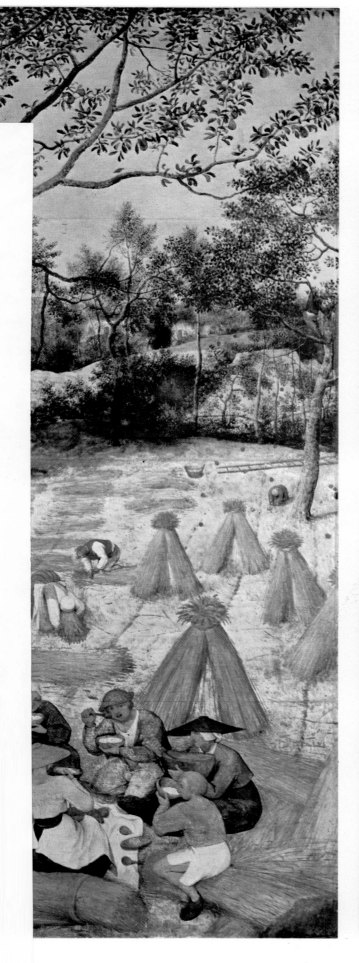

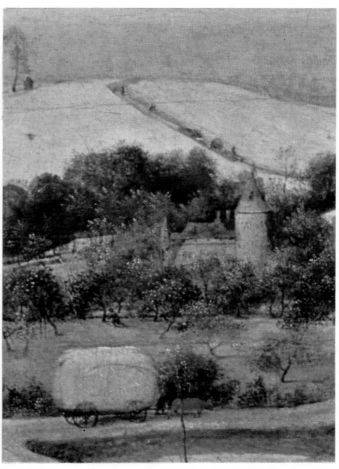

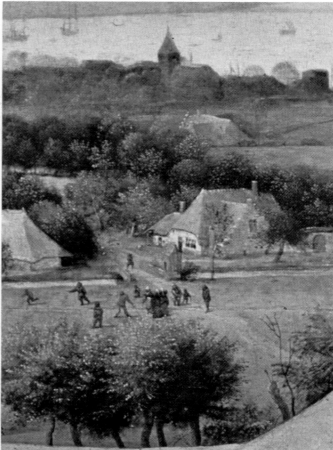

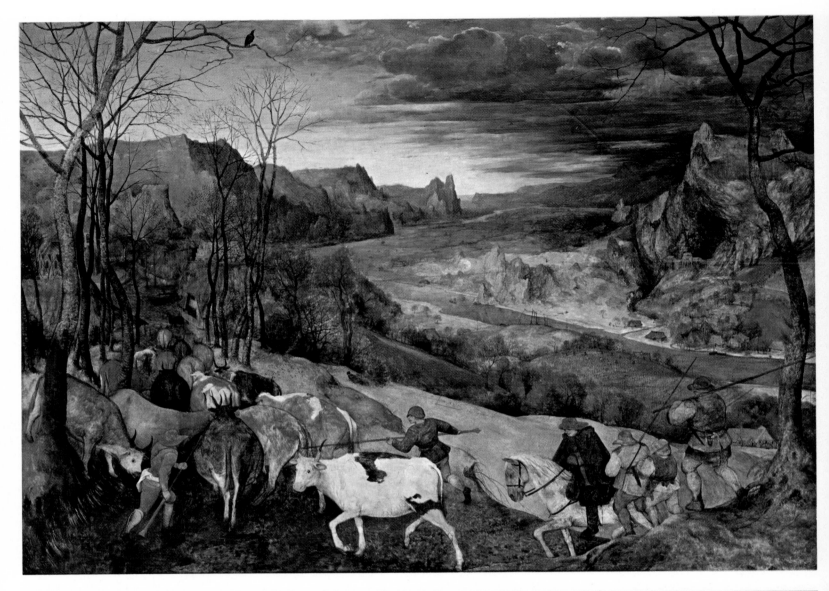

PLATE XXXVIII THE RETURN OF THE HERD Vienna, Kunsthistorisches Museum
Whole (159 cm.) and detail (56 cm.)

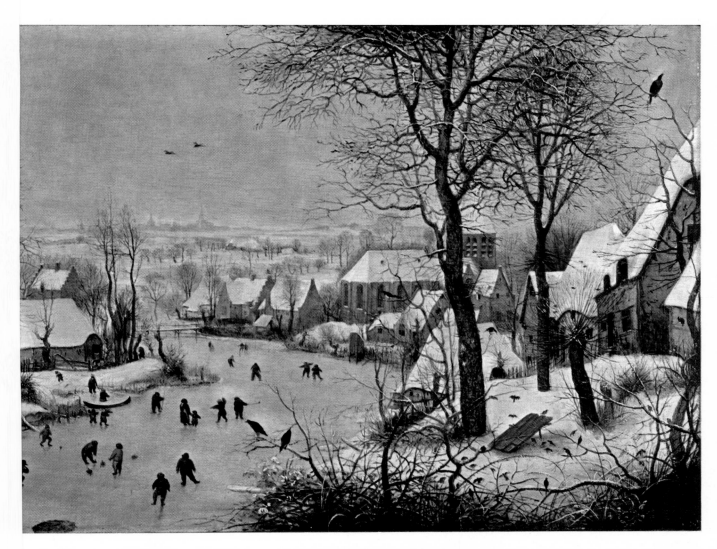

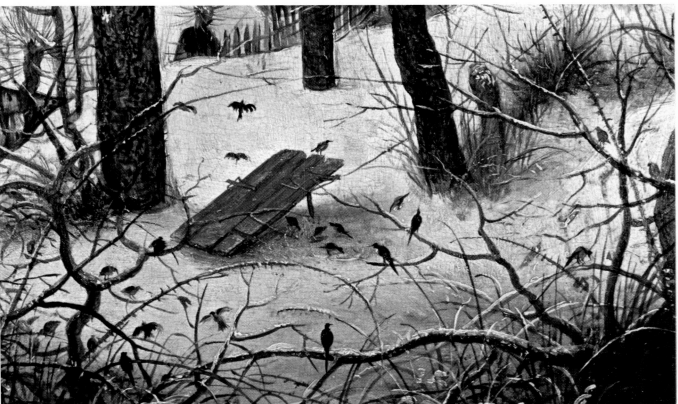

LANDSCAPE WITH SKATERS AND BIRDTRAP Brussels, F. Delporte Collection
56 cm.) and detail (life size)

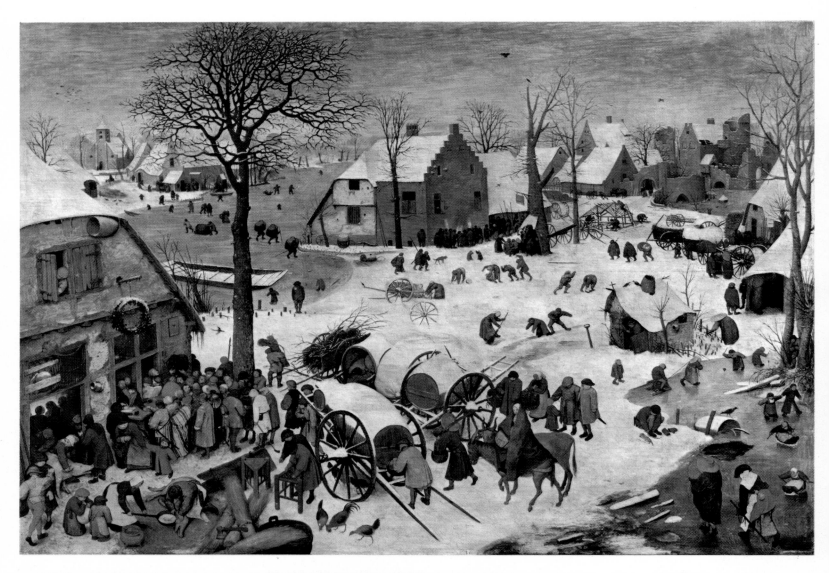

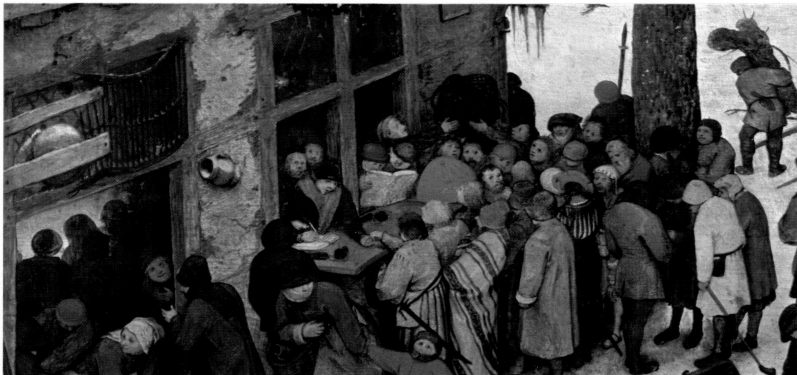

PLATE XL THE NUMBERING OF THE PEOPLE AT BETHLEHEM Brussels, Musées Royaux des Beaux-Arts
Whole (164.5 cm.) and detail (54 cm.)

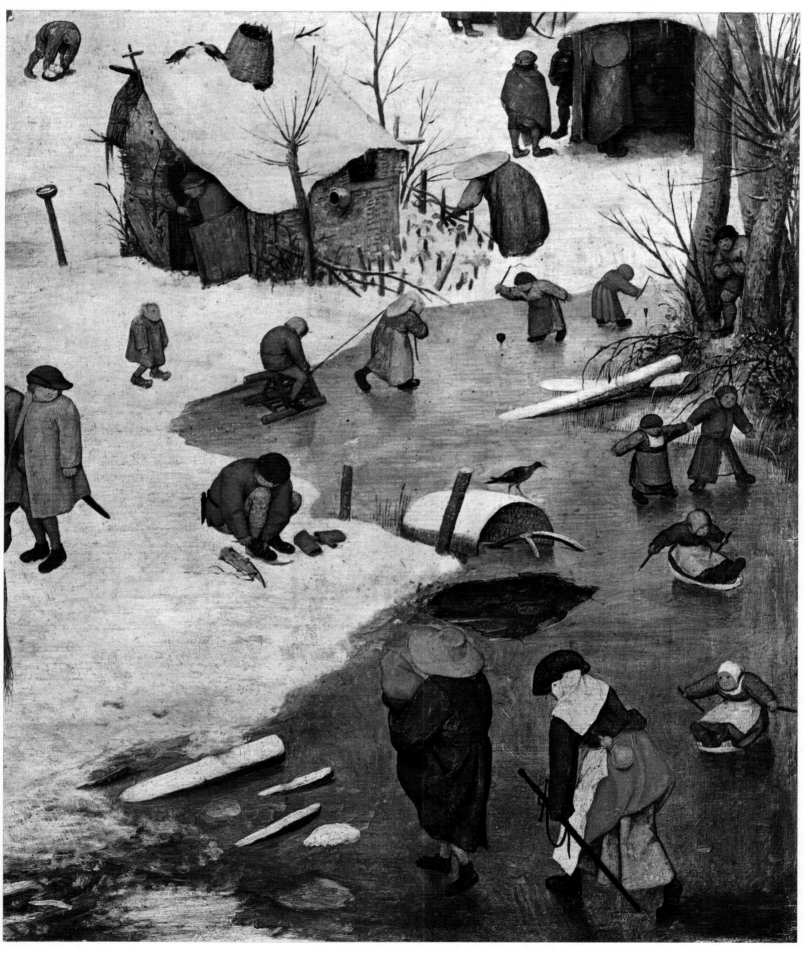

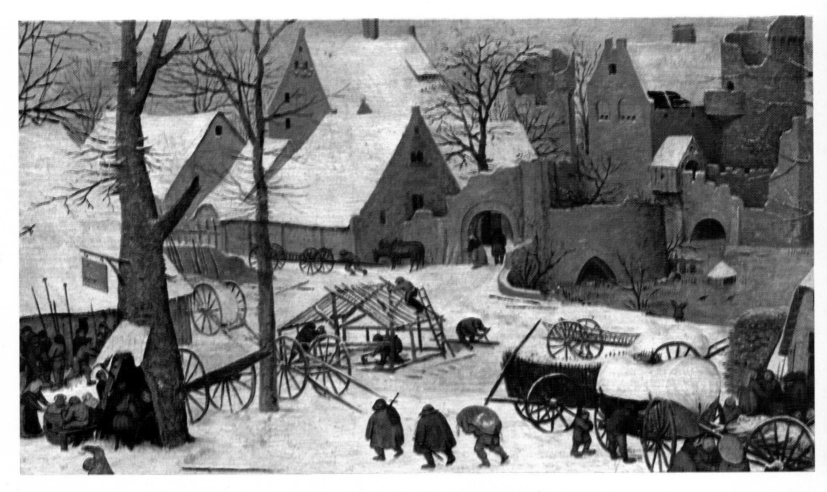

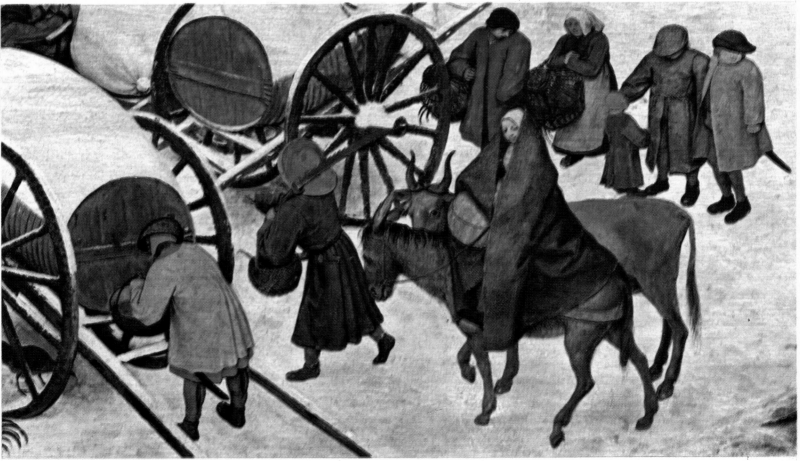

PLATE XLII THE NUMBERING OF THE PEOPLE AT BETHLEHEM Brussels, Musées Royaux des Beaux-Arts
Details (54 cm.)

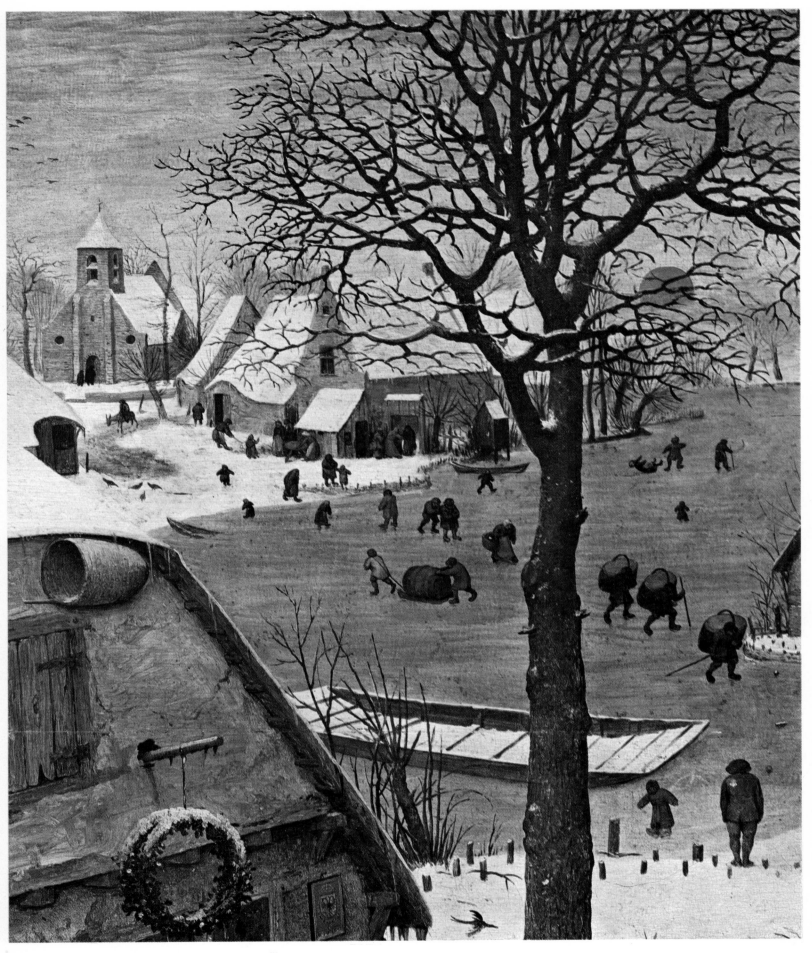

PLATE XLIII THE NUMBERING OF THE PEOPLE AT BETHLEHEM Brussels, Musées Royaux des Beaux-Arts
Detail (49 cm.)

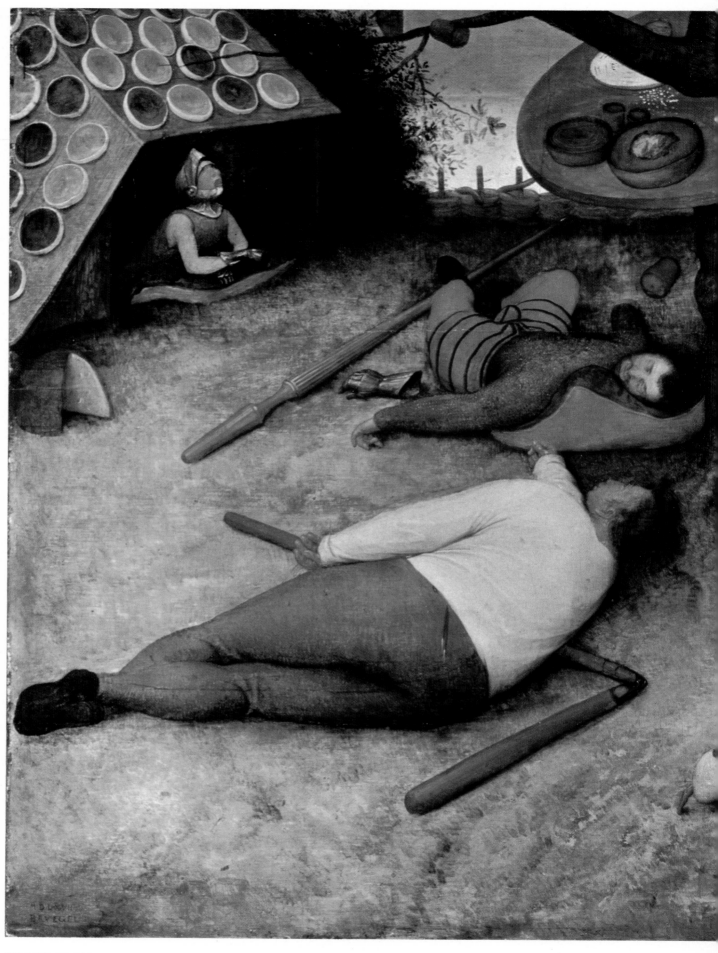

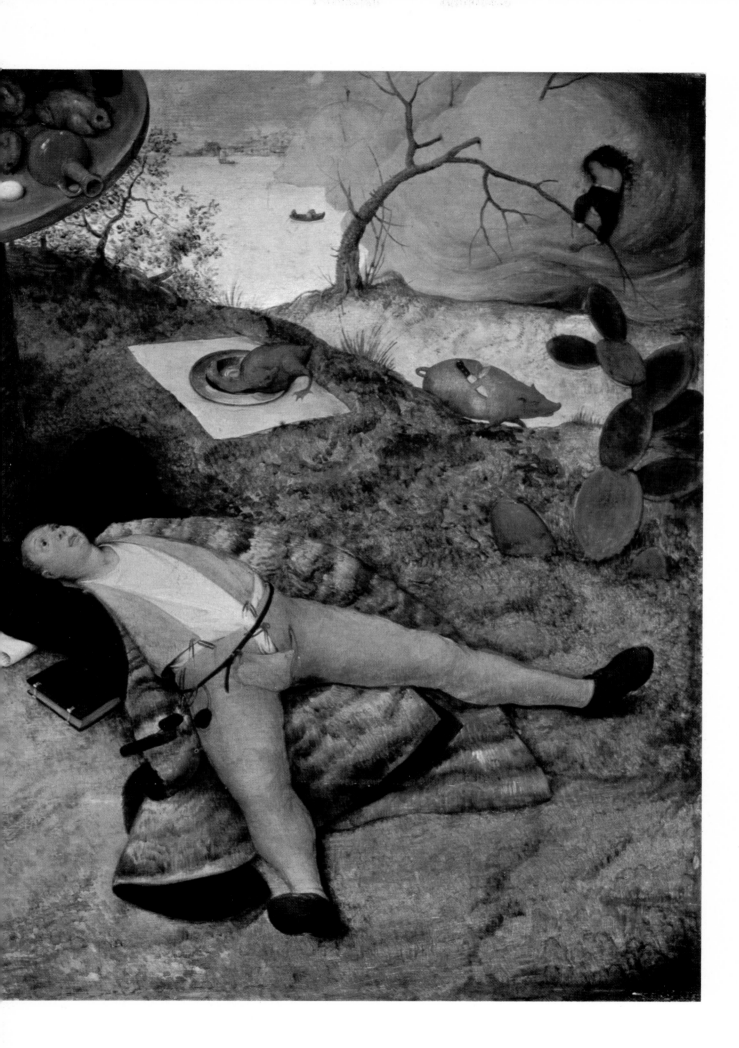

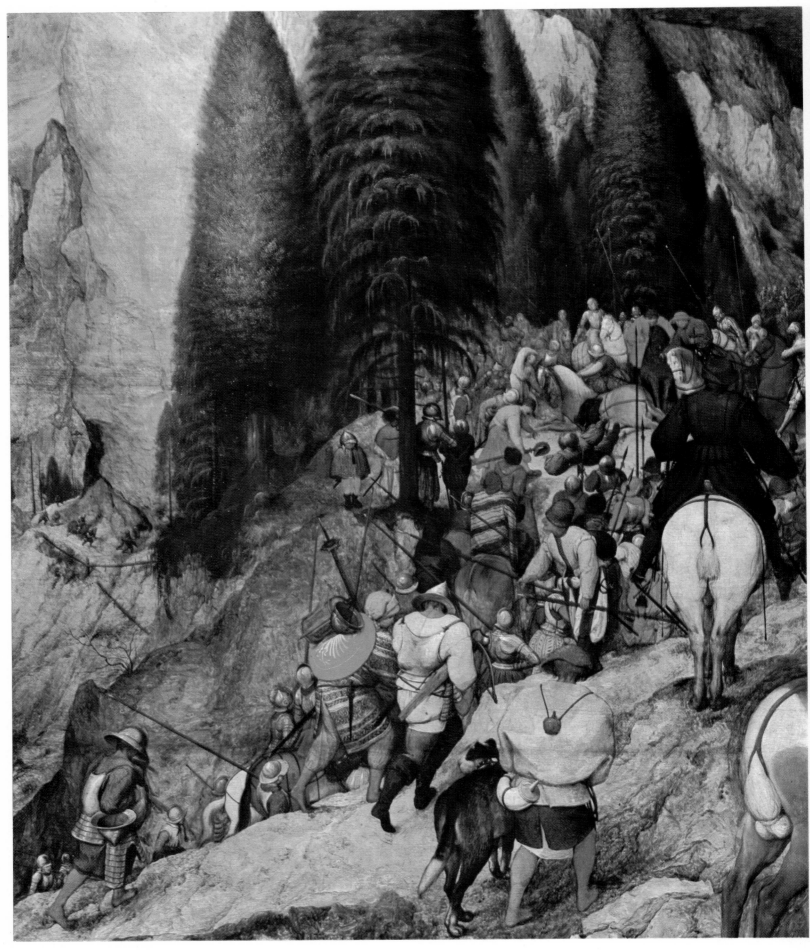

PLATE XLVI THE CONVERSION OF ST PAUL Vienna, Kunsthistorisches Museum
Detail (78 cm.)

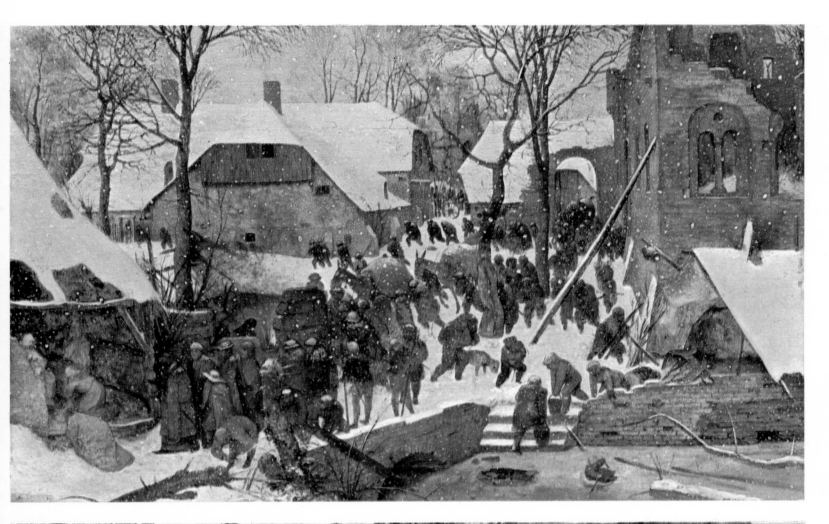

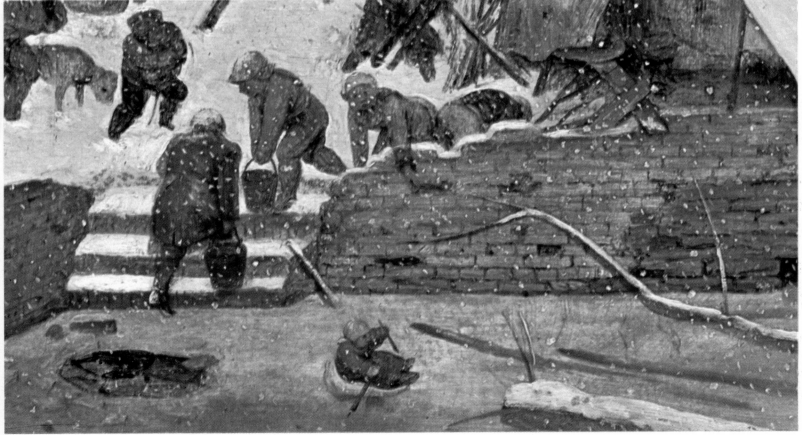

PLATE XLVII THE ADORATION OF THE MAGI IN THE SNOW Winterthur, Reinhart Collection
Whole (55 cm.) and detail (life size)

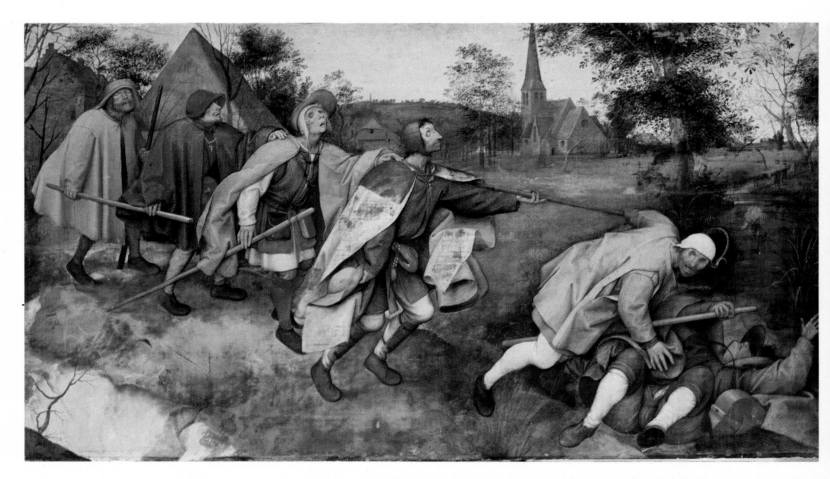

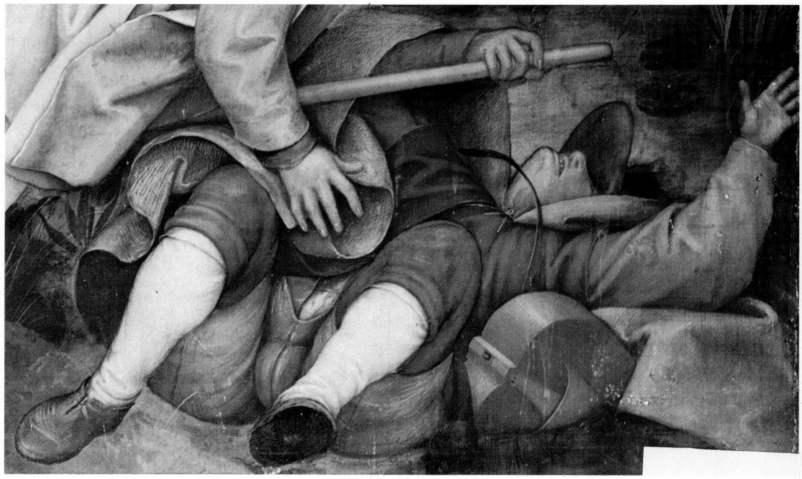

THE BLIND MEN Naples, Gallerie Nazionali di Capodimonte
e)

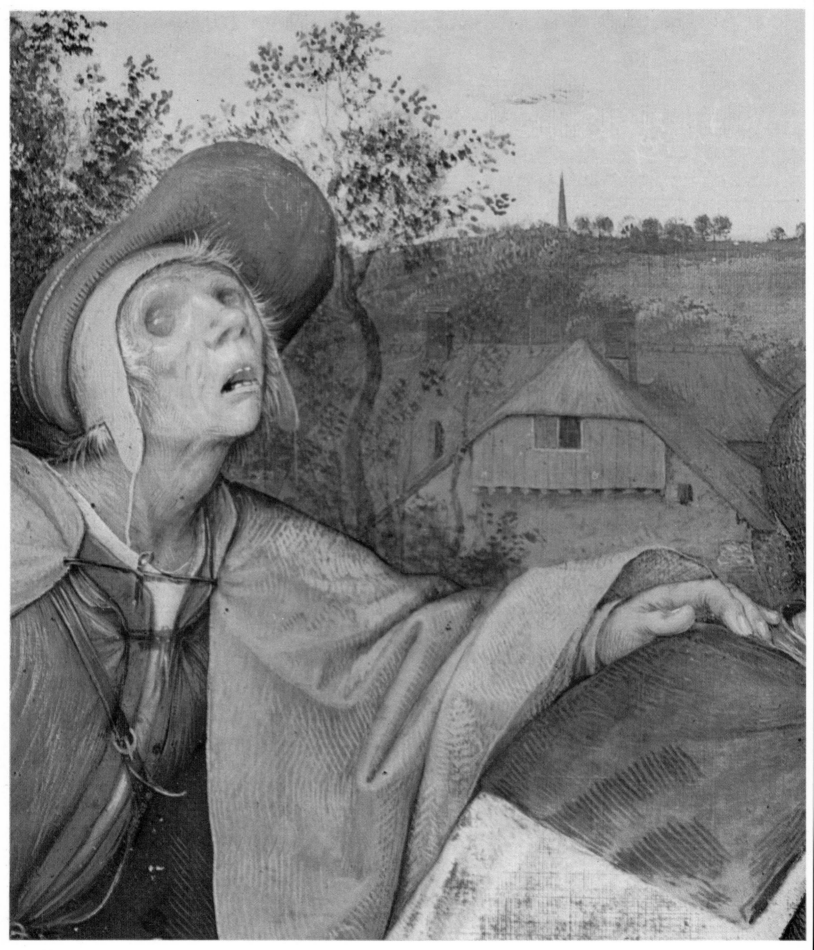

PLATE LI PARABLE OF THE BLIND MEN Naples, Gallerie Nazionali di Capodimonte
Detail (life size)

Om dat de Werelt is soe ongetru
Daer om gha ic indem ru

PLATE LII THE MISANTHROPE Naples, Gallerie Nazionali di Capodimonte
Whole (85 cm.)

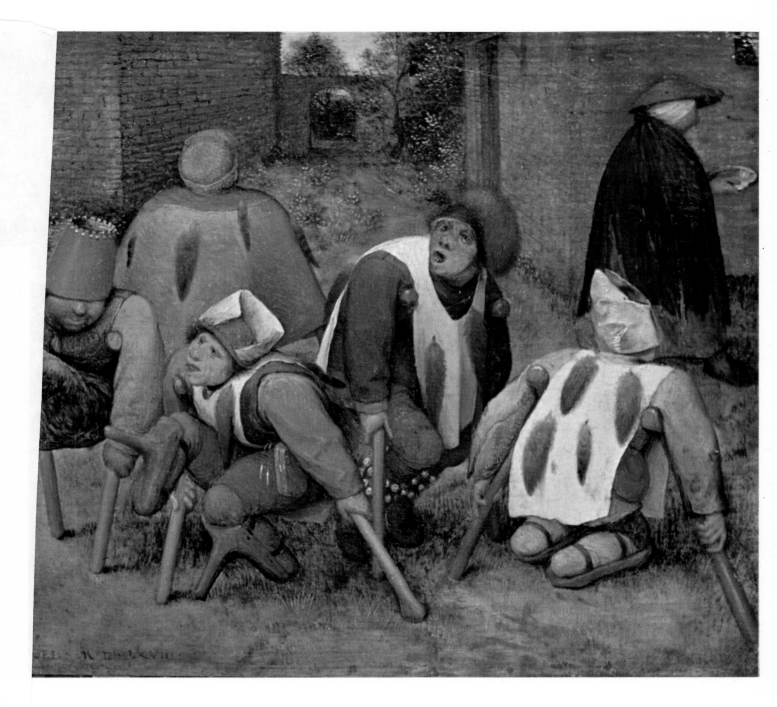

PLATE LIII CRIPPLES Paris, Louvre
Whole (life size)

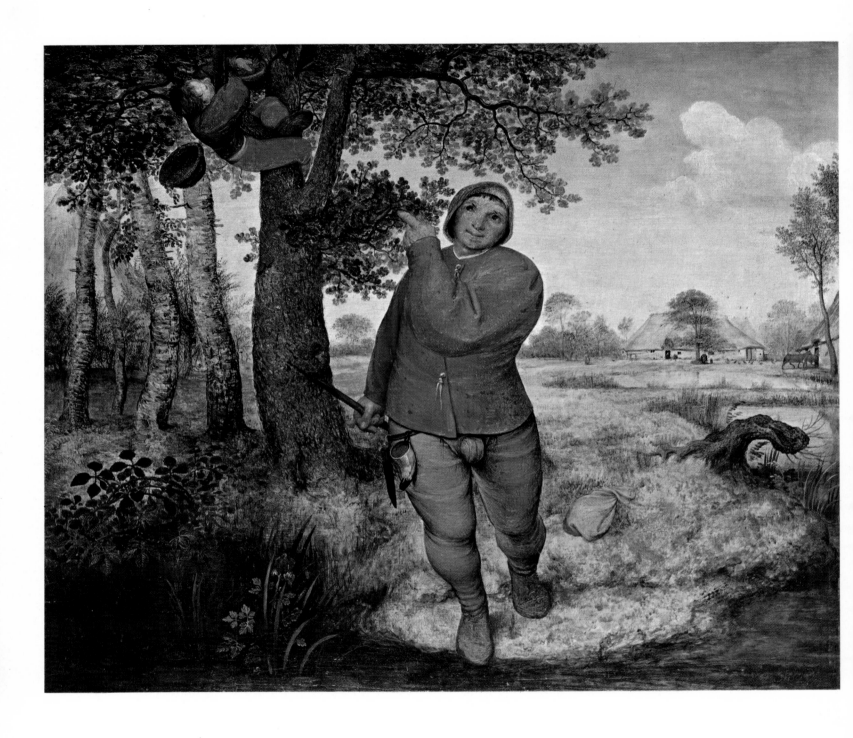

PLATE LIV THE BIRDNESTER Vienna, Kunsthistorisches Museum
Whole (68 cm.)

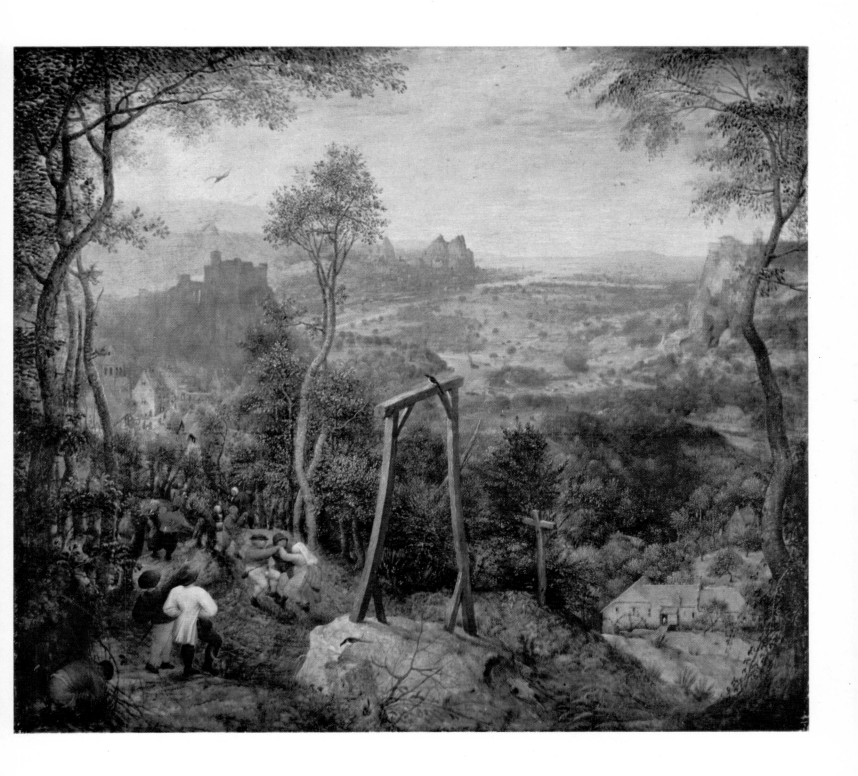

PLATE LV THE MAGPIE ON THE GALLOWS Darmstadt, Landesmuseum
Whole (50.8 cm.)

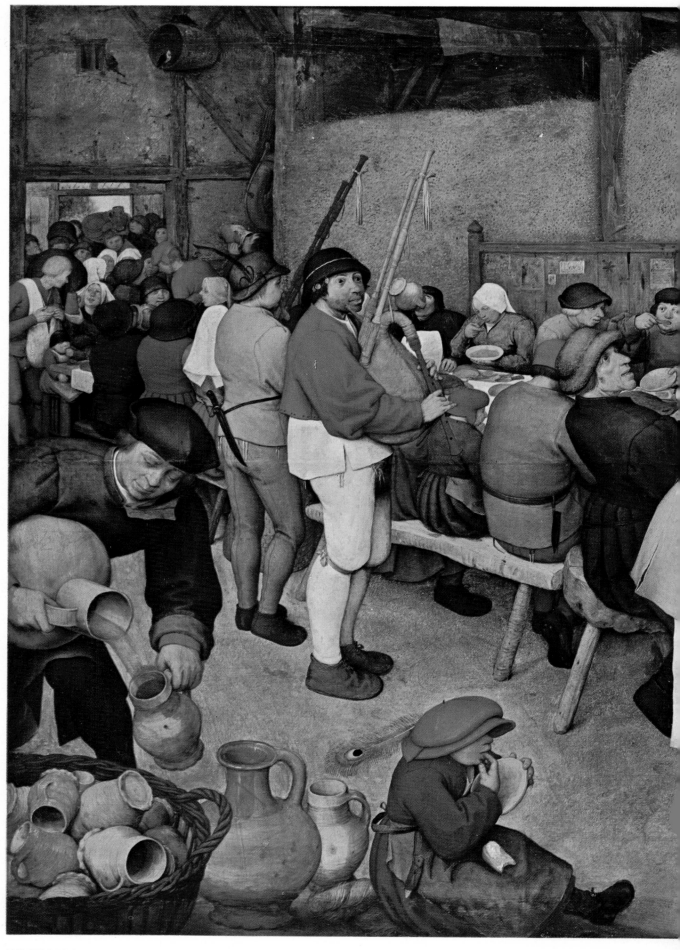

THE PEASANTS' WEDDING Vienna, Kunsthistorisches Museum
Whole (163 cm.)

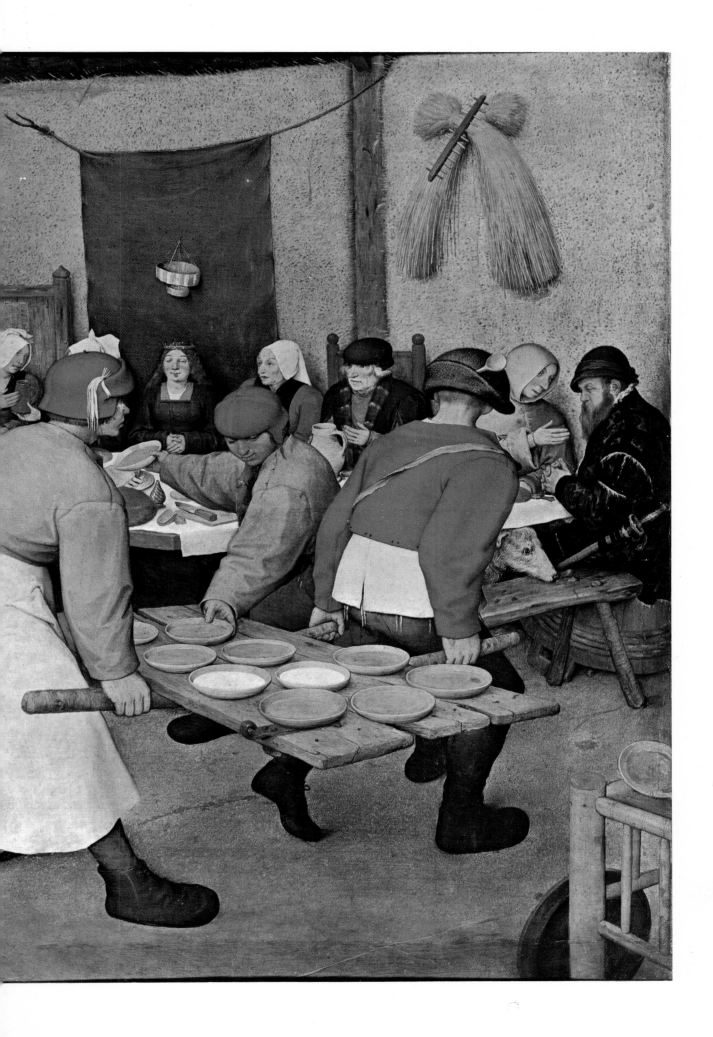

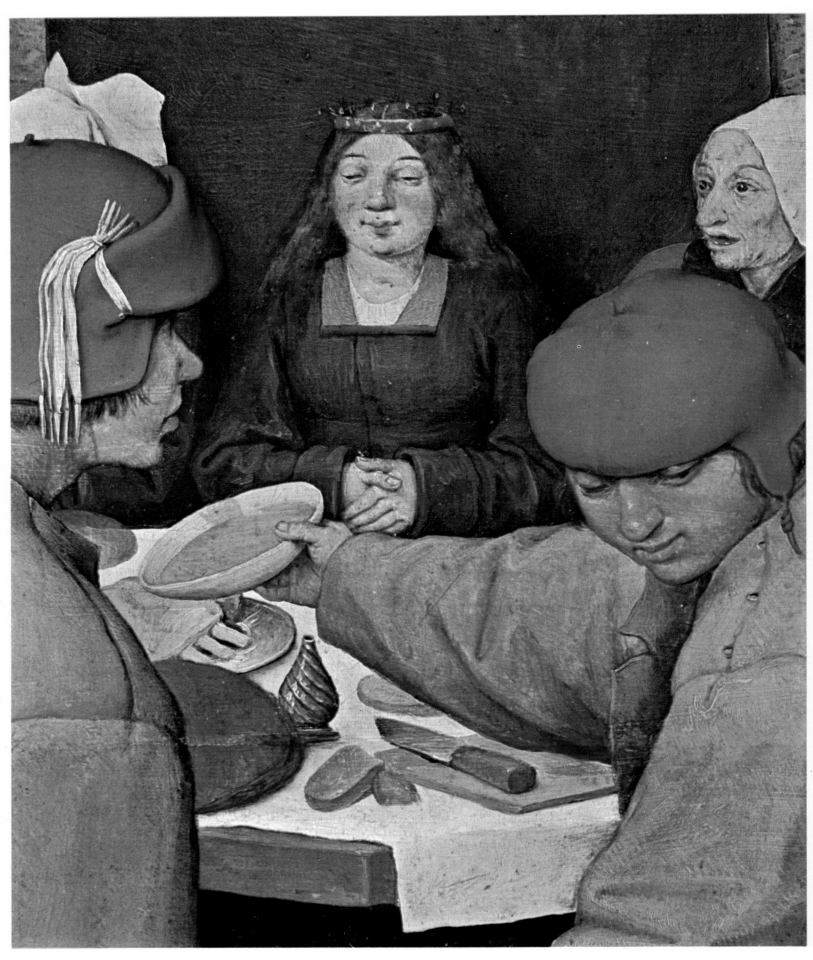

PLATE LVIII THE PEASANTS' WEDDING Vienna, Kunsthistorisches Museum
Detail (24.5 cm.)

S' WEDDING Vienna, Kunsthistorisches Museum
Detail (24.5 cm.)

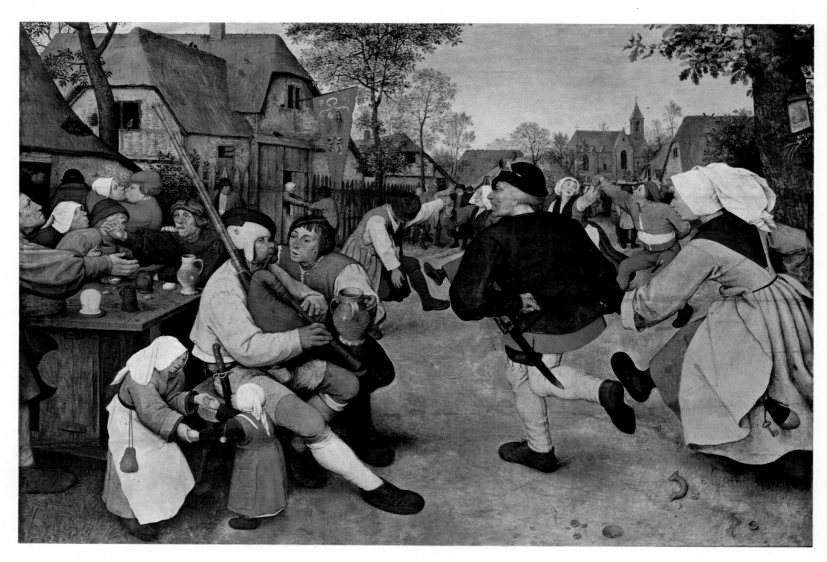

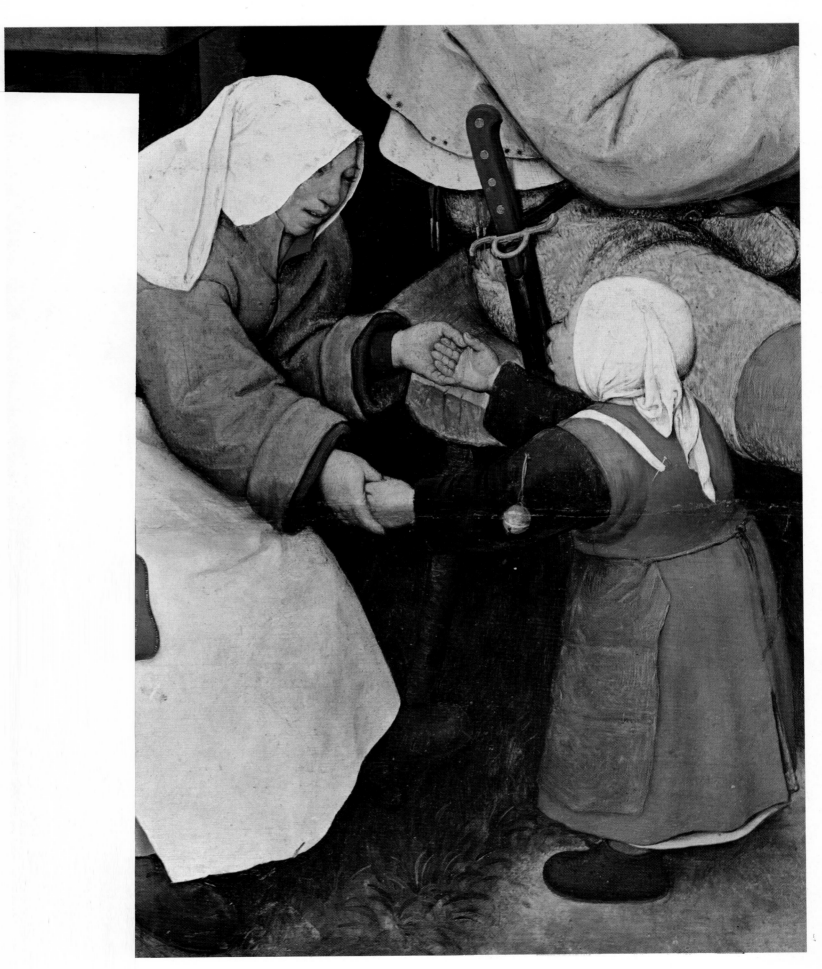

DANCING Vienna, Kunsthistorisches Museum
m.)

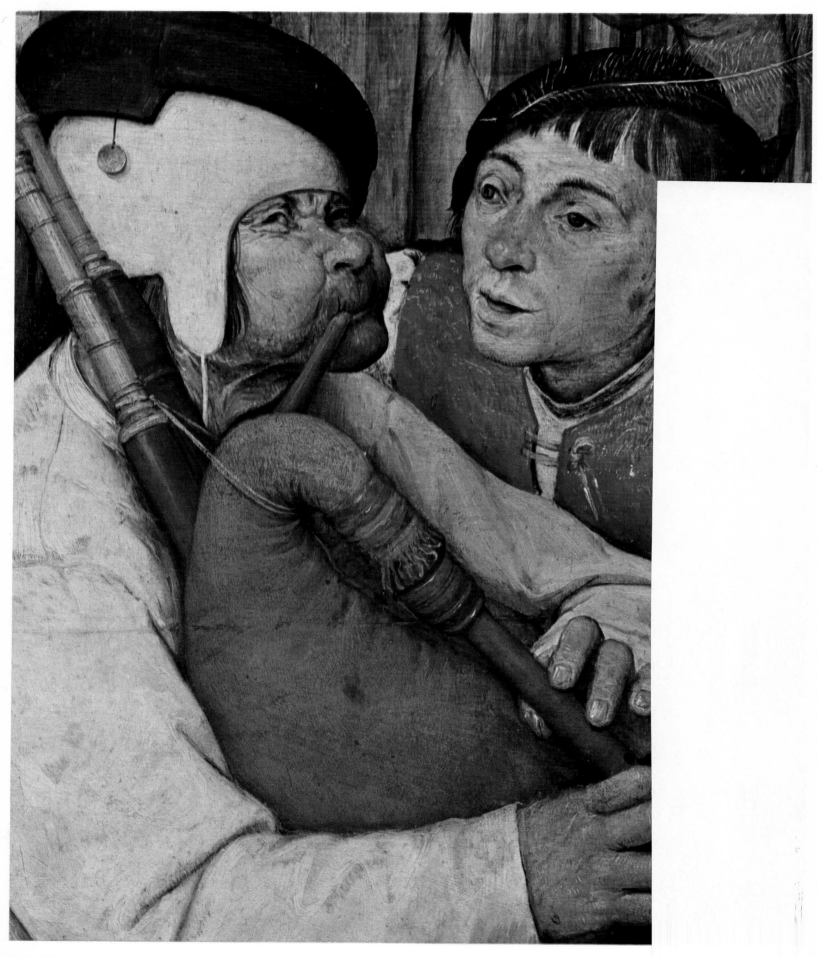

PLATE LXII PEASANTS DANCING Vienna, Kunsthistorisches Museum
Detail (25 cm.)

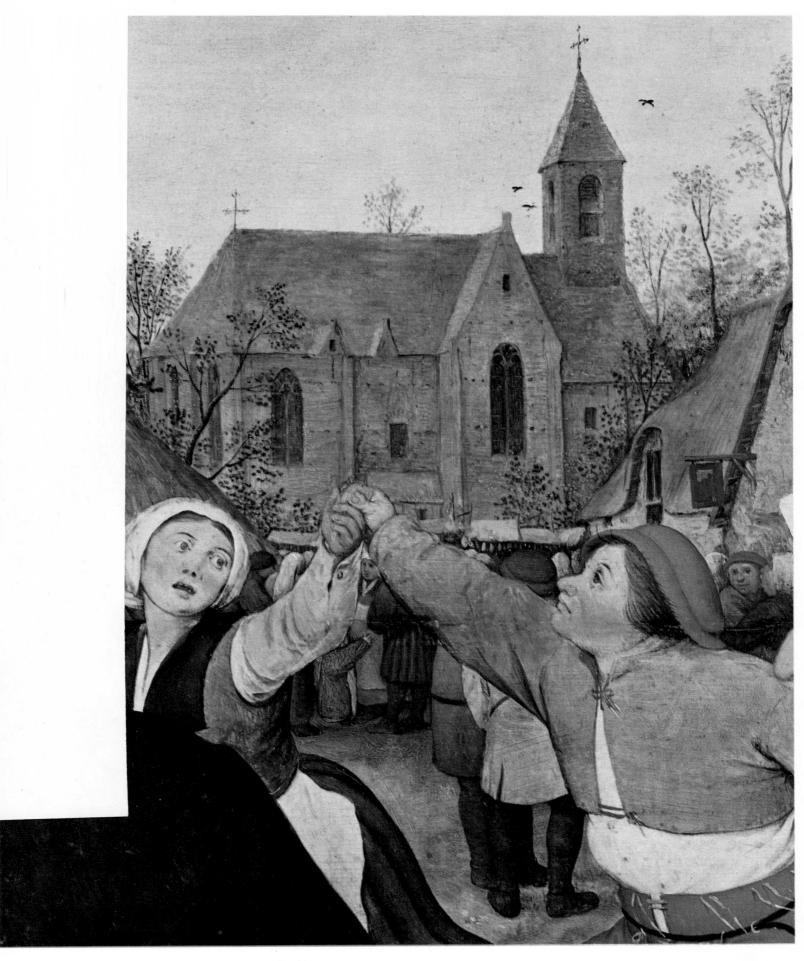

PLATE LXIII PEASANTS DANCING Vienna, Kunsthistorisches Museum
Detail (25 cm.)

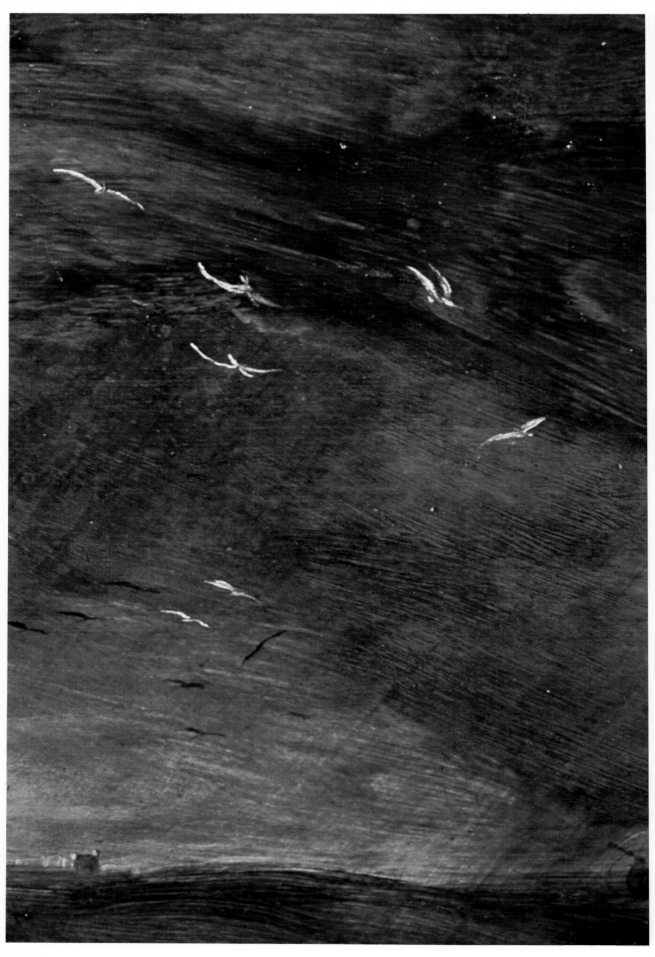

PLATE LXIV STORM AT SEA Vienna, Kunsthistorisches Museum
Detail (life size)

The works

To make the essential data concerning each work more readily accessible to the reader we have used a series of symbols in the heading of each "item" in the Catalogue, placed immediately after the number (the numbering being based on the most probable chronology). The number of each item is used whenever we have occasion to refer to that particular work in the course of this volume. The symbols denote : 1) the authorship of the painting, i.e. whether it was painted by Bruegel himself or not ; 2) the technique used ; 3) the material on which the work was painted ; 4) its location ; 5) whether the work is signed and dated, whether it is complete or a fragment, whether it was left unfinished. The other figures in the headings give the dimensions (height and width) in centimeters, below which is the date. When such information is uncertain and only approximate, an asterisk (*) is placed before or after the figures, according to whether an earlier or later date is also possible. All the information given reflects the opinions of modern art historians ; important differences of opinion and all other data are given in the text.

Execution

▦ Autograph

▨ With the help of assistants

▤ In collaboration with another artist

▦ Extensive participation of other artists

▨ Workshop production

▦ Usually attributed to Bruegel

▦ Attribution rejected by most critics

◪ Traditionally attributed to Bruegel

◪ Only recently attributed to Bruegel

Technique

⊕ Oil

⊕ Fresco

⊕ Tempera

Support

⊕ Wood

⊕ Wall

⊕ Canvas

Location

⦂ Collection open to public

⦂ Private collection

⦂ Location unknown

⦂ Lost work

Other data

▤ Signed work

▤ Dated work

▤ Incomplete work or fragment

▤ Unfinished work

The relative information will be found in the text.

Basic bibliography

The first bibliography, down to 1930, was compiled by E. MICHEL (*Bruegel*, Paris 1931) ; this was subsequently extended by Michel himself to 1951 (*Musée National du Louvre – Peintures flamandes du XVe et du XVIe siècle*, Paris 1953), and later, down to 1958, by F. GROSSMANN. in *Enciclopedia universale dell' arte*, II, Venice-Rome 1959 (*Encyclopedia of World Art*, New York, Toronto, London). The chief sources are K. VAN MANDER's biography (*Het Schilderboek*, Haarlem 1604) and a number of inventories of former private collections, a close study of which was made by G. HULIN DE LOO (1907) and G. GLÜCK (1910) (see below). For information concerning pictures which once belonged to the Habsburgs the reader should consult the various volumes of the JSAK (for this and other abbreviations see below), in particular the 1883 inventory of works of art belonging to Archduke Leopold William of Austria ; in this connection, mention must also be made of the studies by J. DENUCÉ (*Art Export in the Seventeenth Century in Antwerp*, Antwerp 1931 ; *The Antwerp Art Galleries, Inventories of the Art Collections in Antwerp in the Sixteenth and Seventeenth Centuries*, Antwerp 1932, and *Documents concerning Jan Bruegel*, Antwerp 1934). The most important works on Bruegel's paintings are by the following : B. RIEHL (*Geschichte des Sittenbildes in der deutschen Kunst bis zum Tode Pieter Brueghels des Älteren*, Berlin 1884) ; H. HYMANS (in GBA 1890) ; A. RIEGL (in JSAK 1902, and *Das holländische Gruppenporträt*, Vienna 1931) ; A. L. ROMDAHL (in JSAK 1904–5) ; R. VAN BASTELAER and G. HULIN DE LOO (*Peter Bruegel l'Ancien, son œuvre et son temps*, Brussels 1907) ; G. GLÜCK (*Les tableaux de Peter Bruegel le Vieux au Musée Impérial de Vienne*, Brussels 1910 ; *Bruegels Gemälde*, Vienna 1932 ; *Das grosse Bruegel-Werk*, Vienna 1951 [also in English translation] ; *Aus drei Jahrhunderten europäischer Malerei*, Vienna 1933 (with notes by L. BURCHARD) ; M. J. FRIEDLÄNDER (*Pieter Bruegel*, Berlin 1921 and Leyden 1937) ; M. DVOŘÁK (*Pieter Bruegel der Ältere*, Vienna 1921 ; *Kunstgeschichte als Geistesgeschichte*, Munich 1928) ; F. WINKLER, (*Die altniederländische Malerei*, Berlin 1924) ; C. TOLNAY (in JSAK 1934 ; *Pierre Bruegel l'Ancien*, Brussels 1935) ; W. VANBESELAER (*Peter Bruegel en het nederlandsche Manierisme*, Tielt 1944) ; G. JEDLICKA (*Pieter Bruegel*, Erlenbach-Zürich-Leipzig 1947) ; E. MICHEL (in AP 1948 [and cf. above]) ; V. DENIS (*Tutta la pittura di Pieter Bruegel*, Milan 1952 and 1962²) ; R. GENAILLE (*Bruegel l'Ancien*, Paris 1953) ; F. GROSSMANN (*Bruegel: The Paintings*, London 1955 [also in Italian, German and Dutch translations]) ; C. G. STRIDBECK (*Bruegelstudien*, Stockholm 1956) ; M. AUER (in JSAK 1956) ; L. VAN PUYVELDE (*La peinture flamande au siècle de Bosch et de Breughel*, Paris 1962). As regards the drawings we need only mention the fundamental study by C. TOLNAY (*Die Zeichnungen Pieter Bruegels*, Munich 1925, Zürich 1952² and London 1952² [with good bibliography]) and the review of Tolnay's book by O. BENESCH (in K 1953). On the engravings the best authority is still R. VAN. BASTELAER (*Les estampes de Peter Bruegel*, Brussels 1908). On specific problems of criticism the following may be consulted : on the relationship between Bruegel and Bosch, J. COMBE (in AP 1948) and D. BAX (in VKAW, 1956) ; on his connection with P. Coecke, E. MICHEL (in MHL) and J. HELD (in DIB 1935) ; on his collaboration with P. Balten, G. MARLIER (in BMRB 1965) ; on the influence of Italian art, F. LUGT (in FMF), A. VERMEYLEN (in CB 1928), C. TOLNAY (in AP 1951) and C. G. STRIDBECK (op. cit.) ; on his relationship to German art, I. BERGSTRÖM (in NKJ 1956) and F. WÜRTENBERGER (*Pieter Bruegel der Ältere und die deutsche Kunst*, Wiesbaden 1957) ; on his treatment of form, H. SEDLMAYR (in JSAK 1934) ; on his landscapes, L. VON BALDASS (in JSAK 1918), K. ZOEGE VON MANTEUFFEL (*Pieter Bruegel, Landschaften*, Berlin 1934), A. VERMEYLEN (*Pieter Brueghel, Landschappen*, Amsterdam 1925). M. J. FRIEDLÄNDER (*Essays über Landschaftsmalerei*, The Hague – Oxford 1947) ; F. NOVOTNY (*Die Monatsbilder Pieter Bruegels*, Vienna 1948) ; G. J. HOOGEWERFF (*Het lantschap van Bosch tot Rubens*, Antwerp 1954), and K. CLARK (*Landscape into Art*, Harmondsworth 1956²) ; on the painter's culture : G. GLÜCK (in AQ 1943) ; G. DE TERVARENT (in M 1944) ; and J. GRAULS (*Volksraal en volksleven in het werk van Pieter Bruegel*, Antwerp – Amsterdam 1957) ; on the presumed influence of alchemy : J. VAN LENNEP (in BMRB 1965).

List of abbreviations

A : Apollo (London – New York)
AP : Les Arts Plastiques (Brussels)
AQ : The Art Quarterly (Detroit)
BM : The Burlington Magazine (London)
BMRB : Bulletin des Musées Royaux des Beaux-Arts de Belgique (Brussels)
C : Der Cicerone (Leipzig)
CB : Cahiers de Belgique (Brussels)
CV, 1784 : *Catalogue des tableaux de la Galerie Impériale et Royale de Vienne*, Basle 1784 (edited by Chrétien de Mechel)
DIB : Detroit Institute of Fine Arts Bulletin (Detroit)
FMF : *Festschrift für Max J. Friedländer zum 60. Geburtstag*, Leipzig 1927
GBA : Gazette des Beaux-Arts (Paris)

JSAK : Jahrbuch der kunsthistorischen Sammlungen des allerhöchsten Kaiserhauses (Vienna)
K : Kunstchronik (Munich – Nürnberg)
M : Message (Leipzig)
MHL : *Mélanges Hulin de Loo*, Brussels – Paris 1931
MRKD : Mededeelingen van het Rijksbureau voor kunsthistorisch Documentatie (Amsterdam)
MSED : Mémoires de la Société d'émulation du Doubs (Besançon)
NKJ : Nederlandsch kunsthistorisch Jaarboek (The Hague)
OH : Oud-Holland (Amsterdam)
OJ : Oudheidkundig Jaarboek (Leyden)
P : Pantheon (Munich)

RBAH : Revue belge d'archéologie et d'histoire de l'art (Antwerp)
RFK : Repertorium für Kunstwissenschaft (Berlin-Stuttgart)
VKAW : Verhandelingen der Koninklijke Akademie van Wetenschappen te Amsterdam (Amsterdam)
ZBK : Zeitschrift für bildende Kunst (Leipzig)

Outline biography

Very few documents have come down to us concerning Pieter Bruegel called "the Elder" (to distinguish him from his son Pieter, called "the Younger"), or "Peasant Bruegel" (because peasant life forms the subject-matter of so many of his pictures). Little can be gathered as to his character and life from the few episodes known, but we can deduce a good deal from his works, many of which are fortunately signed and dated. To begin with, it should be noted that, although the spelling "Breughel" was normally used by his descendants and also by others when referring to him (together with "Breughel," "Brugel" — found on engravings made after his drawings and undoubtedly in current use [see below, under **1563**] — "Brügel," "Brügl," "Brögel," "Briegl," "Brigel," "Prügl" etc., all of which spellings are found in documents dating from his lifetime or shortly afterwards), he himself always spelt his name "Brueghel" or "Bruegel" [see below, under **1559**]. Uncertainty also exists as to the date and place of his birth, his social status and the names of the masters under whom he studied painting. Writing in 1567, when Bruegel was still

alive, Guicciardini stated that he came from Breda; but in 1604 Van Mander — his first biographer — maintained that he was born in a village near Breda and that he adopted the name of this village as his surname. However, the nearest village to Breda (now in Holland, then in North Brabant) with the name of Bruegel is some thirty-four miles away. There is another village, subdivided into "Groote Brögel" and "Kleine Brögel" in the Campine district of Limburg (now in Belgium, but in those days under the jurisdiction of the Bishop of Liège and not forming part of the Netherlandish provinces) even further (forty-four miles) from Breda. But it is three miles from the modern Brée, also spelt "Breede" or "Brida," or — when the Latin form is used — "Breda." Bastelaer [1907] and other writers believe that Van Mander must have confused Breda in Limburg with the other Breda in Brabant, and they consequently maintain that the painter was born in Brée, pointing out that the landscape background in his works would appear to be derived from the countryside of Limburg. A more plausible suggestion was made by Friedländer [1937], who

drew attention to the fact that in the register of the Antwerp guild (see under **1551**) the painter's name is given as "Peeter Brueghels," implying that the surname was a patronymic. "Peter the son of Brueghel" and not "Peter from Brueghel." Moreover, a number of Bruegels are known to have been living in Antwerp or elsewhere in the Low Countries during the sixteenth and seventeenth centuries, and this does not necessarily mean that they were all born in a village of that name (even if their ancestors originally adopted the name of their birthplace as surname). This lessens Van Mander's emphatic assertion that Bruegel was of peasant origin ("it is wonderful how nature took possession of this man, who in his turn was

art historians believe that he was born between 1520–6.

We have little information regarding Bruegel's early training. According to Van Mander he studied painting under Pieter I Coecke (or Kock) of Aelst (1502–6 December 1550), a prolific and cultured artist who had visited Italy (Vasari praises his works) and Turkey, a painter and designer of cartoons for tapestries and stained-glass windows, doyen of the St Luke's Guild of Artists (1537), architect and translator of Serlio and possibly of Vitruvius (1475–1554). Of the works of Serlio he left a very accurate translation (said by some to have been revised by Serlio himself), which after Coecke's death was completed by his wife, Mayeken Verhulst Bessemers of Malines, who was herself a

house carrying in his arms the master's little daughter, also named Mayeken, whom Bruegel subsequently married (see below, under **1563**).

1551 This is the first certain date, for in this year (in fact, between October 1551 and October 1552 — an "academic year") the name "Peeter Brueghels" was entered in the *liggeren* (registers) of the masters of St Luke's Guild in Antwerp (whither, we are told by Van Mander, he had moved). The name immediately before his is that of *"Joorge Mantewaen, coporen plaetsnyders,"* i.e. Giorgio of Mantua, copper-engraver, none other than Giorgio Ghisi, who in 1550 had engraved on plates the cartoon for *St Paul in Athens* in

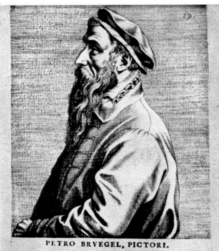

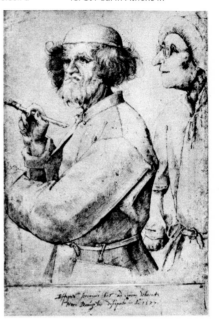

(Left) Portrait of Bruegel published by Lampsonius [Pictorum aliquot . . . Antwerp 1572]. (Right) Presumed self-portrait (caricature) of Bruegel painting (though the inscription says that it represents Hieronymus Bosch); pen-drawing by Bruegel (1566–8; 11¾ × 8½ inches, 29·8 × 21·9 cm; London, V. Korda Collection).

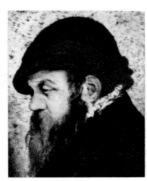

Presumed self-portraits of Bruegel. (Left) From his John the Baptist preaching *(40)*; *(right) from* The Peasants' Wedding *(54)*.

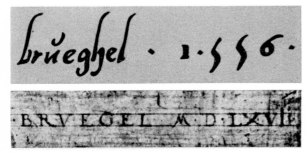

Signatures of Bruegel: (above) on drawing of The Donkey at School *(9 × 11¾ inches, 23 × 30 cm; Berlin Kupferstichkabinett); (below) on 97. Note that in the former the name is spelt with an "h."*

destined to make her his own in so vigorous a manner, when in a humble village . . . she chose the witty and talented Pieter Bruegel from among the mass of peasants to illustrate their lives . . .") and tends to support Guicciardini's statement that he was born in a town.

Equally uncertain, as we have already said, is the date of his birth. The geographer Ortelius, a friend of Bruegel's, tells us that he died *"medio aetatis fiore"* — in the prime of life. This would imply that he was about forty or forty-five years old and, since he died in 1569, that he was born about 1525. In the course of a discussion based on false premises, Bossus [GBA, 1953] maintains that he was born in 1522. We know, however, that he was admitted to the Antwerp guild of painters in 1551, the minimum age for admission being twenty-five (which would mean that he cannot have been born later than 1526) and there are no grounds for assuming that Bruegel allowed many years to pass before obtaining the right to exercise his profession. In short, modern

miniaturist and painter, known in particular for her paintings in tempera on canvas (Guicciardini).

Van Mander's statement about Bruegel's training under Pieter Coecke — doubted by many critics because of the apparent lack of any stylistic affinity between the works of either painter — is confirmed by a piece of evidence which is seldom quoted — Francis Sweerts, a learned and distinguished man, historian of Brabant and friend of such Antwerp humanists as Ortelius, records Coecke's epitaph in his *Athenae Belgicae* (1628). He gives a note before the epitaph, with details of Coecke's life, among which is *"Discipulum habuit Petrum Bruegehlium Pictorem, cui filiam in uxorem dedit"* (He had a disciple, Peter Bruegel the painter, to whom he gave his daughter in marriage). Quoted by G. Marlier, *Pierre Coeck d'Alost* (Brussels 1966) p. 31. Bruegel must thus have grown up in a circle devoted to art, and Van Mander adds a pleasing anecdote of his being seen in Coecke's magnificent

Raphael's famous series. For Bruegel this represented a close contact with Italy, for at that time he and Ghisi were both working for Hieronymus Cock (or so it is normally assumed, though there is no documentary evidence of any connection between Pieter and Cock before 1555). Cock, a well-known publisher of prints, was

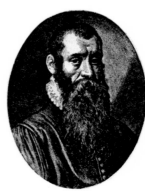

Portrait of Bruegel from an allegorical composition by Bartholomaeus Spranger, engraved by Aegidius Sadeler (1606).

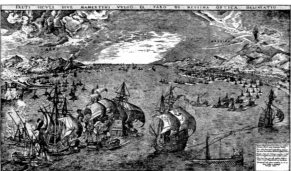

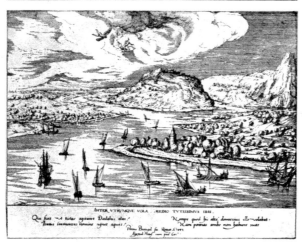

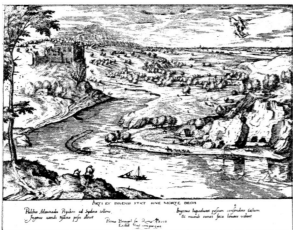

himself an engraver (ca. 1510–70) and was highly esteemed by Vasari, who met him in Rome and says that he had "a proud, firm and skilful hand." Cock's workshop, *In de Vier Winden* (at the sign of the Four Winds) was also a meeting-place for literary men, art-lovers and scholars. Moreover, Cock had a veritable passion for the art of Hieronymus Bosch, and this partly explains why Bruegel made many drawings after that master's works for use by his employer's engravers. Van Mander stresses the importance of such contacts for Bruegel — "he practiced the style of Jeroon van den Bosch and, imitating him, began to paint devilries and drolleries so that he was nicknamed Piet den Drol." Cock also published reproductions of Italian paintings by, among others, Raphael, Michelangelo, Titian, Parmigianino, etc. and in particular landscapes, and in the preparation of these reproductions Bruegel must also have had a share. It is, in fact, highly probable that Bruegel was sent to Italy by Cock in order to study landscapes. In any case, before this journey and his admission to the Antwerp guild, he collaborated with Peeter Balten on a triptych for the Cathedral of Malines.

1552–3 (?) We know virtually nothing about Bruegel's journey to Southern Europe except what Van Mander tells us: "He went to France and from there to Italy." It is, however, quite possible that he was accompanied on this journey by the painter Marten de Vos, (who was perhaps one of Bruegel's collaborators, see 5) at least for part of the way; De Vos is known to have lived in Italy from 1552 to 1558. Further, the geographer Scipio Fabius, writing from Bologna in April 1564 to his colleague Ortelius [Popham, BM 1931], sent greetings to both painters, whom he had probably met in Italy about ten years before. Other details of Bruegel's sojourn in Italy can be deduced from paintings and, in particular, from Bruegel's graphic works. In addition to the well-known painting of *The Harbor at Naples* (12), we have a drawing showing Reggio Calabria (Boymans Museum, Rotterdam), which suggests that he was at Reggio in 1552: the fires to be seen in the drawing are believed to be an allusion to the attack on the city by the Turks in that year. After this Bruegel probably went to Messina, which can be seen in considerable detail on the opposite side of the strait in an engraving of a *Naval Battle* [Hieronymus Cock pictor excudebat M.D.LXI. Cum gratia et privilegio. Bruegel Inuen]. He may have gone as far as Palermo (as would seem to be indicated by certain details in *The Triumph of Death* [23], now in Madrid). The assumption that Bruegel was also at Fondi (halfway

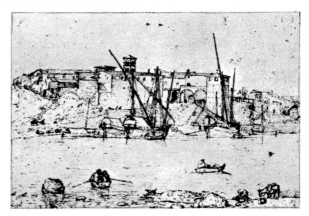

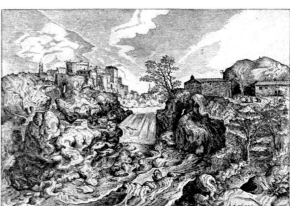

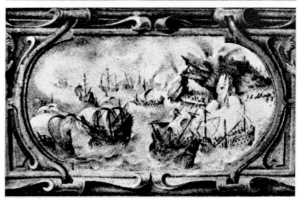

(*Above, from top*) View of Reggio Calabria, *pen-drawing (ca. 1553; 6 × 9½ inches, 15·5 × 24·1 cm; Rotterdam, Boymans Museum).* Naval Battle in the Strait of Messina, *engraving by F. Huys, "Bruegel inuen" (1561; 13¾ × 16½ inches, 35 × 42 cm).* River Landscape with the Fall of Icarus *and* River Landscape with Mercury abducting Psyche, *etchings (10½ × 13 inches, 27 × 33 cm) attributed to G. Hoefnagel, "Petrus Breugel fec. Romae A.o 1553."* (*Right, from top*) The Ripa Grande in Rome, *"a ripa"; pen-drawing (ca. 1553; 8¼ × 11¼ inches, 20·7 × 28·5 cm; Chatsworth, Duke of Devonshire's Collection; the signature is a forgery).* View of Tivoli ("Prospectus Tyburtinus"), *engraving by H. Cock (12¼ × 16¾ inches, 31 × 42·5 cm) after a painting by Bruegel.* The Last Judgment, *miniature by Giulio Clovio (19¾ × 13¾ inches, 50 × 35 cm; New York, Public Library).* Ships in a Storm, *miniature recently attributed to Pieter Bruegel (15¾ × 27½ inches, 40 × 70 cm), in the frieze below the preceding miniature. The identification, based on convincing evidence [see under 1552–3], of Bruegel's share in this page of miniatures by Clovio is due to Ch. de Tolnay [BM 1955].*

PIETER BRUEGEL'S GENEALOGICAL TREE

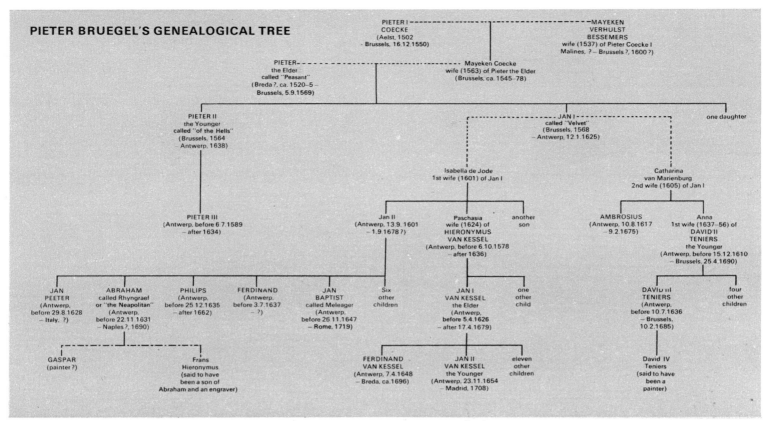

In the genealogical tree, the names in capitals indicate members of the Bruegel family, or of the Coecke, Van Kessel and Teniers families connected with them by marriage, who were active as artists. The dotted lines indicate marriages; dots and dashes mean that the relationship is not quite certain.

between Rome and Naples) was first made by Glück (1952) on the basis of a drawing of the town which he assigned to Bruegel. This attribution is rejected by Grossmann (BM 1959, and *P. Bruegel, The Paintings*, 1966 ed. p. 15, n.) and by Münz (*Bruegel, The Drawings*, 1961, p. 231 no. A6). The drawing is in the Fine Arts Gallery, San Diego, California. Bruegel must have stayed in Rome longer than anywhere else. Two landscape prints of drawings by him have been preserved — one showing Mercury and Psyche and the other Daedalus and Icarus — dated Rome 1553 (*Petrus Breugel fec. Romae A.o 1553*) (for these, see Glück, AQ 1943); there is a pen-drawing of the Ripa Grande by Bruegel in the Duke of Devonshire's collection at Chatsworth; a painting described as executed "in Rome" is mentioned in a seventeenth-century inventory; and that he enjoyed a certain amount of leisure and visited the surrounding countryside would appear to be proved by an engraving entitled *Prospectus Tyburtinus* (*h. Cock excudet*), probably sketched during an excursion to Tivoli. Moreover, the inventory of the property left by the famous miniaturist Giulio Clovio mentions a "gouache" by Bruegel showing a view of Lyons (probably executed during the first part of his journey, through France, if we accept Van Mander's account), together with a miniature by his own hand of *The Tower of Babel* and another, painted in collaboration with Clovio ("a

little miniature, half by Clovio's own hand, half by M.o Pietro Brugole"). Clovio only took up residence in Rome in 1553 after leaving it in 1551. The rest of the journey can be reconstructed from a number of drawings showing views of the Alps, attributed to Bruegel by Tolnay and Benesch (though Auer is doubtful about their authenticity). One of these, now in the Dresden Kupferstichkabinett, shows the Ticino valley to the south of the St Gothard pass (a painting of the St Gothard by Bruegel is

mentioned in the inventory of Rubens' estate); another drawing (Bowdoin College, Brunswick [Maine]) bears the inscription "Waltersspurg," which has been identified as Waltensburg on the upper Rhine in the Swiss canton of Grisons, leading some critics to suppose that the young traveler must have deviated to the east in order to reach Innsbruck, capital of the Tyrol, where he made a sketch of the Martinswand (Kupferstichkabinett, Berlin; but Tolnay maintains that the

drawing is a copy). The date of his return home is generally assumed to have been 1553 (the date of two Alpine views by Bruegel mentioned by Mariette as being in the house of the well-known collector Crozat), though more recently Grossmann [1954], in view of the fact that the style of these drawings differs from that of others which can be dated 1552–3, assigns them to the year 1554 and maintains that Bruegel did not return to Antwerp until 1555. We must, however, remember that the

second state of the print showing skaters at St George's Gate, Antwerp, from an engraving by Huys bears the inscription: *P. Bruegel delineavit et pinxit ad vivum* 1553 (cf. 12). Although this is not a decisive piece of evidence, it should not be ignored.

1557 This is the date given on the *Landscape with the Parable of the Sower* (10), accepted as authentic even by the severest critics. It is the earliest surviving dated painting, though Bruegel did not devote himself mainly to

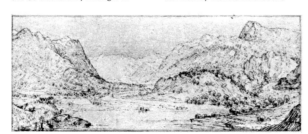

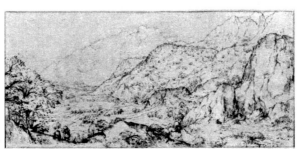

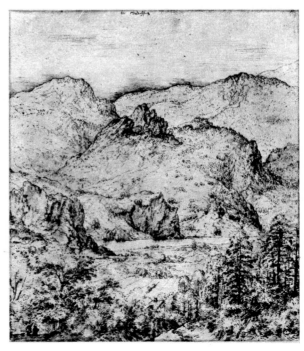

(*Above, from top*) Valley with River, pen-drawing (1554–5; $5\frac{1}{4} \times 12\frac{3}{4}$ inches, 13·4 × 32·3 cm; Dresden, Kupferstichkabinett). The Martinswand near Innsbruck, pen-drawing (1554–5; 8 × 15½ inches, 20 × 39·2 cm; Berlin, Kupferstichkabinett). (*Right*) View of Waltensburg ("*Waltersspurg*"), pen-drawing (ca. 1554; 12½ × 8½ inches, 31·7 × 21·6 cm; Brunswick [Maine], Bowdoin College).

painting until 1562. Until the end of the 'fifties, he would seem to have confined himself to drawing, and in particular to making drawings for engravings. The two important series of "Seven Cardinal Virtues" and "Seven Deadly Sins" date from 1557–60.

In Antwerp, besides working for Nicolaes Jonghelinck, who was one of his most enthusiastic admirers (in his Antwerp house there are said to have been sixteen works by the master), Bruegel, probably through Cardinal Granvelle (see below, under 1562), came into contact with men of culture such as the geographer Abraham Ortelius, whom we have already mentioned, the philosopher and engraver Coornhert, the printer Plantin and the archaeologist Hubert Goltzius (Goltzius' wife, Elizabeth Verhulst, was the aunt of Bruegel's wife). From Van Mander we learn that Bruegel was a great friend of the Nürnberg merchant Hans Franckert (about whom nothing else is known), an art-lover and – apparently – a regular patron of Bruegel. Van Mander tells us that Franckert and Bruegel "both of them dressed as peasants, often went to country festivals or weddings, offering gifts like the other guests and passing themselves off as relatives or fellow-villagers of the bride or bridegroom." We are also told that some of the above-mentioned patrons (for example, Ortelius and Plantin), as well as other friends of Bruegel, were "libertines," that is to say propounders of liberal ideas, very tolerant in matters of religion. Bruegel's way of seeing life has often been compared with that of Erasmus of Rotterdam, who gave such a penetrating yet tolerant account of human absurdity in his *Praise of Folly*. According to some critics [e.g. Tolnay, 1935] Bruegel also

had some connection with the *Schola Caritatis*, a heretical sect under the leadership of H. Nicolaes; this hypothesis, however, rests on no firm foundation (see below, under 1563). In any case, it is true to say that Bruegel frequented intellectual circles in Antwerp, a busy center of trade, with great cultural activity (in 1560 there were 360 painters and sculptors in the city, an enormous number, even when compared with Florence in its heyday). Guicciardini has left us a vivid description of Antwerp, in which he observes that the only comparable city was Venice.

1559 Until this year the artist signed himself "Brueghel," but subsequently he used the spelling "Bruegel," as we can see on his paintings (cf. Catalogue, from 12 on) and on his drawings when he signed them. The reasons for this change are unknown.

1562 From now on, or more precisely from 1563 (q.v.), Bruegel seems to have devoted most of his time to painting, whereas previously, as we have seen, his chief occupation had been the preparation of drawings for engravings. Before moving to Brussels (see under 1563) he may well have visited Amsterdam, for three drawings of towers and gates, usually attributed as belonging to that city, bearing the date 1562, are now preserved in the Museum of Fine Arts at Boston (Mass.) and in the Musée des Beaux-Arts at Besançon. Not all scholars, however, agree that these were made on the spot.

1563, SUMMER In the register of marriages in the church of Notre-Dame de la Chapelle in Brussels there appear the names of "Peeter Brugel" and "Mayken Cocks," followed by the word "Solmt," showing that our painter

married the daughter (then between eighteen and twenty years of age) of his presumed master. After the wedding Bruegel moved to Brussels. According to Van Mander, "while he was still living in Antwerp, he cohabited with a serving-maid, and would have

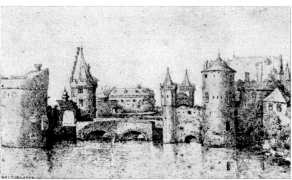

Pen-drawing, view of the city walls, Amsterdam ("BRVEGEL 1562," $7\frac{1}{4} \times 11\frac{3}{4}$ inches, $18\cdot4 \times 29\cdot6$ cm; Besançon, Musée des Beaux-Arts).

married her, but she displeased him because she was an inveterate liar." Consequently, Bruegel left this girl and married Coecke's daughter, "but this mother-in-law insisted that Bruegel should leave Antwerp, so that he would forget the other girl." Some modern scholars, for example Jedlicka, believe that the move was due to political and religious reasons, since the painter was suspected of being a "libertine" or even a heretic, and a year before this the printer Plantin had gone to Paris for a while for similar reasons. Nevertheless, it would hardly seem that Brussels, the seat of government, would have been any safer than Antwerp [Grossmann]. Moreover, we know that the governor of the Low Countries, the austere Cardinal Perrenot de Granvelle, purchased many works by Bruegel, and this fact alone (even if we do not accept

Grossmann's suggestion that Bruegel left Antwerp because he was a protégé of the cardinal) should make us cautious about accepting statements that his paintings contained political or heretical allusions. It may well be that, since the move to Brussels

involved leaving the publisher Cock, this may have persuaded Bruegel to devote most of his time to painting.

1564 Birth of Bruegel's first child, known as Pieter the Younger or Pieter II, who died in 1638 and, like his own son, Pieter III, born in 1589, specialized in copying and imitating Pieter the Elder's paintings. Pieter II and his younger brother Jan (see below, under 1568) received their early training in art from their maternal grandmother Mayeken Verhulst. At the beginning of this year Cardinal Granvelle left the Netherlands.

1566 Date of the only known engraving made by Bruegel himself, *The Rabbit-hunt*.

1567 Lodovico Guicciardini mentions Bruegel in his *Descrittione di tutti i Paesi Bassi*; he is the first writer to tell us something about him.

1568 Birth of Bruegel's second son Jan, called "Velvet Bruegel," who died at Antwerp in 1625. He was a painter of some distinction, and a friend and collaborator of Rubens. His daughter Anna married David Teniers II.

1569 In the archives of the city hall in Brussels we read that a "maestereen van Pieter Breugel" was exempted from the obligation to provide lodgings for Spanish soldiers in his house and that he was paid a fee, which most critics – starting with Wauters – think must have been a first instalment for a picture. Nevertheless there is no evidence that this entry refers to a painter, or specifically to our Pieter Bruegel; on the contrary, Bastelaer believes that it refers to a professor of medicine named Pierre Bruegelius. On 5 September Pieter Bruegel died in Brussels. Van Mander tells us that "shortly before" he had been officially commissioned to make a number of "stuken" (which might mean "paintings" or "cartoons for tapestries") commemorating the construction of the canal between Brussels and Antwerp (completed in 1565), a task which he left unfinished at his death. Van Mander also states that on his deathbed Bruegel ordered his wife to burn a number "of his strange and complicated allegories . . . perfectly drawn and bearing inscriptions," because they were "offensive and bitter"; "either because he regretted having them or for fear lest they might cause trouble for his wife." He was buried in Notre-Dame de la Chapelle, and his son Jan had a tomb erected which was adorned with a painting by Rubens of *St Peter receiving the Keys* (removed in 1765 and now in a private collection in America). This tomb was restored in 1676 by his great-grandson David Teniers III, who placed the following inscription upon it, in which the master's wife and her death in 1578, after she had brought up her sons who were taught painting by their grandmother, herself a miniaturist, are mentioned: *Petro Breugelio / exactissimae industriae, / artis venustissimae / pictori / quam ipsa rerum parens natura laudet / peritissimi artifices suspiciunt, / aemuli frusta imitantur. / Item q. Mariae Coucke ejus conjugi, / Johannes Breugelius parentibus optimis / pio affectu posuit. / Obiit ille anno MDLXIX / haec MDLXXVIII / David Teniers jun. ex haeredibus / renovavit A.o MDCLXXVI.*

Towers and City Gates of Amsterdam, *pen-drawing* ("P. BRVEGEL 1562"; $7\frac{1}{4} \times 12$ inches, $18\cdot5 \times 30\cdot7$ cm; Boston [Mass.]).

Drawing resembling the preceding two ("bruegel 1562"; $11\frac{1}{4} \times 12$ inches, $18\cdot3 \times 30\cdot5$ cm; Besançon, Musée des Beaux-Arts).

Catalogue of works

As we have seen, not very much is known about the earlier part of Bruegel's career. Some critics have doubted the tradition that our painter was apprenticed to Pieter Coecke, pointing out that the styles of the two painters are entirely different. Coecke was one of the many Flemings who adopted from Italy much that is characteristic of the Mannerist style. His draperies flutter, poses are taken from Raphael and the antique elegance is sought above all. Bruegel manifestly avoided all these things. However, Bruegel is universally admitted to be a remarkable exception amongst his contemporaries, revealing interests very different from theirs (despite the thesis advanced by Dvořák, and then Sedlmayr, that Bruegel was essentially more "Italian" than his Romanizing countrymen); the disparity between his style and Coecke's (but for parallels see Michel, MHL, and Grossmann, FKB, 1961) is not sufficient reason to deny the relationship when it is given by such good authorities as Van Mander and Sweerts.

Grossmann (1966) has pointed out some affinities between the early landscape works of Bruegel and works by Jan Corneliszen Vermeyen, who collaborated with Coecke on designs for tapestry. Even more interesting, however, is the suggestion of Simone Bergmans (q.v.) that the painter who has often been noticed as a precursor of Bruegel, and who has been known as the Brunswick Monogrammist, should be identified with Mayeken Verhulst van Bessemeers, wife of Coecke and eventually mother-in-law of Bruegel. Mayeken Verhulst is known from Guicciardini to have been a respected painter, but no work of hers has hitherto been identified. The identification with the Monogrammist is most attractive: the pictures assigned to him (especially *The Wedding Feast* at Brunswick) show that same interest in plain peasant life, that same omission of detail and concentration on basic human shapes that Bruegel was to make especially his own. Further, the figures are very small; Mayeken was a miniaturist, and Bruegel was

sufficiently interested in small figures to collaborate with Giulio Clovio, and to paint his two Towers of Babel, populated by tiny human beings. Quite apart from her possible identity with the Monogrammist, Mayeken might well, as Grossmann and others have pointed out, have taught Bruegel the use of water-color or tempera, a speciality of her native town, Malines. We know from Van Mander that she taught her grandson, Jan Bruegel, this art.

Other influences on Bruegel which have been noted are the landscape art of Joachim Patenier, certain works by Cornelis Matsys, Herri met de Bles, Jan van Amstel (mentioned by Van Mander as an early model for Bruegel) and Pieter Aertsen.

His sojourn in Italy is an apparent puzzle when we note how little trace there is in his works of the achievements of the Italian Renaissance. Yet Vermeylen has convincingly shown that the way in which Bruegel treated *The Wedding Feast* with its huge table and many seated guests is derived from Tintoretto's *Last Supper* and *Supper at Emmaus* in Venice. (*Cahiers de Belgique* 1928); Tolnay argues for a more general assimilation of the lessons of the Renaissance, with its emphasis on the life of the human figure. *Christ and the Woman taken in Adultery* and the recently acquired drawing in the British Museum, *The Calumny of Apelles*, both show a real contact with Italian art. We cannot doubt that Bruegel spent his time intelligently in Italy, and his association with Clovio tells us that he was appreciated while he was there. That Bruegel did not reflect more obviously the experience of the art of Italy will not have been due to indifference on his part; certainly it will not have been due to an obstinate nationalism which caused him to reject anything but Flemish influences (this idea began with the catalogue of Hulin de Loo and Van Bastelaer and was continued by Vanbeselaer).

In any consideration of Bruegel's work it must be remembered that the drawings form a class of their own. Van Mander tells us that he made many beautifully finished drawings, implying that they

were made as ends in themselves, and not always as studies for paintings. To this class belong the drawings made for engraving, chiefly prepared for H. Cock's establishment. Landscape, satire and moralizing works in the manner of Bosch were the chief subjects which Bruegel executed for Cock. The greater part of these are dated in the 1550s; and there are correspondingly few paintings for this period. The paintings increase and the engravings decrease after Bruegel's removal to Brussels in 1562/3; thereafter his contact with Cock necessarily diminished, and he became above all a painter, as he had not been before.

1

⬚🔲 ⊘ 51×68,5 *1550* ▤ ⦂

Landscape with Man sketching
London, National Gallery
At the foot of the mountains, towards the right, is a quarry, near which a rigged ship is about to moor. On the river, to the left, we see what appear to be floating logs. The existence of a print by Bawtelaer, stated to be after a drawing by Bruegel and dated 1553, serves as a basis for Glück's attribution of the painting to our master. Glück dates it before or just after 1550. Neither the attribution nor the date have been taken into account by the compilers of the National Gallery catalogue.

This painting is a clear instance of the influence of Joachim Patenier's landscapes, with their broad rivers and fantastic rock-formations.

2 ⬚🔲 ⊘ 62×118 *1550?* ▤ ⦂

Landscape with the Martyrdom of St Catherine of Alexandria
Washington National Gallery (Samuel H. Kress)
On the left, behind the wheel of martyrdom, beneath a stormy sky, a fire has broken out on a little peak; in the foreground, a peasant is relieving himself in the hollow of a tree-trunk, another is asleep, a third is carrying wood and a fourth gathering it; further back, on the right, is a ship-yard. The

painting was acquired for the Kress Collection in 1950 and has been in the National Gallery since 1959. The attribution to Bruegel proposed by Glück (*The Large Bruegel Book*) has found few supporters and is definitely rejected by Tolnay.

3 🔲 ⊘ 49,5×26,5 *1550* ▤ ⦂

Nocturnal Landscape with Hermit
Indianapolis, Clowes Fund
The lighted lantern near the hermit, bottom left, confirms that this is intended to be a nocturnal scene, which would otherwise be doubtful. The attribution to the master was made by Glück in a private communication and later reaffirmed by him [AQ 1950]. Glück dates it from the 1550s. Valentiner, also in a private

communication, supported Glück's attribution.

4 🔲 ⊘ 24×34,8 *1552–53* ▤ ⦂

Landscape with Ships and a burning City or The End of the World
Dortmund, Becker Collection
Actually, this picture might represent the destruction of Sodom, since the little figures on the right, on this side of the walls of the burning city, could be plausibly identified as Lot, his daughters and his wife. The attribution to Bruegel's early period was suggested by Grossmann [1955] and later reaffirmed by him [1959].

5 🔲 ⊘ 67×100 *1553* ▤ ⦂

Landscape with the Calling of the Apostles
Formerly at Ansbach, Peter van Pölnitz Collection
Signed and dated "P. Brueghel 1553." The river landscape, typical of the Low Countries, or rather of Flemish painting, is supposed to represent the Sea of Galilee. The attribution, proposed by Tolnay [BM 1955], is accepted by Puyvelde and Grossmann, but the latter suggests that the figures may have been executed by Marten de Vos (who probably accompanied Bruegel to Italy [Outline Biography, 1552–3]), while the landscape setting reflects the cosmographic ideas of Patenier. This is the earliest extant signed and dated painting by Bruegel.

6 ⬚🔲 ⊘ 80×186 *1556* ▤ ⦂

Rustic Wedding or Indoor Wedding Dance
Philadelphia John G. Johnson Collection
Several peasant couples are dancing, and flirting, round the table, at which the bride, with a crown on her head, is seated. Others are arguing about the dowry (or, according to some critics, waiting to receive gifts of money), while on the right relatives and friends are bringing in articles of furniture and utensils for the use of the young couple. This may be the work which, according to Van Mander, once belonged to Wilhelm Jacobsz of Amsterdam. Van Mander describes it as painted in tempera on canvas, but he mentions the old man with a purse hanging from his neck, a detail which is not found in any other work by Bruegel. In 1682 it appeared in an inventory of the property of the Antwerp merchant D. Duarte (where it is described as an oil painting, which suggests that Van Mander must have made a mistake as regards the technique [cf. Hulin de Loo]). In 1892 it was sold on the Brussels art market and since 1905 it has been in Philadelphia. Valentiner and Glück accept the traditional attribution to Bruegel, though before this Hulin de Loo had expressed doubts as to its authenticity, while admitting the existence of a version by the master's own hand which could be dated about 1556. Michel definitely rejects it, as do Denis and Tolnay, who describes it as a "pastiche" of Bruegelian motifs; Friedländer does not mention it and Marlier [1963] thinks that it was painted by Pieter Bruegel the Younger.

Hulin de Loo's hypothesis is supported by various other versions of the same theme [cf. Glück], some of which were painted by the younger Bruegel; in particular, a panel (26¾ × 44 inches, 68 × 112 cm) now in the Dublin National Gallery, dated 1620 and bearing his signature; another (28¾ × 42 inches, 73 × 107 cm), by an unidentified artist, is in a private collection in Brussels – with certain variants heightening the erotic attitudes of some of the couples – and was shown at the "Siècle de Bruegel" exhibition (1963).

7 ⬚🔲 ⊘ 115,5×163 *1556*? ▤ ⦂

Adoration of the Magi
Brussels, Musées Royaux des Beaux-Arts
Acquired in 1909 at the Fétis action. Has been seriously damaged by damp and little remains except the outlines. Obviously the poor state of preservation makes it difficult to judge this work; nevertheless, in the past it has been generally accepted as an authentic work [Friedländer, Hulin de Loo, Glück, Van Puyvelde etc.] and most critics deem it to be a youthful work painted about 1556 (though Jedlicka dates it 1562–3). It is, however, rejected by Tolnay, who thinks

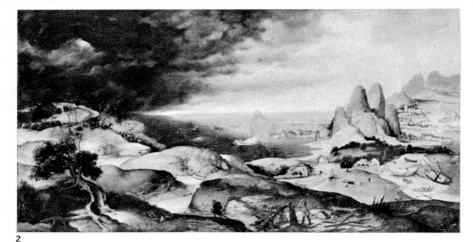

2

that the composition is alien to Bruegel, and by Michel, according to whom it is "a replica by one of the artist's closest disciples ... monotonous as regards the attitudes of the personages and the gestures of the hands." For Grossmann, on the other hand, it might be Bruegel's first work, and he reminds us that at Malines a very liquid kind of tempera (as in this work) was frequently used instead of tapestries to cover walls and that this technique was adopted by Coecke's wife (see above), who came from Malines, so that, Grossmann concludes, despite the bad state of preservation due to the flaking away of the colors, the "superiority" of the execution in this *Adoration* as compared with that of the numerous copies "shows that this is the original, for, as regards the composition, it is too closely related to other works by Bruegel to allow us to attribute the conception to any other artist." Genaille does not discuss the painting.

8 ⊞ ⊗ 102×155,5 *1556*? ▤ ⫶

Expulsion of the Money-Changers from the Temple
Copenhagen, Statens Museum for Kunst
On the left, among the dentist's clients, is the pocket-picking scene made famous by Bosch's *Conjuror* now at Saint Germain-en-Laye (see *The Complete Paintings of Bosch*, 6), but, contrary to what we see in the Bosch painting, the pickpocket is on the point of being arrested. Another noteworthy iconographical feature is the Muslim crescent on top of the

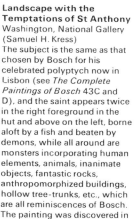

Temple — it indicates the Unbelievers. Purchased in 1929 from a Brussels art dealer. The attribution to Bruegel and the date 1556 proposed by Friedländer [P 1931] are accepted by Glück and Van Puyvelde; Michel is doubtful and thinks that it may have been executed by a pupil; it is definitely rejected by Tolnay — "feeble composition, draughtsmanship and execution, a pastiche of Bosch motifs"; by Genaille — "a pastiche of Bosch"; by Denis — "a pastiche of various elements borrowed from Bosch and Bruegel."
Friedländer mentions two other versions, one of which (43¾ × 67¾ inches, 111 × 172 cm) appeared at the Brunner sale in Paris (1910), while the other (23¼ × 29½ inches, 59 × 75 cm) was formerly in the Phillips Collection, London, and was exhibited at Brussels in 1902.

9 ⊞ ⊗ 43×29,2 *1557* ▤ ⬛

The Archangel Michael vanquishing Satan
Eindhoven (Holland), Philips de Jongh Collection
Acquired by its present owner from the Vitale Bloch Collection, Berlin. Glück believes it to be a youthful work, painted about 1557; Jedlicka seems doubtful; Tolnay rejects it ("neither the personage, nor the composition, nor the execution reminds us of Bruegel"); to Friedländer it seems that the movement of the figure is curiously awkward; Denis accepts it as an authentic work and points out affinities with the manner of Mantegna (also remarked by Glück). The state of preservation is poor.

10 ⊞ ⊗ 74×102 1557 ▤ ⫶

River Landscape with the Parable of the Sower or the Estuary Washington, National Gallery of Art (Putnam)
Signed and dated, below on the right, "[Br] VEGHEL [1] 557."
Formerly in the Stuyck de Bruyère Collection, Antwerp. Discovered by Friedländer in 1931 and accepted by most critics as a genuine work, though doubts have been cast on the attribution by Tolnay, who maintains that it is impossible to be certain owing to the poor state of preservation. Michel rejected it in 1931, but later accepted it as authentic, with some reservations. The broad landscape is painted in the traditional way; the foreground is brown, the second plane green and the background blue, as had been the practice since the Van Eycks and before. The scene is viewed from above, like a map, recalling Patenier.

11 ⊞ ⊗ 57,8×85,7 *1558*? ▤ ⫶

Landscape with the Temptations of St Anthony
Washington, National Gallery (Samuel H. Kress)
The subject is the same as that chosen by Bosch for his celebrated polyptych now in Lisbon (see *The Complete Paintings of Bosch* 43C and D), and the saint appears twice in the right foreground in the hut and above on the left, borne aloft by a fish and beaten by demons, while all around are monsters incorporating human elements, animals, inanimate objects, fantastic rocks, anthropomorphized buildings, hollow tree-trunks, etc., which are all reminiscences of Bosch. The painting was discovered in 1934 by Van Puyvelde in the

house of an old Belgian family, after which it went to the R. Frank Collection, London, and then to the Samuel H. Kress Collection, New York. According to Friedländer and Glück (who dates it about 1558) it is an authentic work, but Tolnay believes that it is a youthful work by Jan Bruegel. It is excluded from the catalogue of the master's works by Jedlicka, Denis and Genaille (who describes it as a "pastiche after Bosch"), despite the skilful execution. As well as the Boschian motifs, the landscape reflects the influence of Patenier.

12 ⊞ ⊗ 41×70 *1558* ▤ ⫶

The Harbor at Naples
Rome, Galleria Doria
From the sources we learn that there may have been two paintings of this subject. One of them is mentioned in the Granvelle inventory (Besançon, 1607): *Navires en mer tranquille avec petites figures en icelle et paysage lointain de Pierre Breughel, tenant d'haulteur un pied trois polces deux quarts, largeur un pied treize polces*, these measurements being approximately those of the Doria painting. Another marine painting with boats figures in the Rubens inventory (Antwerp, 1640): *Une pièce représentant des petits bateaux, faite en détrempe, du dit Vieux Breughel.* The city of Naples can be identified from the ruins of the Castel dell' Uovo, and above all from the characteristic shape of the Maschio Angioino at the shore end of the semicircular mole. Ludwig Burchard [1912] was the first critic to attribute this painting to Bruegel, because of its resemblance to a print of a

5

View of the St Gothard *painted by Momper (Vienna Kunsthistorisches Museum).*

Skaters at St George's Gate, Antwerp, *engraving (9¼ × 11¾ inches, 23·2 × 29·9 cm), probably after a presumed painting by Bruegel.*

3

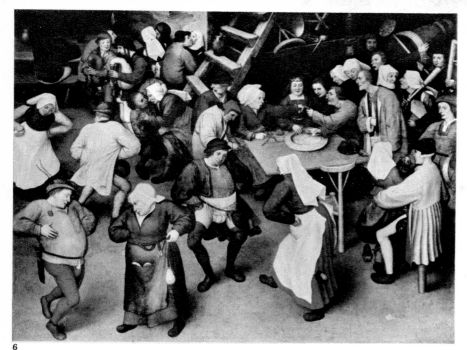

crook) might be an allusion to Hermes, and the whole painting might be a pictorial version of a passage from the *Corpus Hermeticum* listing the qualities that anyone aspiring to become an alchemist must possess. The work can perhaps be identified as one mentioned in the Prague imperial inventories of 1621, where it is described as *Eine Historia vom Dedalo und Icaro vom alten Prügl* [*sic*], and in those of 1647–8, where it figures as *Ein landtschafft, Dedalo und Icaro* – a work which Granberg [*Om Kejsar Rudolf II*, 1922] believes is the painting now in the National-museum at Stockholm, where it is attributed to H. Bol. The work we are discussing was acquired on the London art market and has been in the Brussels Museum since 1912. Before that time it had been unknown (Hulin de Loo, to quote one example, believed that the items in the imperial inventories referred to a hypothetical painting connected with an engraving made by Bruegel in Rome in 1553 [Outline Biography 1552–3]).

The whole problem is an extremely thorny one for students of Bruegel. Is it the original or a copy? Does it date from the artist's early period or was it one of his last works? The first thing to note is that another version (on wood, $24\frac{3}{4} \times 35\frac{1}{2}$ inches, 63 × 90 cm), formerly in the J. Herbrand Collection, Paris, and now in the D. M. Van Buuren Collection, New York, is considered by some critics, e.g. Glück, to be of better quality than the Brussels picture; in the former Daedalus is seen flying in the sky, a detail lacking in the Brussels painting (though Fierens maintains that the figure of Daedalus is a clumsy addition). Jedlicka believes that both versions are copies, while Van Puyvelde and Glück maintain that they are both originals; most critics are, however, convinced that the Brussels painting is the original, though some refrain from expressing a definite opinion pending a scientific examination of both works. Like Jedlicka, Michel maintains that the brushwork is so markedly

6

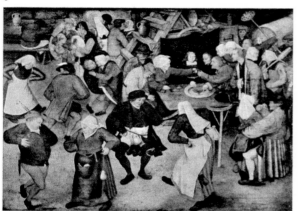

Copy of 6 ($28\frac{3}{4} \times 42$ inches, 73 × 107 cm); Brussels, private collection.

Naval Battle at Messina made by Frans Huys in 1561 after a drawing by the master. Jedlicka points out that in the Doria painting, too, a battle is in progress, since little puffs of smoke can be seen near the ships. The attribution is generally accepted, but is rejected by Michel (who thinks that it was painted by a pseudo-Bruegel, to whom he also attributes *The Fall of Icarus* [13] and the Berlin *Proverbs* [16]), and by Genaille. Most critics believe that it is a youthful work, perhaps painted in Italy or shortly after Bruegel's return; Friedländer dates it about 1558 after a drawing of 1552, while according to Grossmann it was painted in 1562–3.

13 ⊞ ◍ 73,5 × 112 *1558* ▤ ⫶

Landscape with the Fall of Icarus Brussels, Musées Royaux des Beaux-Arts
In the midst of a gleaming landscape life goes on peacefully and nobody is paying any attention to the fall of the mythical aeronaut, all we can see of him being all his legs framed in spray – on the right, between the ship and the shore; the plowman, the shepherd, the fisherman and the sailors carry on with their work; in a bush on the left the corpse of an old man can be seen, perhaps an allusion to the proverb: "No plow ever stops because a man dies";

similarly, the sword and the purse near the plowman might refer to another saying: "Sword and money need careful hands" [Van Lennep]. That Ovid's *Metamorphoses* provided the inspiration is generally admitted, even if this was a mere pretext for depicting a marvelous interplay of light and shade on the hills and water. Glück (AQ 1943 and see also Tenarent, M, 1944) showed that Bruegel was well aware of the text in Ovid, even if at first sight the painting seems to be unconcerned with the tale of Icarus. The importance given to the plowman and other homely characters is, argues Glück, a demonstration of the moral of the tale. It is they who follow the sure path in life, sticking to duty and reality; the over-ambitious high-flyers have no such claim on our attention. Van Lennep gives a complicated interpretation of the picture based on alchemy: if the sun were strong enough to melt Icarus' wings, it ought to be high above the horizon, but as it is only just rising, it should be interpreted as a harbinger of the philosopher's stone and might even be an allusion to the labyrinth, a favorite symbol among alchemists; similarly, the sea might represent Mercury, the cause of much trouble for inexperienced alchemists; the fall of Icarus might represent the precipitation of a volatile product; the plowman might

be the symbol of agriculture, which according to the "philosophers" was comparable with alchemy; the shepherd gazing at the sky (comparable with Ovid's leaning on his

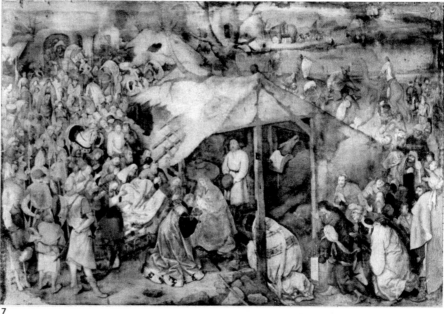

7

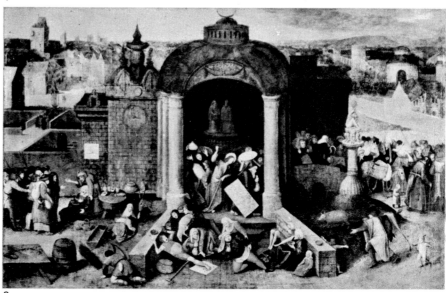

8

57

58

inferior to the beautiful conception that it must be attributed to a pupil or assistant – a pseudo-Bruegel to whom he attributes other works like *The Harbor at Naples* (12), and the Berlin *Proverbs* (16) etc. (though the fact remains that we know absolutely nothing about Bruegel's workshop and assistants). As for the dating, the differences of opinion are equally wide : some writers [Glück, Tolnay] think that it was painted about 1555, immediately after Bruegel's return from Italy ; Genaille, on the other hand, dates it 1562–3 and compares the treatment of light with that found in a drawing now in the Louvre (*Landscape with rising Sun*) which is dated 1561 ; for Vanbeselaer [*Dietsche Warande en Belfort*, 1946] it is a work of Bruegel's late period, and Grossmann agrees, though only

partially. The painting is a brilliant achievement and a good example of Bruegel's irony ; he treated the same mythological subject in the drawing dated 1553 mentioned above and in another which was probably the source of an engraving, showing a ship, published by Galle ("bruegel" with the engraver's initials, "F.H.") ; though in this the treatment is quite different.

14 ⊞ ⊗ 24×37 *1559? 🗎 ⋮

A Thin Couple attacking a Fat Man Copenhagen, Statens Museum for Kunst
Another example of the contrasts so dear to Bruegel (cf. 17). The fat man appears to be a cleric, while the thin couple are a man and woman of the lower classes. Believed to be authentic by Hulin de Loo, Friedländer and P. Wucher

[*Prima idea*, 1960]. Michel at first [1931] declined to make a definite attribution and later [1948] excluded the possibility of its being by Bruegel's own hand, followed in this by Glück, who maintains that it is a seventeenth-century work, perhaps by an artist of the school of F. Francken the Younger. Tolnay also denies that it is a genuine Bruegel. Grossmann does not include it in his book on Bruegel's paintings

15 ⊞ ⊗ 74,5×98,4 1558 🗎 ⋮

Twelve Flemish Proverbs Antwerp, Meyer van den Bergh Museum
Painted on an oak panel, signed and dated "15 [5]8 BREVEGHEL." After a recent detailed examination, J. de Coo [BMRB 1965] reaffirms that the twelve "locutions" were originally painted on twelve wooden platters (a popular custom in those days), which in the seventeenth century were clumsily joined together to form the complex we are now discussing. Each proverb is represented by one figure only and accompanied by an inscription, the latter dating from the time when the platters were joined together. The inscriptions with Denis' translations and comments, are as follows : from the left, top row : ONTYDICH TVYSSCHEN, DRONCKEN DRINCKEN/ MAECKT ARM, MISACHT DEN NAEM, DOET STINCKEN (Continual drinking or drunkenness leads to poverty, dishonor and ruin) ; EEN PLACEBO BEN ICK ENDE ALSOO GESINT/DAT ICK DE HVYCK ALOM HANCH NAEDEN WINT (I am an opportunist, of such a kind that I turn my coat in the direction the wind is blowing) ; IN D'EEN HANT DRAGHE VIER, IN DANDER WAETER/MET CLAPPAERS EN CLAPPEYEN HOVD ICK DEN SNAETER (In one hand I carry fire, in the other water, and I spend my time with chatterboxes and gossiping women. [In other words, gossips spread discord]) ; INT SLAMPAMPEN EN MOCHT MY NIEMANT VERRASSCHEN /AL QVYT, SIT ICK TVYSSCHEN TWEE STOLEN IN DASSCHEN (None was my

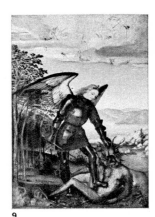

9

equal when it came to carousing ; but now, reduced to poverty, I am between two stools, sitting on ashes). Middle row : WAT BAET HET SIEN EN DERELYCK LONCKEN/ICK STOP DEN PVT ALS TCALF IS VERDRONCKEN (The calf looks at me with puzzled eyes ; what is the use of blocking up the well after it has been drowned, i.e. tardy remorse is of no avail) ; DIE LVST HEET TE DOEN VERLORE WERCKEN/ DIE STROYT DIE ROSEN VOOR DE VERCKEN (If anyone wants to labor in vain, let him cast roses before swine) ; THARNASCH MAECKT MY EEN STOVTEN HAEN/ICK

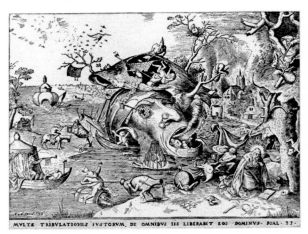

Engraving entitled Le Doyen de Renaix *(1557 ; versions without the title also exist), connected with 57.*

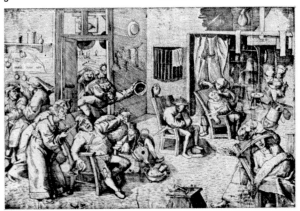

Engraving showing The Temptations of St Anthony *("Cock. excud. 1556," Oxford, Ashmolean Museum) ; almost certainly designed by Bruegel and hypothetically connected with 58.*

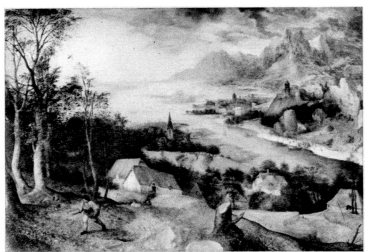

10

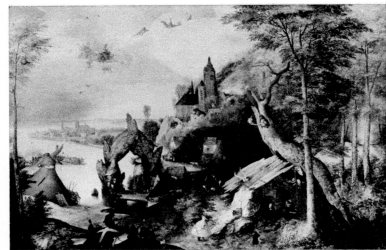

11

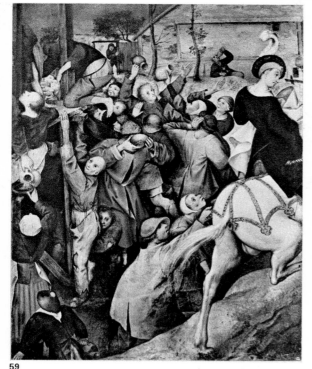

59

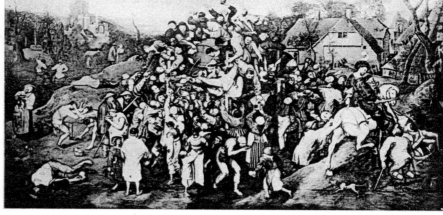

(*Above*) The Feast of St Martin, *version of 59 published by Bastelaer and Hulin de Loo [1907] without any mention of its present location. (Below, from top) The same subject, in an engraving by N. Guerard (Brussels, Cabinet des Estampes de la Bibliothèque Royale), and in a painting bearing the signature of Peeter Balten (40¼ × 63½ inches, 102·4 × 161 cm; Antwerp, Koninklijk Museum).*

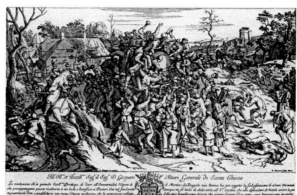

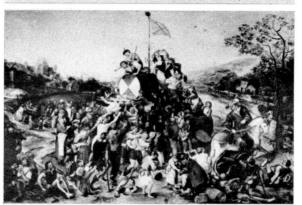

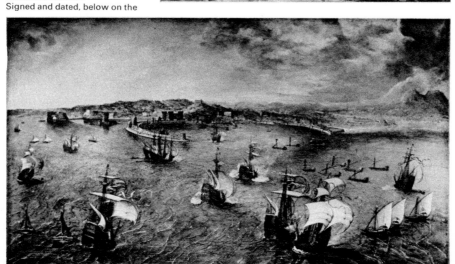

12

HANGHE DE KAT DE BELLE AEN (Armor makes me a fine fellow, and I tie a bell to the cat's tail, i.e. military uniforms make even cowards brave) ; MYNS NAESTEN WELDEREN MYN HERTE PYNT/ICK EN MACH NIET LYDEN DAT DE SONNE INT WAETER SCHYNT (My neighbor's good fortune grieves me ; I can't bear to see the sun reflected in water, i.e. envy prevents a man from being happy). Bottom row : CRYGEL BEN ICK EN VAN SINNEN STVER/DVS LOOP ICK MET DEN HOOFFDE TEGEN DEN MVER (I am aggressive, proud and hasty, so I beat my head against the wall, i.e. bad-tempered people are to blame for their misfortunes) ; MY COMPT HET MAGER, AEN ANDERE HET VET/ICK VISCHE ALTYT ACHTER HET NET (I always get the lean, and the others the fat, and I always fish outside the net, i.e. fools strive in vain) ; ICK STOPPE MY ONDER EEN BLAV HVYCKE/MEER WORDE ICK BEKENT HOE ICK MEER DVYCKE (I hide myself under a blue cloak, but the more I do so, the more easily people recognize me, i.e. a wife's infidelity makes a husband notorious, however much he may try to hide it) ; WAT ICK VERVOLGHE, EN GERAECKE DAER NIET AEN/ ICK PISSE ALTYT TEGEN DE MAEN (Whatever I try to do, I never succeed ; I am always pissing at the moon, i.e. one must never aim too high). The whole complex is mentioned in the catalogue of works of art belonging to Nicolaes Cheeus and auctioned at Antwerp in 1621. In this catalogue it is described as by Bruegel the Elder, but in the inventory of the property of Cheeus' widow (1663) it appears as a work by Pieter the Younger, to whom it is unhesitatingly attributed by Tolnay [1925], who compares some of the figures – e.g. the man beating his head against a wall – with similar figures in the Berlin *Proverbs* (16), noting that those in the work we are discussing are weaker. Burchard [1927–8] and Glück

[1932] also attribute it to Pieter the Younger, though Glück seems a trifle doubtful ; Friedländer is convinced that it is by Pieter the Elder and would like to date it from the later period ; Van Puyvelde does not mention it ; Grossmann thinks that it is a pastiche of Bruegelian motifs, clumsily executed in a manner quite unlike the master's ; Genaille seems doubtful. All the other critics accept it as genuine, including the cautious Michel, who in 1931 described it as "a genuine original . . . the brushwork being vigorous and the coloring intense," and in 1948 reaffirmed his opinion (this critic, comparing it with the Berlin *Proverbs*, reaches a conclusion that is the direct opposite of Tolnay's and even eliminates the Berlin painting from the corpus of Bruegel's known works). Denis dates it between 1560 and 1580, while De Coo accepts Friedländer's dating. Originally the figures stood out against a vermilion-red ground, most of which has now disappeared.

16 117×163 1559

Flemish Proverbs Berlin, Staatliche Museen
Signed and dated, below on the

right, BRVEGEL 1559 (the last two figures look like an addition). This crowded but not altogether harmonious composition, typical of the painter's first period, illustrates about 120 proverbs or popular sayings which W. Fraenger [*Der Bauernbruegel und das deutsche Sprichwort*, 1923] has analyzed and discussed as regards their relationship to Northern European folklore in general ; an even better interpretation is given by J. Grauls [*Volkstaal en Volksleven in het werk van Pieter Bruegel*, 1957], who relates them to Flemish sayings. Glück too gave careful interpretations, *The Large Bruegel-Book* 1952. Below, we give the most plausible of these interpretations, with – where necessary – the corresponding English sayings, or else interpretations based on suggestions made by Dr Italo Sordi of Milan (for the numbers, cf. the diagram of the painting on page 94, divided into five rows to facilitate identification).

Top row, from left : *1* To look through one's fingers (to let things slide) ; *2* The broom is sticking out of the window (the owners are out) ; *3* To be married without a broom (to be living in sin) ; *4* To sit with one's clogs on (to wait in vain) ; *5* Cakes are born on his roof (he was born with a silver spoon in his mouth) ; *6* To shoot one arrow after another (to receive no reward for one's efforts) ; *7* The pigs are running wild in the corn (everything is going wrong) ; *8* His backside is burning (he's in a great hurry [?]) ; *9* To play the violin in the stocks (not to see how ridiculous one is) ; *10* To turn one's coat according to which way the wind is blowing (to be a turncoat) ; *11* To stand looking at the stork (to let an opportunity slip) ; *12* To cast feathers to the wind (to fail to reap the fruits of one's labors ; *13* A bird can be recognized by its feathers (?) ; *14* To kill two flies with one blow (to kill two birds with one stone) ; *15* It doesn't matter whom the burning house belongs to, provided we can warm ourselves at the embers

(I'm all right, Jack); *16* Fear makes an old woman run (fear lends one wings); *17* To drag a log behind one (to be hampered); *18* One blind man leading another; *19* Horse-dung is not the same as figs; *20* To see the church and belfry before the journey is over (to count one's chickens before they're hatched); *21* He's watching the bears dance (he's starving); *22* To keep an eye on the sail (to keep one's weather eye open); *23* To sail with a fair wind behind one (to be in fortune's way); *24* To shit beneath the gallows (to sit on the edge of a volcano); *25* Why do geese go barefoot? (mind your own business); *26* Crows fly where carrion lies. Second row: *27* To shit on the world (not to care a damn what anyone says); *28* There's a knife on it (a kind of challenge); *29* To consult the cards (to give away secrets); *30* To hold one another by the

39 To shave a fool without using soap (to exploit the stupidity of others); *40* It's growing out of the window (it can't be concealed); *41* To fall off the ox onto the donkey (to fall out of the frying-pan into the fire); *42* To kiss someone's ring (to show exaggerated respect); *43* To fish behind other men's nets (to have to be content with what others have left); *44* To rub one's backside against the door (to be ungrateful); *45* A beggar doesn't like it if another begs at the same door; *46* To be able to see through an oak plank provided there's a hole in it (to boast that there's nothing one can't do); *47* Like a shithouse hanging over a ditch (probably means that something is obvious); *48* Two people shitting through the same hole (making a virtue out of necessity); *49* Throwing money into the water (wasting money); *50* A cracked wall can be easily

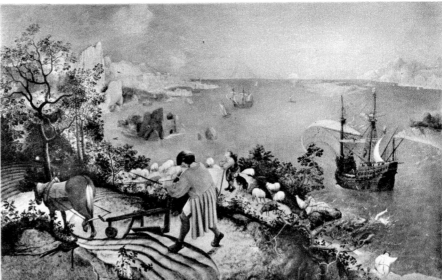

13

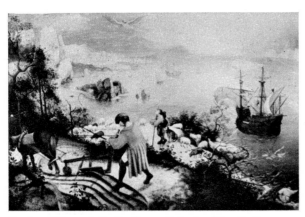

Version of 13, now in the Van Buuren Collection (New York).

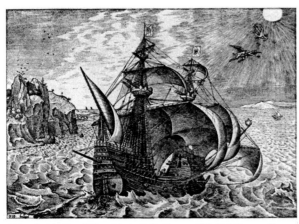

(Above) A Listing Ship with the Fall of Icarus ("F. H.," "bruegel"; 9¾ × 11¼ inches, 25 × 28·7 cm), possibly connected with 13.

nose (to detest one another); *31* The die is cast; *32* An eye for an eye (interpretation based on the fact that in the painting an eye can be seen between the open blades of the scissors, or else the "eyes" might be those of the scissor handles); *33* There's a hole in the roof (the idea's wrong); *34* An old roof needs a lot of repairing; *35* To have thick skin behind one's ears (to be an arrant rogue); *36* To piss at the moon (to attempt the impossible); *37* On the roof there are rafters (someone might be eavesdropping); *38* Two fools under one cloak (to do two foolish things at once);

demolished; *51* To be indignant because the sun is reflected in the water (to be envious); *52* To hang one's habit on the fence (to leave a monastic order); *53* Swimming against the stream; *54* The pitcher goes so often to the well that at last it breaks (your sins will find you out); *55* To make wide belts out of other people's leather (to be generous with other people's property). Third row: *56* Each herring has to be hung up by its own gills (one must pay out of one's own pocket); *57* The world upside down; *58* What can smoke do to iron? (striking out wildly will do no good [?]); *59* The spindles fall into the ashes (to fire into the air); *60* To be sitting between two stools in the ashes (to want too much and get nothing); *61* If you let the dog in, it will run straight to the cupboard (give him an inch and he'll take an ell); *62* It depends on how the cards fall (it's a question of luck); *63* There are scissors hanging outside (pickpockets are on the prowl); *64* To keep on gnawing at the same bone (to harp on a question); *65* Leave at least one egg in the nest (be discreet); *66* If the eggs have not yet been laid, you can't be sure of getting chickens (same meaning as 20); *67* The pisspot is hanging on the door (shameful deeds cannot be concealed); *68* To speak with two mouths (to be deceitful); *69* To bring baskets of light out into the daylight (to spread news when it would be better that it should not be known); *70* To light a candle to the Devil (to ask favors of one's enemies); *71* To confess to the Devil (to confide in someone who may use what he hears to one's disadvantage); *72* To whisper in someone's ear (to put a flea in someone's ear); *73* What's the use of a nice plate if there's nothing on it?; *74* The stork invites the fox (reference to Aesop's fable); *75* It's written in chalk (it will never be forgotten [?]); *76* A spoonful of scum (a sponger); *77* To piss on the spit (to insult someone); *78* He knows how to catch fish with his hands (he's a smart

Etching by L. Vorsterman ("Pieter Brughel Pinxit"; diameter 7½ inches, 19 cm), connected with 60.

fellow); *79* Big fish eat little ones; *80* You can't turn the spit with him (it's no good arguing with him); *81* To be sitting on burning coals; *82* To catch an eel by its tail (to escape by the skin of one's teeth [?]); *83* To take the hen's egg and miss the goose's (to lose a big advantage in order to get a little one); *84*

To be hanging between the sky and the ground (to have one's head in the clouds [?]); *85* To fall down and break the basket (to squander one's inheritance). Fourth row: *86* The hypocrite; *87* To cook a herring in order to enjoy the smell (same meaning as 110 [?]); *88* To carry water in one hand and fire in the other (to spread gossip, or else: to do harm in one way and make up for it in another); *89* The pig takes the spigot (to be incapable of doing even the simplest things); *90* He who wears armor bells the cat (weapons make even cowards brave); *91* To be able to digest even iron (to have the stomach of an ostrich); *92* Armed to the teeth; *93* One holds the distaff while the other spins (to spread wicked rumors [?]); *94* To throw a blue coat over one's husband's shoulders (to cuckold one's husband); *95* The pig has been stuck through the belly (same meaning as

61

62

14

60

31 [?]) ; *96* To throw roses to the pigs (to cast pearls before swine) ; *97* Two dogs with only one bone will never agree (to lead a cat-and-dog life) ; *98* To make the world dance on one's thumb (to twist everyone round one's little finger) ; *99* To put a false beard on the face of Our Lord (to believe that one can get away with it) ; *100* The last two get only one *Pretzel* [Epiphany cake] (first come, first served) ; *101* To sit in the sun (to make one's own shadow) ; *102* To hold tight [?] ; *103* To yawn in front of the oven (to be lazy [?]). Bottom row : *104* The best of women tied the Devil to the mattress (women know more than the Devil [?]) ; *105* To dash one's head against a wall ; *106* To put on one's armor (to lose one's temper [?]) ; *107* Shear the sheep, don't skin it (don't go too far) ; *108* One shears the

considering it to be an authentic Bruegel, with the exception of Michel, who attributes it to the pseudo-Bruegel because — according to him — it is inferior ("puerile draughtsmanship, rigid and monotonous gestures") to the other picture of proverbs in Antwerp (15), thus contradicting the opinion of Tolnay, according to whom only the Berlin painting is by the master's own hand. Glück thinks that the most likely date would be the end of 1559, between *Carnival and Lent* (17) and *Children's Games* (18), but Tolnay dates it before *Carnival and Lent*. The state of preservation is good, except for a few "moralistic" modifications attributable to Victorian prudery (for example, the figure of the man leaning out of the window on the left [Tolnay]).

17 ⊞ ⊛ 118×164,5 1559 ▤ ⫶

The Battle between Carnival and Lent Vienna, Kunsthistorisches Museum Signed and dated, below on the left, BRVEGEL 1559. In the left foreground Carnival, a burly, fat man, is sitting astride a cask, with saucepans as stirrups, a pie on his head and a spit in his hand. This figure is very close to the fat man on the barrel by Bosch in the Yale fragment *Allegory of Pleasures* (see *The Complete Paintings of Bosch* p. 93). He is being pushed forward by a masked man with sausages strung round his neck and a funnel-shaped cap on his head ; the other members of Carnival's suite are likewise masked and are carrying more or less improvised musical instruments ; in accordance with a custom still in vogue a little boy is carrying two candles wrapped in straw on the end of a stick. Towards the right, Lent is seen with a beehive on his head, an allusion to the honey that could be eaten on fast days ; he is carrying a shovel on which are two herrings and is seated on a church stool mounted on a little cart drawn by a monk and a nun ; behind the chair is a pot containing the mussels and sweets consumed on some of the days in Lent ; similar delicacies are carried by the children following behind, some of whom are shaking rattles ; a sacristan is carrying the holy water for the Easter Saturday mass. On the left, in front of the tavern, the farce of the *Vuile*

(*Above*) *Close-up photograph of the last "proverb" but one in 15, showing clearly that it was originally painted on a wooden platter.*

Bruid is being performed (this used to be erroneously interpreted as *The Nuptials of Mopsus and Nisa* (cf. 63) ; behind this are lepers wearing foxes' tails (cf. 51) ; still further behind, a burlesque representation of the encounter between Orson and Valentine (from the Charlemagne cycle) ; these two farces (which can be seen in more detail in prints [cf. 63]) and the procession were traditional features of the Carnival season. Towards the center, behind the playing children, preparations for Easter are in full swing ; houses are being spring-cleaned (a woman on a ladder is cleaning the outsides of her windows) etc. Further to the

right, completing the survey of Lenten customs, we see fish (by the well), palm-branches (for Palm Sunday) being offered for sale, the adoration of the Crucifix (through the open doors of the church), the giving of Lenten alms and (in the far background) worshippers leaving the church after the sermon, each of them carrying his own chair. As far as the meaning is concerned, the picture can be divided in half. On the left, is Carnival and all that he stands for : gluttony and debauchery (the theatrical performances, the men dicing [their heads covered in waffles, by the way] in the extreme left foreground ; playing of musical instruments, the two

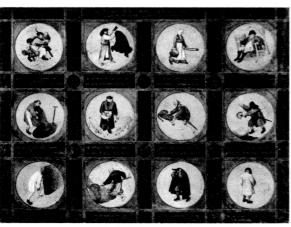

15

sheep, another the pig (to be incapable of following a good example) ; *109* Meek as a lamb ; *110* Much ado and little wool (much ado about nothing) ; *111* To block up the well after the calf has been drowned (to shut the stable door after the horse has bolted) ; *112* He who wants to live in this world must know when to give way (give and take) ; *113* To put a spoke in the wheels, *114* If you drop the gruel, you can't expect to pick it all up again (it's no good crying over spilt milk [?]) ; *115* An axe complete with handle (everything) ; *116* A hoe without a handle (a useless thing) ; *117* He can't find his way from one loaf to another (he doesn't know which way to turn) ; *118* To look for the smallest axe (to be a lazy worker). As regards the interpretation of the work as a whole, some critics believe that it should be taken as a portrayal of "the world upside down," which is specifically represented in locution 57.

It is probably the painting mentioned in an inventory (13 August 1668) of the property of Peter Stevens of Antwerp (who owned eleven works by Bruegel) as *Le Monde renversé, représenté par plusieurs Proverbes et Moralités*. It was acquired by the Berlin gallery in 1914, from a private collection in England. The critics are unanimous in

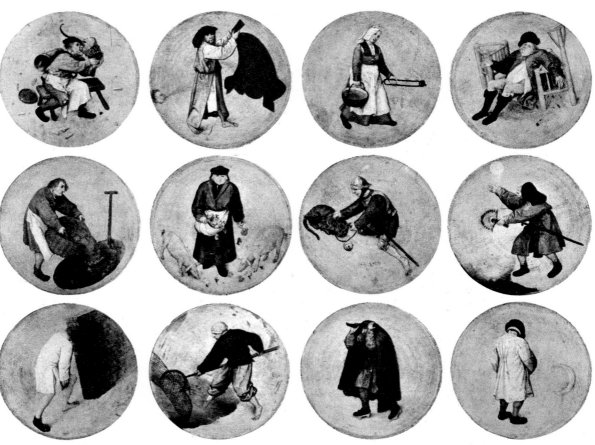

The twelve component parts of 15, reproduced separately in the order in which they appear in the Antwerp complex.

inns). On the right is Lent, presented as a ludicrous figure, yet attended by associate figures depicted as serious and tragic. There are wretched beggars, blind and maimed; a woman begs for her sick child – next to it is a corpse covered in a sheet. There used to be more examples of wretchedness, now overpainted, e.g. the cart drawn by the barefooted woman contained a corpse; two sick children lay by the church-door (discoveries of Dr Wilde reported in Tolnay, and Glück [1953]). Alms are given in a charitable spirit, but on the left, the beggars are ignored.

The painting figures in two old Antwerp inventories, one of the property of Ph. van Valckenisse (1614) and the other of that of H. de Neyt (1642) [Denucé, 1932], and it was mentioned even earlier by Van Mander. It was removed from the Weltliche Schatzkammer in Vienna in 1748, and was later in Prague

and Graz, before returning in 1765 to the Austrian capital. The very crowded composition reveals Bruegel's delight in narrative description, since he manages to include an enormous number of aspects and attitudes, without detracting in any way from the impression of the whole.

A copy or replica exists in the National Museum, Cracow; Waagen (Treasures of Art, IV, 1857, p. 515) and Hymans (*Oeuvres* III, 1920, p. 261) mention a version as belonging to the Duke of Portland, Welbeck Abbey; the Arundel inventory of 1655 mentions a "*Querella de Carnevale e quaresima in aquazzo, Breugel Vecchio*" (BM, 1911, p. 283). Hulin de Loo, 1907, mentions a copy of part by Pieter II, in the Joly Collection, Brussels.

18 118×161 / 1559-60

Children's Games Vienna, Kunsthistorisches Museum

Signed and dated, below on the right, BRVEGEL 1560. In this "encyclopedia of Flemish children's games" [Hulin de Loo] – there are no fewer than eighty-four (many of them being easily identifiable because they are still played), as has been noted by A. de Cock and I. Teirlinck [*Kinderspel en Kinderliest in Zuid-Nederland*, 1902–5] – Tietze-Conrat [OJ 1934] claims to recognize an allegory, the first of a series of paintings illustrating the ages of man. Conversely, Tolnay believes that it is one of a series of four, (cf. 63), the others being *The Battle between Carnival and Lent* (17) and two lost paintings known only through prints, *The Skaters* and *Kermis at Hoboken*, the whole series representing the four seasons. Stridbeck [1956] interprets the painting in a more esoteric way, claiming that it is an allegory of the mad and sinful world, like the two paintings of *Proverbs* (15 and 16); lastly, Van Lennep

detects allusions to alchemy, a symbolization of the process of coagulation (which – it would seem – is likewise symbolized by children's games in the codex of Salomon Trismosin's *Splendor Solis* in the Kupferstichkabinett in Berlin), or even of the golden age of the philosopher's stone. The painting is mentioned by Van Mander and also figures in Chrétien de Mechel's catalogue [CV, 1784]. Its authenticity is generally accepted. The tiny, vividly colored figures play their games against a background which on the left is typically Flemish, whereas on the right the skilful treatment of perspective and the style of architecture remind us of the Serlio engravings published by Coecke's widow. Here again, as in the preceding pictures, Bruegel gives free rein to his curiosity and love of narrative, notwithstanding which the figures are placed in a setting strictly governed by the rules of perspective. The state of preservation is good.

19 33,5×55 / 1562

The Suicide of Saul or The Battle between the Philistines and the Israelites Vienna, Kunsthistorisches Museum
Inscription, below on left: Saul XXXI CAPIT. BRVEGEL M. CCCCC. LXII, giving us not only the artist's name and the date, but also the subject and the biblical reference. In fact the "principal" episode, isolated as it is in other works by Bruegel, so that it serves almost as one of the wings of a stage, is to be found in 1 Samuel XXXI. 1–5: "And the Philistines followed hard upon Saul . . . and the archers hit him, and he was sore wounded . . . Then said Saul unto his armor-bearer. Draw thy sword and thrust me through therewith; lest these uncircumcized come and thrust me through, and abuse me. But his armor-bearer would not; for he was sore afraid. Therefore Saul took a sword, and fell upon it. And when his armor-bearer saw that Saul was dead, he fell likewise upon his sword, and died with him." The landscape may be a reminiscence of the painter's journey through the Alps on his way to Italy; the overwhelming majesty of the mountains is used to create a vivid contrast with the seething mass of soldiers – like a swarm of locusts [Dvořák] – who do not seem to notice the death of the king and his armor-bearer. Delevoy suggested that the microscopic exactitude of the execution raises the question of collaboration between Bruegel and his future mother-in-law, Mayeken Verhulst, who, as we have already said, was a well-known miniaturist. The painting figures in De Mechel's catalogue [CV, 1784]. Glück maintains that two additions have been made to the panel – a strip four centimeters wide at the top and another one centimeter wide at the bottom.

20 20×23 / 1562

Two Monkeys
Berlin, Staatliche Museen
Signed and dated, below on the left, BRVEGEL MDLXII. The picture apparently came originally from the Pieter Stevens Collection in Antwerp, which was broken up in 1668; it is known for certain that it belonged to a Russian princely family before being acquired in Paris by the Berlin Museum in 1930. Some critics interpret this little work as symbolizing the servitude of the Flemish provinces under Spanish rule, or else as an allegory of man, the slave of his sins.

It has been pointed out that here are the first signs of Bruegel's tendency towards monumentality – two figures in a harmonious setting, accurately drawn and circular in shape, with the monkeys' tails playing a prominent role; in the background we see the Scheldt, the skyline of Antwerp and the towers of Notre-Dame, which have been identified on the basis of the description in the catalogue of Pieter Stevens' sale in Antwerp, 1668: *La ville d'Anvers avec deux singes* (Burchard, in Glück, 1953).

21 43×30,7 / *1562*

The Resurrection
Rotterdam, Boymans-Van Beuningen Museum
Executed with pen and brush on paper (stretched over a panel). It bears the inscription BRVEGEL, which was apparently written twice, the second time on top of the first. The work portrays two episodes of Christ's Resurrection, since the meeting between the Maries and the Angel is also shown. According to Van Lennep it contains allusions to alchemy: Christ, as He emerges from the sepulcher, points to the sun rising over the sea (though whether the Savior's arm is really pointing towards the sun is a matter of opinion); in the foreground is a hollow tree-trunk with a bundle of dead branches, all these things being supposedly allusions to the origins of the philosopher's stone (which alchemistic texts of the fifteenth and sixteenth centuries identify with the Resurrection), while the actual production of the philosopher's stone is said to be taking place in the shadow of the hollow tree, the sepulcher and the dead branches symbolizing the putrefaction which was an essential feature of this operation and the rising sun representing the actual appearance of the longed-for stone. Attention was first drawn to this grisaille by Cohen [1924], who describes it as a genuine Bruegel dating from about 1562. Friedländer and Grossmann [1954] are of the same opinion, but Tolnay [1925 and 1952] rejects it. There exists a very faithful reproduction in the form of a print (BRVEGEL INVEN. COCK EXCVDEBAT; 17 × 11¾

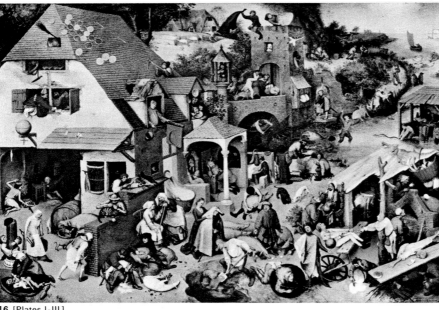

16 [Plates I-III]

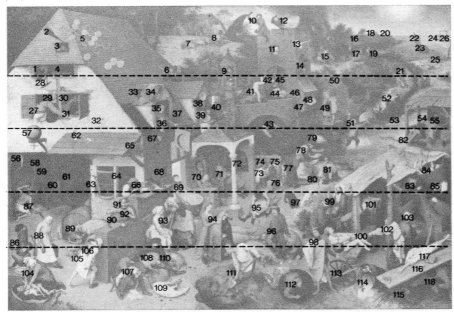

Diagram of 16; the sayings are indicated by numbers corresponding to those in the text.

inches, 43·5 × 30 cm), which is generally believed to have been engraved after the grisaille, though according to Denis and Van Lennep it derives from a lost work – which is equivalent to denying the authenticity of the Rotterdam grisaille.

This work, if a genuine Bruegel, is an interesting example of the grace and refinement which our painter understood very well (cf. e.g. the holy mourners in the fore-ground of *The Carrying of the Cross*), but usually avoided.

22 ▦ ◴ 117×162 ▤⋮ 1562

The Fall of the Rebel Angels Brussels, Musées Royaux des Beaux-Arts Dated and signed, below on the left, M.D.LXII BRVEGEL. Acquired by the museum in 1846 for 500 francs, as a work by "*Bruegel d'Enfer,*" and as such figured in the catalogues until, after it had been attributed to Bosch, the signature was discovered, hidden by the

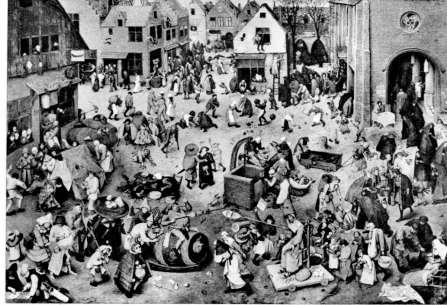

17 [Plates IV-VI]

The Battle between Carnival and Lent (*Brussels, Joly Collection*), *version of part of 17, attributed to Pieter Bruegel the Younger.*

Encounter between Orson and Valentino, *woodcut ("BRVGEL 1566";* $10\frac{3}{4} × 16\frac{1}{4}$ *inches, 27·5 × 41 cm), having some connection with 17.*

frame. The subject was a very popular one with the older masters and all the traditional figures are shown. In the center is St Michael, his slender limbs clad in armor, followed by the loyal angels armed with swords and encouraged by others blowing long trumpets ; the archangel is seen fighting against his rebel colleagues, represented as hybrid monsters, part human, part fish, birds, amphibians, reptiles, vegetables and other objects, which according to Grossmann may be intended to symbolize the vices (the capital vices being on the left), and the enemies of Good in general (in the center, towards the right, are the

beasts of the Apocalypse)."It looks like an aquarium full to the brim," as Friedländer observes. There are obvious reminiscences of Bosch, in particular of *The Hay-Wain* triptych in Madrid and *The Last Judgment* in Vienna (cf. *The Complete Paintings of Bosch* Nos 21 B and 50 C). It is interesting that this work was painted eight years after the triptych of the same subject by Frans Floris (1554), painted for the cathedral in Antwerp. Floris had executed a High Renaissance piece based on Tintoretto. Bruegel deliberately harks back to the earlier Flemish tradition, unconcerned with the Italian Renaissance. The figures are

"Gothic" in type, and the horrific repertoire of monsters belongs to an earlier age. He adds his own touch to the themes treated by Bosch, and reveals a clear feeling for order amidst apparent chaos. We need only note how, above the tumultuous rabble of infernal creatures, the colors become lighter – pink, sky-blue and white – in harmony with a circular rhythm stressed by the two great white angels brandishing swords, while the tall and elegant figure of St Michael dominates the center and the obscene mob of the denizens of Hell. Michel [AP, 1948] blames the restorers for making the angels on either side appear too bright, with the result that the painting now gives the impression of being divided into two parts, whereas before it formed an admirable whole, with subtle graduations and transitions in the tones.

23 ▦ ◴ 117×162 ▤⋮ *1562-63*

The Triumph of Death Madrid, Prado In this picture Death is shown triumphing over all sorts and conditions given. In the fore-ground are certain carefully defined examples : the King, the Cardinal, the housewife with her distaff and her baby, the pilgrim (his throat being cut for all the souvenirs in his cap), two fine young knights, – all have succumbed, or are on the point of succumbing to Death. On the right, the gay and luxurious have been startled from their gaming and their dinner ; a fashionable young couple (note one of Bruegel's rare pretty and well-dressed women) on the extreme right are still at their music-making, but the young man looks haunted, and a skeleton is accompanying them on a viol. This couple, as Genaille has remarked, recall the heedless lovers on top of the wain in Bosch's *Hay-Wain*. In the middle ground, more ordinary men and women struggle against the onslaught of the Death-figures. A crowd of

people is being pushed into a huge grave, its door held open by a draw-bridge device. On top of the grave, a skeleton beats a pair of kettle-drums. An army of skeletons is drawn up on either side of the grave ; to the left, a net catches men, and in the center is a dark and sinister ship : it is infernal, as we can see from the flames and the monsters. The principal figures in the foreground of the picture are the figure of Death riding a skeletal horse, wielding a scythe and trampling over bodies ; and further to the left the cart filled with skulls, drawn by a weary, half-dead nag surmounted by a skeleton tolling a bell and holding a lantern. Beyond the water (in which scenes of drowning are shown) is a desolate landscape : no grass grows, the trees are blasted, the bones of animals are scattered about, and a number of gallows, decked with bodies, are silhouetted against the sky. On the left a great bell is being tolled by two skeletons ; beyond can be seen the red glare of a distant conflagration, with black plumes of smoke. Ships founder in the sea and on the right a man falls to his death from some rocks.

Tolnay (1935) first pointed out that Bruegel has here drawn on two traditions, the Italian idea of Death mounted on his horse and trampling men underfoot (based on the Apocalypse) : and the Northern idea of the Dance of Death (expressed by Holbein in his woodcuts). It is worth mentioning too that the Death-cart is a reminiscence of those chariots in the many series of Triumphs (of Love, Chastity, etc. etc.) based on Petrarch, and executed repeatedly, in tapestries and engravings especially. Bruegel has also, as Grossmann notes, emphasized the moral aspect of the drama of Death. The victims he shows have led evil lives :.they are the proud, the covetous, the luxurious, the angry (a case could be made for identifying the foreground figures as examples of the Seven Deadly Sins) ; in the background are criminals. Their death is full of horror, for their punishment is Hell, as the sinister black ship proclaims.

Glück pointed out that the figure of Death on Horseback strongly echoes the same figure in the fresco of *The Triumph of Death* at the Palazzo Sclafani in Palermo, a factor which supports the hypothesis that Bruegel may have visited Sicily (see Outline Biography 1552). A similar figure is also to be seen in a medieval fresco in the Campo Santo at Pisa.

It is not certain whether this is the painting mentioned by Van Mander "in which are depicted all the means of defence against death," but it is quite likely that it is the work listed as forming part of the inheritance of Philips van Valckenisse (Antwerp, 1614), and described as *Triumph van den Doot, van Bruegel*; in 1774 it reappears in an inventory of works of art in the Palacio de San Ildefonso, whence it passed to the Prado in 1827. The attribution to Bruegel is accepted unanimously, but not all the critics agree as to the date. Hulin de Loo suggested 1565 or 1566, but Michel [1931] would date it as late as 1566—9. It seems more likely that it was painted between

The Nuptials of Mopsus and Nisa, *engraved with the burin by P. van der Heyden ("Brvegel – inventor"* $8\frac{3}{4} × 11$ *inches, 22 × 28·2 cm).*

95

The Rebel Angels (22) and
Dulle Griet (27), that is to say
at a time when Bruegel was
still strongly influenced by
Bosch and was giving his own
interpretations of the themes he
borrowed in his younger days
from that master. About 1562
would thus seem to be a
plausible date, which is
accepted by most critics down
to Grossmann, while 1562–3, as
suggested by Genaille, is even
more likely.

24 45,5×64,8 1563?
**Landscape with St
Christopher** Switzerland (?),
private collection
Signed and dated P. BRVEGEL
1563 (the last figure is barely
legible). In the foreground
peasants are gathering or
carrying away wood ; further

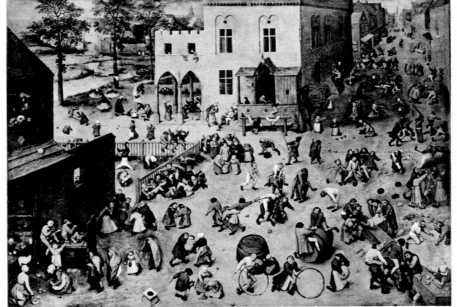

18 [Plates VII-IX]

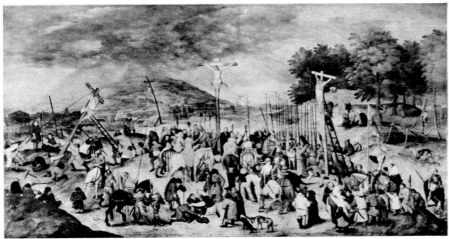

Painting attributed to Pieter Bruegel the Younger in the Catalogue of the Museum of Art at Philadelphia
to which it now belongs (formerly in the Wilstach Collection).

Painting attributed to Pieter the Younger, which in 1907 belonged
to the Abbé Cotteleer, Antwerp.

back, in the center, a harbor, in
which, among other ships
visible, one is sinking near an
isolated rock towards the left ;
at the foot of this rock is the
little figure of the saint carrying
the Child Jesus across the water
on his left shoulder. It was attrib-
uted to Bruegel by Friedländer in
in a private communication, and
is mentioned — as an authentic
work — by Van Puyvelde [P 1960]

25 37×55,5 1563
**Landscape with the Flight
into Egypt**
London, A. Seilern Collection
Signed and dated BRVEGEL
M D.LXIII. Van Puyvelde [1962]

mentions the painting, but
dates it 1561 (the last figure is,
according to him, barely
decipherable), and he also gives
different measurements (37 ×
25·5 cm, 14½ × 10 inches). It
was discovered in 1939 by
Glück [AP 1948], at which time
it belonged to the heirs of Mrs
Holbrooke, Bladon Castle,
Burton-on-Trent ; in that same
year it was sold at Christie's in
London to its present owner.
The little figures of The Flight
scene are set in an extensive
landscape reminiscent of
Patenier — mountains, rocks
and water. St Joseph, seen
from behind, is leading the
donkey along as he walks

downhill ; the Virgin Mary is
riding on the donkey and looks
like a forerunner of the Virgin
in The Numbering (38),
painted three years later ; on the
right, a tree-trunk with two
birds, and a shrine from which
the overturned statue of an idol
is projecting (a detail nearly
always included in the
iconography of this subject).
Glück points out that a painting
of the same subject figures in the
Granvelle inventory (Besançon,
1607), which reappears in a
number of old lists, but, despite
this scholar's assertion — for that
matter, rather hesitant — it does
not seem to be identical with the
present work (cf. 80). It is
accepted by most critics as a
genuine work, but not by Tolnay,
who believes it be a copy.

26 22×18 1563*
Head of an Old Woman
Munich, Alte Pinakothek
This came to the Nürnberg
picture-gallery in 1804 from the
castle of Neuburg on the
Danube and was transferred to
Munich in 1912. Unanimously
accepted as an authentic
Bruegel, except by Tolnay
[1935], who believes it to be
either a copy or a pastiche — he
draws attention to defects in the
draftsmanship (in the coif,
the left shoulder etc.), which
were also noticed by Genaille.
There is less agreement about

the dates ; Michel would like to
date it about 1559 (he thinks
that it is a study from a live
model and almost a preliminary
sketch for Dulle Griet [27]) ;
Glück prefers a later date, about
1568, and Grossmann is of the
same opinion ; he would
compare it with the head of the
blind man (49) who is fourth
from the left and also the head
of the Connoisseur in Bruegel's
famous drawing, of which the
best-known example is in the
Albertina, Vienna.

27 115×161 *1563*
"Dulle Griet" ("Mad Meg")
Antwerp, Mayer van den Bergh
Museum
Below, on the left, are traces of a
signature, all but illegible and
probably a forgery, followed by a
date which would appear to be
MDLXIIV [sic], interpreted by

some as 1562 and by others as
1563, though all agree that the
work must have been painted at
the time when Bruegel was once
more drawing inspiration from
the infernal menageries of
Bosch (cf. Combe in AP, 1948).
The composition teems with
innumerable Bosch motifs,
grouped around the armor-clad
figure of the witch (if that is
what she is), who strides
defiantly towards the mouth of
Hell, amidst monstrous beings,
metamorphoses, obscenities and
tumult ; in short, the whole
repertory of sexual and magical
symbols, from the egg to the
lyre and the crystal ball, set in an
atmosphere of smouldering
fires. "Mad Meg" is a witch, a
sorceress, one of the Furies from
Hell (Glück) ; according to
Minnaert (A 1943) she was a
figure of Flemish folk-lore,
used to frighten children — an
echo of the goddess Gridr.
She is the embodiment of female
wickedness. Denis describes the
picture as a new version of a
very ancient theme — the
wickedness of a woman ready to
embrace Hell itself ; according to
Grossmann she is a
personification of avarice, a
theme much in vogue in
Bruegel's days (there is a print
dated 1556 portraying this vice
for which Bruegel probably
provided the conception). Note,
in this connection, the tall figure
in flowing robes behind the
protagonist, who is extracting
coins from his backside with a
ladle ; on his back this strange
personage carries a boat with a
glass sphere in it, inside which a
man is holding up a roast fowl —
these being undoubtedly
symbols alluding to alchemy,
though it is difficult to accept
Van Lennep's thesis that the

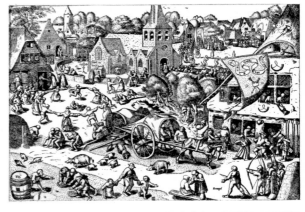

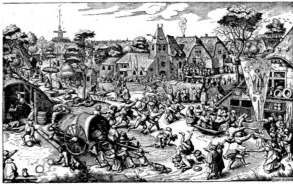

(From top) The Hoboken Kermis ("Bruegel" ; 11¾ × 16¼ inches,
29·7 × 41 cm). The St George's Kermis ("BRVEGEL INVENTOR" ;
13½ × 20¾ inches, 34 × 53 cm).

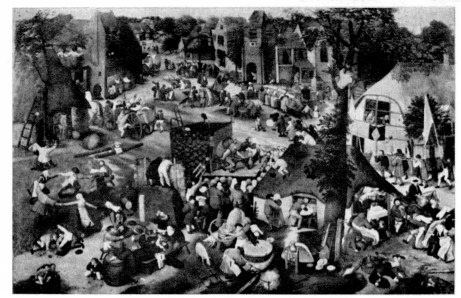

Painting attributable to the workshop of Pieter Bruegel the Younger (Brussels, Musées Royaux des Beaux-Arts).

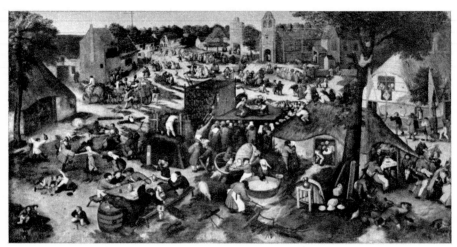

Painting (Avignon, Musée Calvet), formerly attributed to Bruegel the Elder, but now to an anonymous follower.

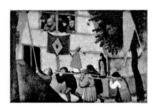

Fragment of a painting of a Procession, *perhaps by Pieter the Younger,* Brussels, Musées Royaux des Beaux-Arts.

whole painting is alchemistic. According to this critic, Griet's pose is similar to that of a novice-alchemist advancing towards a fire with a sword in his hand, in other words about to descend into Hell, an experiment which books on alchemy advise neophytes to make. Some of the surrounding symbols might serve to support this hypothesis, in particular the boat with the sphere in it, since the former might be the alchemistic vessel (the normal symbol for a crucible), while the latter could be the glass jar which alchemists used to place on the crucible after filling it with the components of the philosopher's stone, the roast fowl being an allusion to these components (among alchemists the glass jar was known as "the hen's nest"); the man supporting the boat is in reality laying an egg, the contents of which he is

removing with a spoon, these contents consisting of gold coins, the production of which was the aim of alchemists; above the entrance to Hell hangs a sphere with men and women inside it, according to some writers an allusion to the proverb: "Bliss and glass are

easily shattered," though it might also be an allusion to alchemists' jars containing homunculi, etc. Other critics, for example Michel, think that the painting contains allusions to the troubles threatening the Low Countries — a kind of indictment of foreign tyranny.

Van Mander describes the picture and says he thinks it is in the collection of the Emperor Rudolph II; it figures in the seventeenth-century inventories of works in the Hradschin at Prague (*Ein Daffel mit Feuerbrunst dorbey die Furia mit unterschiedlichen Monstren*); it was stolen by the Swedes during the sack of the city in 1648 and did not reappear again until the nineteenth century. It was sold by auction in 1894 at Cologne, where — on Friedländer's advice — Mayer van den Bergh purchased it for 390 marks. Though no doubts are expressed as to its authenticity, the critics disagree regarding the date. Glück and Jedlicka suggest 1562, since that is how they read the date, which the compilers of the museum's catalogue read as 1563; Hulin de Loo, Friedländer and Michel propose 1564, and Genaille thinks it cannot be later, as he thinks it belongs to the Antwerp rather than the Brussels period. Tolnay assigns it to 1565-6, judging the inscription to be a forgery.

28 ▦ ⊕ 114×155 1563 ▤ ⋮

The Large Tower of Babel
Vienna, Kunsthistorisches Museum
Signed and dated, below on the right, BRVEGEL FE. M.CCCCC. LXIII. This was one of the sixteen works by Bruegel which in 1565 belonged to the Antwerp merchant Jonghelinck Van Mander mentions it as belonging to the Emperor Rudolph II; in 1659 it was in the Archduke Leopold William's collection and in 1784 it figured in the Mechel catalogue [CV]. The Tower of Babel (which Sebastian Brandt in his *Ship of Fools* described as a symbol of human folly) was a subject that interested Bruegel deeply; besides the two painted versions he executed a miniature on ivory while he was in Rome, which is mentioned in the Giulio Clovio inventory

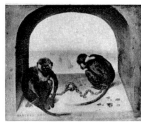

20 [Plate XIV]

(Outline Biography). The subject had often been treated in Northern Books of Hours: it is to be found in the Grimani breviary (Venice), possibly seen by Bruegel, and it was painted by Patenier (painting now lost).

Here Bruegel reveals a keen interest in technical matters and craftsmanship, as well as a thorough knowledge of architectural problems, as we can gather from the meticulous care with which he depicts microscopic technical details — winches, centerings, ladders and so forth; and the various stages which different portions of the structure have reached can be seen as if we were looking at a vertical section ("one can see inside it from above," as Van Mander remarks), without in any way detracting from the grandiose effect produced by the whole work. Nor is this effect impaired by the miniature-like blue city on the left, with its pointed Gothic roofs, or by the busy traffic in the harbor on the right, or the workmen swarming everywhere — little ants who only make the colossal, tottering edifice seem more imposing. Genaille thinks that in this picture Bruegel affirms his admiration for human achievement — rather than disapproves, according to the orthodox interpretation of the subject. Tolnay makes the point that the tower is really supported by a huge mass of rock (visible on the right). The fact that the tower stands upright is thus due not to Man but to Nature. By placing the

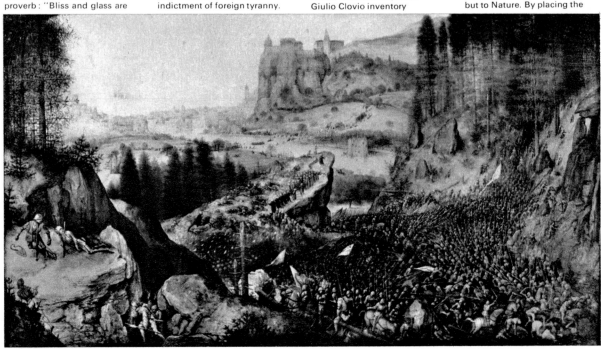

19 [Plate XV]

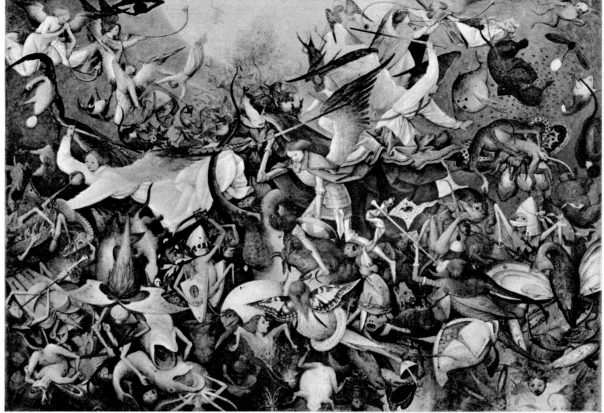

22

21

foreground very close to the spectator (as in several other compositions), the painter is able to show us Nimrod and his courtiers passing among the stone-cutters, who continue their work without paying any attention, while the architect explains the details to the monarch.

29 🏴 ⊕ 60×74,5 1563* 📑 ⋮

The Small Tower of Babel
Rotterdam, Boymans-Van Beuningen Museum
No critic has ever cast any doubts on the authenticity of

this panel-painting, mentioned by Van Mander together with the preceding work as being in Vienna ("another panel of the same subject, but smaller"). If we have understood his somewhat vague words rightly, it, too, belonged to the Emperor Rudolph II, though on the back it bears the arms of Elizabeth of Parma, wife of Philip V. The date, on the other hand, has been the cause of much discussion; some critics (Friedländer, 1937; Jedlicka; Grossmann, 1955) think that it was painted at the same time as the larger version (1563);

Glück suggests 1554; Tolnay (1938) dates it as late as 1567, a dating with which Genaille and Grossmann (1959) agree. Despite its greater, miniature-like completeness, it is inferior to the rugged, almost dilapidated grandeur of the Vienna version. The state of preservation is good.

30 🏴 ⊕ 124×170 1564 📑 ⋮

The Procession to Calvary
Vienna, Kunsthistorisches Museum
Signed and dated, below on the right, BRVEGEL M.D.LXIIII.
This crowded composition containing over five hundred figures is set against a broad sweep of landscape: the broad, winding road admirably suggests the movement and rhythm of the throng. The long and tumultuous procession is broken by the red tunics of the guards trying to maintain order; the crowd is particularly dense at the point where Simon of Cyrene (second plane, towards the left), restrained by his wife, is arguing with the soldiers; and near the cart containing the two thieves accompanied by friars, which is about to cross a stream (middle distance, towards the right); above all, at the spot where the crosses have already been hoisted into position, on a little plateau in the background (almost in a top right-hand corner). Christ, who has fallen beneath the cross (in the center of the composition), is almost lost amidst the surging and indifferent crowd. In the right foreground, brought nearer to the spectator and in larger dimensions, are the figures of the holy women, comforted by St John and grouped around the Virgin Mary, while behind, near the trunk of a tree, are other mourners. In 1565 this painting was already in the hands of Jonghelinck; Van Mander mentions two versions of the

theme, both belonging to Emperor Rudolph II. The one we are discussing here figures in the inventory of works of art in the Geistliche Schatzkammer in Vienna (1748); in 1809 it was taken to Paris as part of the booty seized by Napoleon and it remained there until 1815.

Michel maintains that the landscape in this painting is based on one of the plates in the *Moeurs et fachons de faire des Turcz* by Peter Coecke, 1533, and also on *The Procession to Calvary*, now in Antwerp, painted by Pieter Aertsen in 1552, and on the Basle

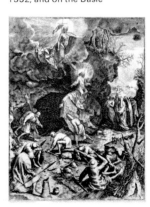

Engraving ("BRVEGEL INVEN. COCK EXCVDEBAT") reproducing 21.

Golgotha by the "Brunswick Monogrammist" — three artists who, as we have already seen, are frequently mentioned as sources of Bruegel's inspiration. Herri met de Bles also painted a version of the theme (Rome, Galleria Doria), similar in conception and containing numerous figures.

There are two interesting points for the understanding of this picture. One is that the principal personage, Christ, is practically lost in the crowd and is hard to pick out. Bruegel may have been following the

habit developed by Bosch in this respect: the image of goodness and saintliness is almost swamped by the images of worldliness and evil (cf. especially the Lisbon *Temptation of St Anthony*).

The other interesting feature is the way in which Bruegel has treated the Holy Mourners in the right foreground. Even allowing for perspective, they appear to be much larger than the other squat little figures — they are of elongated "Gothic" proportions; their rich clothes are painted in the elaborate earlier Flemish manner — a complex display of folds. And the figures themselves are treated heroically — their grief is tragic and their poses are given grace and dignity. The whole treatment of this group is deliberately in quite a different key from that of the treatment of the crowd. It could be suggested that Bruegel has set these holy people, belonging to the sacred Gospel story, apart, admitting that their sanctity entitled them to a superior beauty. But Christ he has placed on a level with the ordinary rabble, because Christ became a poor man, and offered salvation to just such ordinary souls as these.

31 🏴 ⊕ 108×83 1564 📑 ⋮

The Adoration of the Magi
London, National Gallery
Signed and dated, below on the right, BRVEGEL MDLXIIII.
In 1890 it was in a Viennese collection, and in 1900 it was purchased by Georg Roth of that city, who in 1921 sold it to the London gallery. A surprising feature is that the composition is vertical, which is contrary to the painter's normal preference for the horizontal format; it was suggested by Friedländer originally that this was because the picture was intended for an altar, which would make it an exception (the grisaille *Resurrection* is the only other vertical composition by Bruegel). The action — as in *Christ and the Woman taken in Adultery* (33) — is confined to a relatively small number of personages, who occupy all the available space, a reflection of Italian influence. Dvořák thought that Correggio was the real source of this composition based on a system of diagonals in depth; Tolnay maintains that the painter was undoubtedly influenced by Michelangelo's Bruges *Madonna*. We cannot help noticing a curious mixture of awkwardness, astonishment and irony on the faces of the personages, some of them being almost grotesque — for example, the king on the left, the bespectacled bystander on the right, and the man who is whispering something into Joseph's ear — but Dvořák points out that there is also an atmosphere of solemnity and devoutness, touched with religious emotion, such as is found in crude mystery plays staged in villages. Once again, Bosch may be the source for the ambiguous character of this *Adoration*: his Prado *Epiphany* has been interpreted as more a

picture of the evil of the world into which Christ is born, than a picture of holy awe (see *The Complete Paintings of Bosch*).

32 ⊞ ⊘ 36 × 54,5 *1564-65* ▤ ⁝
The Dormition of the Virgin
Upton House, Edgehill (National Trust)
Signed BRVEGEL, with illegible traces of a date somewhere around 1565. Formerly in Lord Lee of Fareham's Collection at Richmond, having been purchased in 1930 from a London dealer. It is known that Bruegel painted it for his friend the geographer Abraham Ortelius, who had an engraving of it made (the print is not reversed) by Philip Galle (*Sic Petri Bruegelij archetypú Philipp. Galleus imitabatur; Abrah. Ortelius sibi et amicis fieri curabat*). A version of the same subject is mentioned in the inventory of works of art left by Rubens (Antwerp, 1640) as a *blanc et noir du Vieux Breugel*, which might well be this grisaille. The attribution has given rise to some controversy. Michel (1931), though he admires the stupendous composition ("Never has the death of a holy personnage been evoked with more intensity and grandeur") and admits that it must be a genuine work, points out that it has a definitely seventeenth-century tone, in the manner of Rembrandt, which at first puzzled him, though later (1948) he withdrew any doubts he might have had. Glück and others declare that it is a genuine Bruegel, but Tolnay (1935) rejects it, maintaining that it contains an error in perspective which is not to be found in the print (the back of the chair in the foreground is not parallel to the cross-bar) and that, in his opinion, the whole execution is hesitant. Grossmann rejects Tolnay's allegations and maintains that it is a genuine original. It is an admirable nocturne, beautifully conceived; the little lights, the

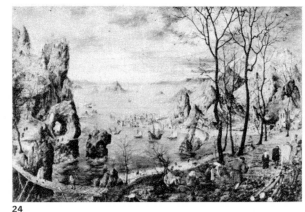

24

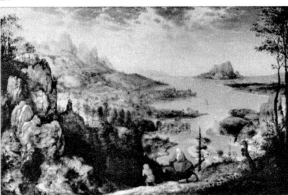

25

Rich Cooking, engraving ("*pieter brueghel inuē, 1563*"; 8¾ × 11½ inches, 22·5 × 29 cm).

fire burning on the hearth and the supernatural glow emanating from the dying woman illuminate the figures crowding round the bed and create an ensemble rich in lighting effects. According to Glück the young man asleep on the left is John the Evangelist; he is treated with the same quiet naturalism as the cat curled up in front of the fire.

33 ⊞ ⊘ 24,1 × 34 1565 ▤ ⁝
Christ and the Woman taken in Adultery
London, A. Seilern Collection
Signed and dated, in bottom left-hand corner, BRVEGEL M.D.LXV. Grossmann (BM 1952) first published this grisaille when it came to light in 1952 in the collection of Lady Hampden. Christ is shown writing, in Flemish, the words made famous by the Gospel according to St John "He who is without sin amongst you, let him cast the first stone."
L. Burchard (writing at a time when the picture was known only through copies, and the engraving) gave the early history of the painting (in German edition of Glück LB-B): it was bequeathed by Jan Bruegel, the master's son, (died 1625) to Federico Borromeo,

Lenten Fare, engraving ("*brueghel inuē 1563*"; 8¾ × 11½ inches, 22·5 × 29 cm).

Cardinal Archbishop of Milan. The Archbishop returned it to the family after having had a copy made. It was later in the collection of Pieter Stevens (like 27) of Antwerp. That the painting remained in the family and was bequeathed by Jan as a special gift may indicate that Bruegel himself liked it.

As has been remarked by almost every critic who has discussed the work, this grisaille reveals the influence of the great Italians, especially Raphael, in its composition. The background is non-existent: the picture is made up entirely of standing figures (like the London *Adoration*, 31). The simplified and beautiful draperies, the *contrapposto* stance of the woman are very much in the Italian manner. Christopher White, in his article publishing Bruegel's drawing *The Calumny of Apelles* (BM 1959), re-affirms this in the light of the newly discovered drawing.

26

Only Tolnay rejects the attribution to Bruegel, considering the picture a copy.

Among the various replicas known, we must at least mention one of outstanding quality now in the Accademia Carrara at Bergamo, painted on wood in approximately the same dimensions and inscribed, below on the left, BRVEGEL M.D.LXV.

"The Months"

Five paintings from this series, comprising some of Bruegel's best work, have survived. The whole series was formerly in the Jonghelinck Collection, and in an agreement concluded with the Antwerp city authorities it is mentioned under the title *de tweelf maander* (the twelve months) (Denucé, 1932). The Jonghelinck Collection later became the property of the city of Antwerp, and in 1594 six paintings of "months" were presented by the city to the Archduke Ernest; an inventory of works of art belonging to Archduke Leopold William, made in 1659, mentions only five of these: *Fünff grosse Stück einer Grossen, warin die Zeithen des Jahrs von Öhlfarb auf Holcz ... Original vom alten Brögel*. According to most of the critics the series (perhaps left unfinished) was intended to illustrate all twelve months of the year, but Tolnay (1934 and 1935), supported by other scholars, put forward the hypothesis that there were originally only six "pieces," each of them representing two

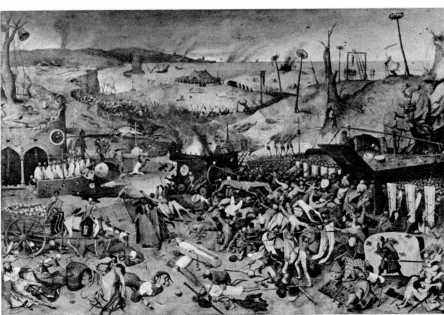

23 [Plates X-XIII]

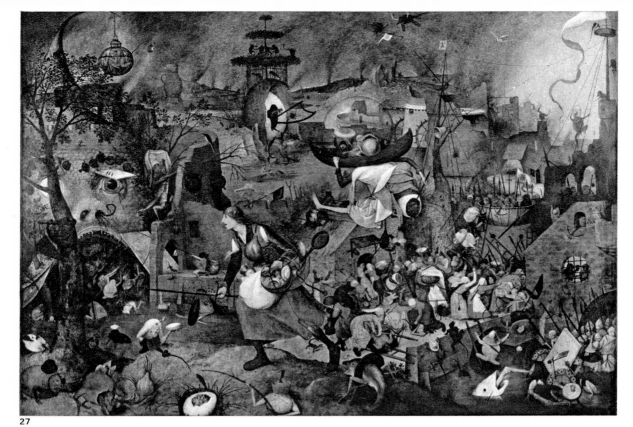

27

months. If this is so, the only missing painting would be that representing April and May. Tolnay's suggestion seems to find support in an inventory (latter half of seventeenth century) of works of art then in possession of the Brussels court, which mentions six paintings (*en geschildert van Breughel*) together representing the twelve months of the year, i.e. two months to each picture. It should, however, be noted that this inventory (published by De Maeyer, *Albrecht en Isabella en de Schilderkunst*, 1955) states that these "Months" were then in Brussels, whereas they would appear to have already gone to Vienna, unless the works mentioned in the inventory were copies. Grossmann does not concur with Tolnay's hypothesis. He points out that of the sixteen paintings by Bruegel in Jonghelinck's Collection, only *The Tower of Babel, The Procession to Calvary* and *The Twelve Months* are specified, leaving eight unmentioned, if

the "two-months" theory is adopted. He also considers there are enough analogies with the previous "one-month" tradition, e.g. calendars and breviaries, to justify a similar classification to Bruegel's series.

Dvořák was the first to appreciate the deep significance of these stupendous paintings, in which the characteristics of different seasons, together with the things and human types represented, provide an admirable panorama of life. These are not imaginary, cartographic landscapes reminding us of fairytales, but calm or turbulent scenes set beneath clear or stormy skies; they are not filled with learned, astrological allusions, but constitute a kind of rustic calendar, depicting the labors of men alone with the soil. They have a deeply felt poetry which is entirely Bruegel's own. In short, despite certain reminiscences of Flemish Books of Hours and of the numerous prints made for calendars, and despite the fact

that they are "composite" landscapes (features typical of the Low Countries are juxtaposed with reminiscences of the Alps), they are entirely original works of art, with the greatest truth to life.

34 118×163 1565

A. The Dark (or Cloudy) Day, or **The Gloomy Day** Vienna, Kunsthistorisches Museum Signed and dated, below on the left, BRVEGEL MDLXV.

This painting is probably the first of the series because at the time the New Year was in March, not January. For discussion on this point see especially Novotny and Glück. Tolnay, however, thinks that the series begins with E, *The Hunters in the Snow*. Of the numerous opinions as to which month(s) is shown, we will confine ourselves to a few examples. Tolnay thinks that February–March is depicted here, chiefly because of the activity of pollarding the willows; Glück considers

March-April to be correct. Grossmann thinks February is shown, Genaille does not commit himself to specific months (and his approach may be the right one), but indicates that this is late winter, early spring.

Other details relevant to the month are: the paper crown worn by the child could be a sign of the Epiphany (January) or Carnival (February) like his lantern. The waffles too, being eaten, may refer to Carnival (see *The Battle between Carnival and Lent*). Glück, however, denies that these details belong particularly to January–February.

The stormy and almost menacing landscape is beautifully rendered; the lowering sky sheds a cold light over the stormy waters, the snow-covered mountains, the humble dwellings below and the patient labors of human beings, set against a landscape pivoting on the sparse clump of leafless trees. The state of preservation is good.

34 114×158 1565

B. Haymaking or **Reaping** Prague, Narodni Gallery Formerly bore a forged signature, below on the left, which was removed in 1931. Acquired – it is not known how – in 1864 from the collection of Princess Leopoldina Grassalkowitsch née Esterhazy; later bequeathed to Prince Lobkowitz von Raudnitz, and is now on loan to the National Gallery in Prague. Tolnay argues for June–July, Glück for May–June, Grossmann for July. The limpid atmosphere and the gay colors form a striking contrast to those of the preceding picture. Against the background of a tranquil landscape, the foreground offers a diverging rhythm of basket-carrying peasants passing in front of a shrine containing a statue of the Virgin and walking towards the right, while three young women carrying rakes are walking in the opposite direction towards a peasant who is diligently sharpening his scythe. The painting reveals the same deep understanding of nature and the same treatment of light and color that we find in the other pictures of this series, to which all critics agree that it belongs; they also agree that it should be dated 1565.

Rubens, who much admired Bruegel, seems to have borrowed the theme of the three young peasant women in his picture *The Return from the Fields* (Florence, Pitti Palace).

34 118×163 1565

C. The Harvest New York, Metropolitan Museum (Rogers) Signed and dated, below on the right, BRVEGEL [MD]LXV. It seems certain that this work was removed from the Belvedere in Vienna during the Napoleonic wars (1809) and taken to Paris. It did not reappear until 1910, when a Parisian named Jean Doucet sold it to P.–J. Cels of Brussels, who resold it in 1912 to the Metropolitan as a genuine Bruegel. Tolnay makes it August–September, Glück and Delevoy July–August,

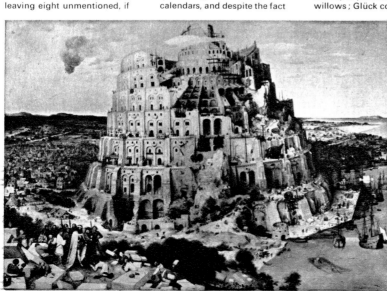

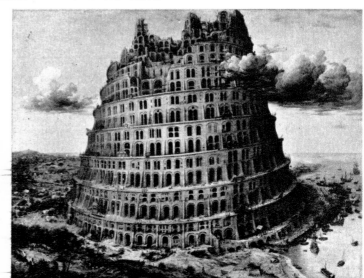

Grossmann August. Some writers e.g. Sir Martin Conway *The Van Eycks and their Followers* (London 1921) claim to identify the landscape as being on the shores of Lake Geneva, which the painter might have seen on his way to or from Italy. The picture is dominated by the golden glory of the harvest; the women binding the sheaves or gleaning might almost be anticipations of Van Gogh; the rhythm created by the harvesters is found again three years later (on an almost heroic, Michelangelesque scale) in a drawing now in Hamburg, and the man sleeping with his legs apart while his companions are eating and drinking is a forerunner of the man of letters taking a nap in *The Land of Cockaigne* (47) painted two years later.

34 117×162 1565

E. Hunters in the Snow
Vienna, Kunsthistorisches Museum
Signed and dated, below in the center, BRVEGEL M.D.LXV. This work, mentioned by De Mechel (CV, 1784), has always been in Vienna, where until the

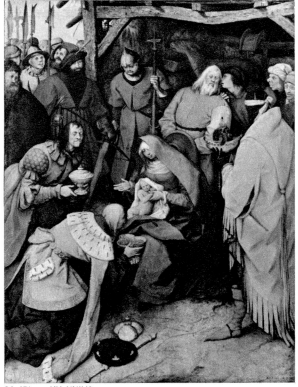

31 [Plates XX-XXIV]

34 117×159 1565

D. The Return of the Herd
Vienna, Kunsthistorisches Museum
Signed and dated, below on the left, BRVEGEL MDLXV. Tolnay thinks this picture depicts October–November; Glück, September–October, Grossmann, either October or November A. Haberlandt (in *Beiträge zur Volkskunde Tirols, Festschrift für H. Wopfner*, II, Innsbruck, 1948) points out that in the Tyrol (where he believes this picture is set) the cows are driven home on 16 October. Light brown and bluish greens are used to convey the autumnal tints, nature discolored by the first cold days and the trees already stripped of their leaves, in a setting which Hulin de Loo

thought reminiscent of the Alps. The rhythm of this composition, rising slowly towards the left, is unusual for Bruegel, who generally preferred descending rhythms. Dvořák points out that this rhythm extends beyond the front edge of the foreground towards the spectator, who thus becomes a participant in the scene portrayed, as he does in *The Harvest* and the other pictures of this series. Although Jedlicka thinks that the state of preservation is good, this does not seem to be the case, and Michel says that it is "a first-class-work, but unfortunately in a bad state."

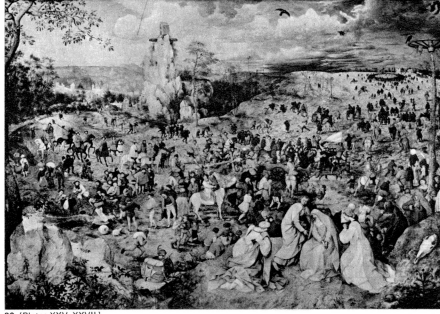

30 [Plates XXV-XXVII]

ready to singe the pig (pig-killing is one of the traditional winter activities and is often shown in calendar-miniatures, normally for December), and the dark shapes of the dogs and the men stand out starkly against the snow to the lower right border with its little figures on the ice. "Never has the poetry of a Northern landscape been expressed with such intensity, not without majesty in its oppressive sadness; here things are expressed with a grandiose clarity, without any trace of nebulous sentimentality, without exaggerated complications — a rare event in Nothern European painting" (Michel). The state of preservation is not very good according to Novotny.

35 38×56 1565

Winter Landscape with Skaters and Birdtrap
Brussels, F. Delporte Collection
Signed and dated, in the lower right-hand corner, BRVEGEL M.D.LXV. Acquired by the present owner from the Galerie Louis Manteau, Brussels. Attempts have been made to identify the landscape as the village of Pede-Sainte-Anne in Brabant (Marlier) and to discover a moralizing tendency in the subject: in particular, the relationship between the certain death awaiting the innocent little birds on the right and the perils to which the carefree skaters on the left are exposed — the danger being represented not so much by the treacherous ice as by the vicissitudes of life (Id.). In 1927 the work was shown at the exhibition of Flemish and Belgian painting from 1300 to 1900 held at Burlington House, London, and gave rise to considerable discussion. In an article on this exhibition, Friedländer (C 1927) supported the attribution to Bruegel, which was accepted almost unanimously by other critics. Michel, who at first (1931) was inclined to disagree, eventually accepted it (AP

1948), though he remarked that, compared with "*The Months*" (34), dating from the same period, it is painted far more meticulously ("*petitement*"). It is certainly true that this work inaugurated the intimate genre of "*scenes*," with an emphasis on tone-values rather than "local" color. It is probably because of this novel feature that it was copied or imitated more than any other work by Bruegel, especially by Pieter the Younger. One of these, signed and dated 1564, was published by Shipp (A 1954): it was found in the collection of A. Hassici in London, and it was considered by Shipp to be the

original of our painting. The latter is not considered entirely autograph by Grossmann. It was exhibited in the *Siècle de Bruegel* exhibition at Brussels, 1963.

36 77×88 *1565*

The Hireling Shepherd
Philadelphia, Museum of Art (John G. Johnson)
In a spacious heathland a wolf is seen devouring a sheep from the flock he has attacked, while the shepherd is running away — an allusion to the words of the Gospel (St John, X.13): "The hireling fleeth, because he is an hireling, and careth not for the sheep." The work appeared

32

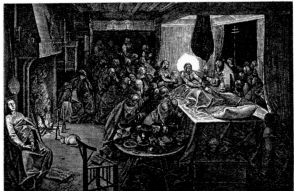

Dormition of the Virgin, *engraving by Ph. Galle (12¼ × 16½ inches, 31 × 42 cm) after 32, commissioned by Ortelius.*

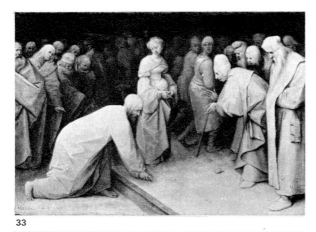

33

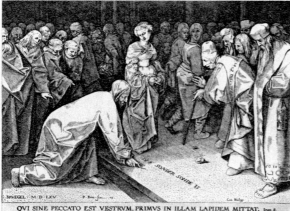

Christ and the Woman taken in Adultery, *etching by P.Perret* ("*BRVEGEL. M.D.LXV*"; 10½ × 13½ inches, 26·9 × 34·5 cm).

at the sale of the Pallavicino Grimaldi Collection in Rome (1899); later it passed from the Leo Nardus Collection in Paris to the Johnson Collection. Several versions of this picture seem to be recorded in old inventories: in 1621 there is listed in the Prague Kunst-und Schatzkammer *830 Ein schaffhirt von Peter Prugeln, alten.* (original), as well as the following item *1130 Ein Hirt mit wasserfarben vom alten Prügl.* The work is mentioned in the imperial inventories (Vienna 1621), described in one version as *Ein hirt mit wasserfarben vom alten Prügl* (a shepherd in tempera by Bruegel the Elder) and in another as *Ein bothe* (a messenger), while in the 1647–8 inventory it figures as *Ein Hürdt* (a shepherd). The 1655 inventory of the Arundel Collection mentions *Un pastor fugendo, BREUGEL, in aquazzo* (cf. BM XIX, 1911 p. 284). There exists an engraving by Philip Galle (1561) after a drawing by our master, in which the theme of the "hireling shepherd" is treated in greater detail. The question of the authenticity of the Philadelphia painting remains open; it is accepted by Glück and Hulin de Loo, (with the necessary reservations concerning the overpaint) but others, for example Van Puyvelde, Jedlicka, Michel, Grossmann and Tolnay, consider it to be a copy, which Puyvelde and Tolnay attribute to Marten van Cleve. A number of other versions exist; one of

these (on wood, 29½ × 41 inches, 75 × 104 cm) is in the Béague Collection at Méry-sur Seine and is considered by Tolnay to be better than the work we are discussing. The painting is certainly based on a fine conception of Bruegel's: the effect produced by the desolate, receding landscape as setting for the burly figure of the shepherd seems to be fully worthy of his happy imagination. The Philadelphia painting appears to have been extensively repainted.

37 🏁 ⊗ 40×54,5 *1565*? 🗎 ⦂
The Good Shepherd
Brussels, Kronacker Collection
The possibility that a pendant to the preceding picture existed was suggested by Glück (with whom Friedländer and other critics agree), owing to the fact that at least two paintings are known in which the shepherd is allowing himself to be savaged by the wolf in order that his sheep may escape. Of these, one is the work we are discussing (formerly in the University Museum, Princeton) while the other is known to have once been in the Pollack Collection, Vienna; both of them are attributed by most critics to Pieter the Younger, but Glück detects – especially in the landscape – a conception far more vigorous than we normally find in the works of this painter. The present owner of the former of these two pictures informs us that Grossmann and other experts

say that it was executed by the elder Bruegel himself.

38 ⊞ ⊗ 116×164,5 1566 🗎 ⦂
The Numbering of the People at Bethlehem or **The Payment of the Tax**
Brussels, Musées Royaux des Beaux-Arts
Signed and dated, below on the right, BRVEGEL 1566. Wautens (Catalogue of the Musées Royaux des Beaux-Arts Brussels, 1908) was the first to suggest that this might be *The Flight into Egypt* by Bruegel mentioned in the Besançon inventory of the property of Cardinal Granvelle (Castan MSED 1867) and later in the Rubens inventory (Antwerp, 1640), but it seems hard to believe that the compilers of old catalogue could have made such an error in interpreting the subject. Nothing is known of the work we are discussing until the nineteenth century, when it

belonged to a certain Van Colen de Bouchout of Antwerp; later it passed to the Huybrechts Collection in that city before being sold in 1902 to the museum. Both the titles given in the heading would fit this composition; the first as an allusion to the passage in the Gospels (Luke, II, 1–5) describing the census ordered by Augustus, which was the reason why Joseph and the pregnant Virgin Mary (seen in the foreground, towards the right) went to Bethlehem; the second could be an allusion to the fact that government officials, seen on the left, sitting in the tavern "of the green laurel-wreath" took advantage of the census to collect taxes. The theme is an unusual one, and Hulin de Loo may well have been right when he suggested that it might have been derived from a Nativity play. What strikes the eye is the portrayal of everyday life in a Netherlandish village, in

winter, at the moment when the opaque red disc of the sun is setting in a snow-laden sky. Some of the inhabitants are slaughtering a pig; others are skating, a woman is sweeping away the snow and some carpenters are busy erecting the framework of a shed. Nobody pays the slightest attention to Joseph who, being a carpenter, is carrying an enormous saw on his shoulder, or to Mary, sitting on her donkey between two carts. Some of the elements are borrowed from the traditional miniatures illustrating calendars, e.g. the slaughtering of the pig and the setting sun, the latter also reminding us of Japanese prints (Grossmann). Attempts have also been made to establish a hidden link between the ruined castle in the right background, said to have been inspired by the ramparts and towers of Amsterdam, which Bruegel must have seen if he visited the city in 1562 (Id.),

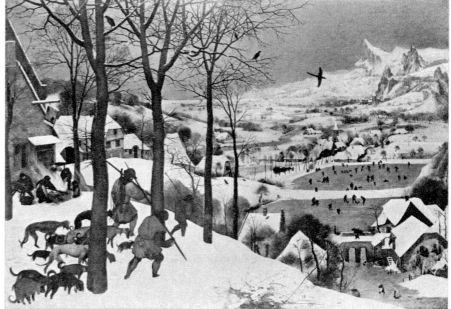

34 E [Plates XXVIII-XXXI]

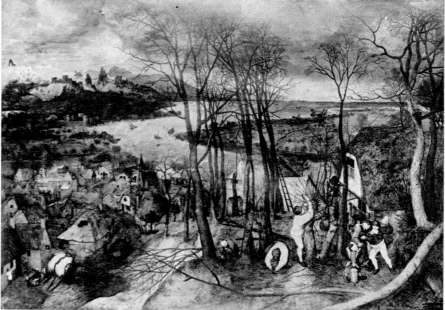

34 A [Plates XXXII-XXXV]

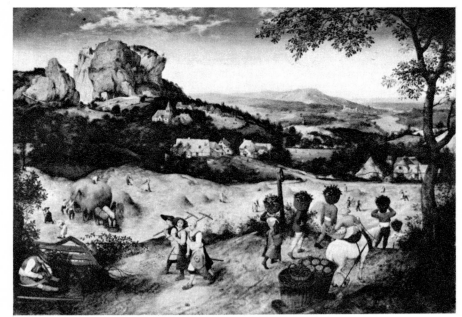

34 B

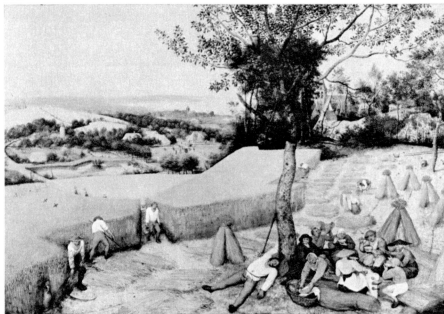

34 C [Plates XXXVI-XXXVII]

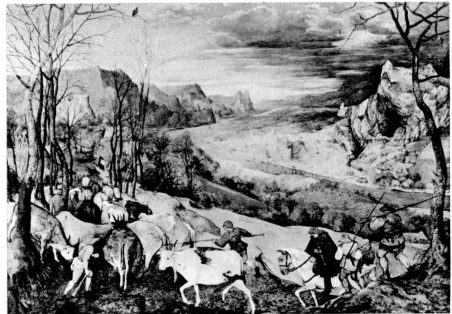

34 D [Plate XXXVIII]

here symbolizing the decaying edifice of paganism, and the building under construction, symbolizing the rise of Christianity (Marlier, in *Le Siècle de Bruegel*, p. 72, 1963). Up until now biblical and evangelical events were nearly always interpreted in painting as solemn ceremonies, the figures standing in majestic isolation and virtually timeless ; a few decades later Caravaggio was depicting the protagonists of the sacred story as contemporaries, treating the events as though they had only just happened, but invariably isolating them in the darkness of a restricted setting, illuminated by magical rays of light. For Bruegel, however, creatures and episodes are immersed in the bustle of everyday life, set in the midst of an indifferent crowd of anonymous men and women who play no part in the story.

Hulin de Loo and Tolnay think that the work we are discussing is a pendant to 39, but Glück does not think there are sufficient grounds for this theory. The surface has deteriorated in the parts covered with snow, and the same can be said of the roofs and the sky ; the whites have obviously failed to withstand the ravages of time. Numerous copies of this work are known, but these were painted by Pieter the Younger. Of outstanding quality is one dated 1610 in the Brussels museum, and there are others in the Mayer van den Bergh museum at Antwerp and in the museums of Caen and Lille (the last-named painted on canvas).

The Massacre of the Innocents Vienna, Kunsthistorisches Museum Below, on the right, are the remains of a signature, BRVEG . . . Van Mander tells us that in his day it was, as he believed (''als ick acht''), in the Emperor Rudolph II's Collection at Prague ; in 1748 it was listed as being in the Geistliche Schatzkammer. It is usually dated 1565–6, but Tolnay believes that it dates from 1563–4, while other writers, including Delevoy, place it as late as 1567, since they think that it contains allusions to the violent reprisals carried out by the Duke of Alba in that year ; the latest contribution to this theory is an article by Stanley Fermer ''P. Bruegel and the Duke of Alba'' *Renaissance News*, XIX, no. 3. Autumn 1966. Alba is identified with the old bearded man in black, on a white horse in the middle-distance. Glück had remarked on this possible identification some time before (see LBB p. 78). Ever since Hymans (1891) there have been doubts as to the authenticity of the picture; few scholars accept it without reservations, among these few being Hulin de Loo (who believed that it is a pendant to *The Numbering* [38], painted about the same time) and Glück, to whom we owe the first vigorous defence of its genuineness. He argues that the defects which caused doubts are due to extensive restoration of the seventeenth and

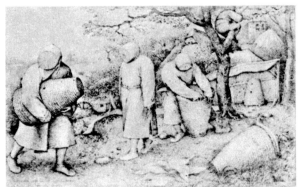

Beekeepers, *pen-drawing* (''BRVEGEL MDLXV [VII or VIII]'' ; 8 × 12¼ inches, 20·3 × 30·9 cm; Berlin, Kupferstichkabinett).

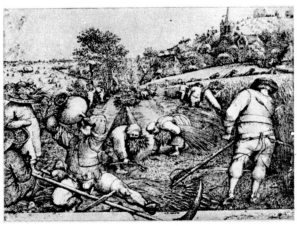

Summer, *pen-drawing* (''BRVEGEL MDLXIII'' ; 8¾ × 11¼ inches, 22 × 28·5 cm; Hamburg, Kunsthalle), *iconographically related to 34 C.*

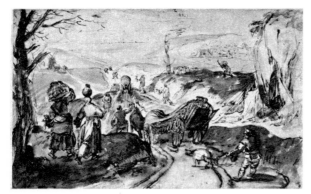

Pen and water-color drawing, seventeenth-century Flemish school (8¼ × 12¾ inches, 21 × 32·5 cm; Munich, Staatliche Graphische Sammlung), possibly having some connection with the hypothetical 64.

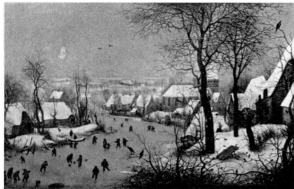

35 [Plate XXXIX]

36

37

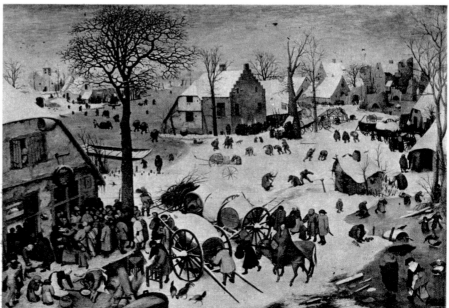

38 [Plates XL-XLIII]

M.D.LXV. Bequeathed to the museum by Count Ivan Bathyány. Grouped around the Baptist (at the back, almost in the center) is a throng of astonished listeners, who seem to be dazzled and overawed. In the foreground, a number of picturesque figures are standing, some of them in exotic costumes – the attention of these foreground figures is not rapt by the saint. According to Glück, the man who is having his palm read by a gipsy might be the merchant Franckert, a friend of the painter's, while Tolnay suggests that the bearded man visible between two others with their backs turned to the spectator might be Bruegel himself. In the distance, towards the right, is a landscape which has not been identified, despite the fact that it contains Flemish elements, although intended to represent the banks of the Jordan. Where the left-hand bank juts out into the river there is a miniscule representation of the Baptism of Christ (Jedlicka), a traditional detail in the iconography of this subject. Glück points out that Bruegel has probably represented a contemporary scene: an open-air sermon preached by one of the religious dissidents of the time. People of all classes used to flock to these talks.

Grossmann points out that John the Baptist is specifically characterized as the Forerunner. He is gesturing at Christ who stands in the crowd. Grossmann also draws attention to the fact that fortune-telling was forbidden in the Netherlands in the sixteenth century, and was especially forbidden by Calvin. The gentleman in black may then be rejecting the preaching (to which he is not listening); or perhaps a prohibition is understood as applying to the whole scene.

Bruegel may have had a memory of Cock's *Moeurs et Faschons . . . des Turcz* for his elegant Orientals. Note too the vacant faces of the listeners in the crowd: their round eye-sockets and gaping mouths are very close to those of *The Beggars* and *The Blind leading the Blind*. According to Tolnay the composition is based on a work by the "Brunswick Monogrammist," of which a copy is now in the Wicar Museum at Lille. The authenticity of the work we are discussing is doubted by Hulin de Loo. Van Puyvelde includes in his catalogue another version (on wood, 43 × 71½ inches, 109·5 × 182·5 cm), signed and dated P. BRVEGEL 1565, which is now in the Vittorio Duca Collection in Milan, maintaining that it is of better

quality than the Budapest painting. Various copies executed by the master's sons are now in the Alte Pinakothek, Munich, in the Liechtenstein Gallery at Vaduz, and the Koninklijk Museum at Antwerp.

41 119×157 1566

Wedding Dance in the Open Air Detroit, Institute of Arts Below, on the right, is the date, MDLXVI. Purchased on the London art market in 1930, at which time it was in a poor state of preservation, owing to flaking and repainting; in 1942 it was cleaned, and the colors are now so thin that the drawn outlines show through. Valentiner (1930) was the first to draw attention to it and to claim that it is a genuine Bruegel; Tolnay and Jedlicka believe that it is a copy, but Friedländer discerns in it an anticipation of Rubens' *Kermis*, and thinks that this is the original, while Genaille deems it worthy of the master, to whom it is also attributed by Denis and Grossmann ("the quality of the brushwork and details in the composition which are not to be found in the copies, reveal the hand of Bruegel"). The painting has recently been fully discussed by Ernst Scheyer in AQ 1965, p. 167 ff. He pronounces enthusiastically in favor of its authenticity and Grossmann observes that there no longer seem to be grounds for doubt on this point. Hulin de Loo and Michel drew attention to a panel-painting of the same subject (46 × 65¾ inches, 117 × 167 cm) acquired in 1929 by the Koninklijk Museum in Antwerp at the Spiridon sale in Paris, a work which, according to these two scholars, is authentic, at least so far as the lower portion is concerned. The landscape – and, in general, the whole of the upper portion – differs considerably from that which we see in the Detroit painting. The detail of the table at which the mother and mother-in-law and bride sit, with a piece of

eighteenth centuries, since the picture is recorded as broken in two as early as 1619 (Vienna inventory quoted in Glück LBB p. 76). Jedlicka thinks that it is a copy by Pieter the Younger; Tolnay points out a number of defects "faulty drawing of the human figures; pale, dull coloring", but nevertheless includes it among the genuine works, as does Michel, after first drawing attention to the absence of some of the master's outstanding characteristics and admitting that he shares Friedländer's doubts. More recently Genaille declares that it is a very fine original work dating from 1556, and Van Puyvelde also includes it in his catalogue. Grossmann (1958) maintains that, among the various copies extant, the version at Hampton Court (42½ × 61 inches, 109 × 155 cm), despite the poor state of preservation, "is better, in the portions left intact . . . than any other version known to us, not

excluding the painting in Vienna"; and he also declares that it is authentic, and that the Vienna version is a workshop product to parts of which the master added a few touches. His authority for this claim is a comparison of the X-ray examinations of each picture. He also points out that the Hampton Court picture came originally from Queen Christina's Collection, and before that was (probably?) in the Imperial Collection at Prague – thus perhaps identical with Van Mander's picture. Van Puyvelde (1962) mentions another version (45¼ × 64¾ inches, 115 × 164·5 cm) in the collection of Baron Descamps, Brussels, which according to him is likewise authentic.

40 95×160,5 1565

John the Baptist preaching Budapest, Szépművészeti Muzeum Signed and dated BRVEGEL

cloth draped up behind, is omitted. The bride in fact, in the Detroit painting, has left her ceremonial seat, and is dancing gaily in the crowd. She is the girl with long loose hair and a dark green dress in the middle-ground, to the left of the central tree (Scheyer has thus convincingly identified her, comparing her with Bruegel's other representations of brides darkly clad with loose hair, and he draws on contemporary costume books too). Bruegel has given a most vivid sense of life and movement to his dancers — the rhythm of the dance is strongly conveyed. Grossmann considers that Bruegel in his series of peasant feastings had a didactic purpose, to portray the sins of gluttony, lechery and wrath in particular. Here we have lechery. In the case of the Antwerp picture the landscape is probably a modern addition; at all events the picture has been much repainted (the figures towards the front, especially the two dancers and the man playing the bagpipes, also differ from similar figures in the preceding picture, not only in the shapes, but also as regards the men's codpieces, which are here smaller and unnaturally flat, whereas in the Detroit painting they are rather prominent). Michel observes that the master's aim does not seem to have been the portrayal of a surging crowd, but rather the rendering of the movements of well-defined individual figures, and that "the work lacks the triumphal grandeur of his greatest achievements." Friedländer, however, rightly maintains that the Antwerp version is a good copy of the original. Hulin de Loo dated it 1558 (on the basis of the engravings mentioned below), but Michel prefers 1565–6, which would seem a more likely date for the prototype.

Hulin de Loo also mentions a copy by Pieter the Younger (on canvas, $58\frac{1}{4} \times 76\frac{1}{4}$ inches, 148 × 194 cm) which in 1907 was in the store-rooms of the Kaiser Friedrich Museum in Berlin and which he believes to have been extended round the edges, especially at the top, the original dimensions having been $43\frac{3}{4} \times 63$ inches (111 × 160 cm), closer, that is to say, to those of the Detroit painting. Another version, on wood, is in the Musée des Beaux-Arts at Narbonne, but in this the whole subject is clumsily reversed and there are considerable variants in the landscape setting compared with the Detroit and Antwerp versions. Although we can attribute the work to Pieter the Younger's immediate circle rather than to himself, it should be noted that in its present condition the Narbonne painting is closer to the old engravings of the theme which have come down to us, in particular to one bearing the monogram of Pieter van der Heyden and the inscription P. BRVEGEL INVENT., which would seem to have been the ancestor of a whole series of other versions; moreover, since the work we

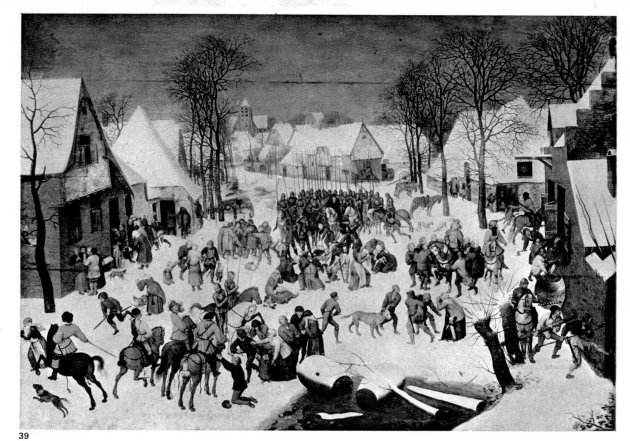

39

Another version (according to Grossmann by Bruegel's own hand) of 39 (Hampton Court, Royal Gallery).

are discussing is reversed as compared with the prints, this engraving has a better claim to be considered the most faithful reproduction of the original; nevertheless, the presence of one figure "the wrong way round" (the man drinking on the left, towards the center) suggests that it would be more prudent to refrain from expressing a definite opinion. Other copies are now in the Borchard Collection, New York (formerly in the Dorus Hermsen Collection [Tolnay]), in the Alte Pinakothek, Munich (on wood; 35 × 20 inches, 89 × 51 cm), in the Morel Collection at Ghent (1907; signed P. BREGHEL), and in the Weber Collection, Hamburg (on wood, $16\frac{1}{2} \times 22\frac{1}{4}$ inches, 42 × 56·5 cm); and one was formerly in the Urussoff Collection, Leningrad (signed P. BREVGHEL), etc.

42 🖼 🔵 $\underline{55 \times 43}$ 🗒 ⦂

Dancing Peasant
Laren (Holland),
Van Valkenburg Collection
Replica of the man dancing in the foreground (on right) of Detroit painting (41). Hulin de Loo first drew attention to it, but did not believe that it was a genuine Bruegel; Friedländer and Michel agree in principle, though the latter does not seem altogether averse to attributing it to the master's own hand. Scheyer (*op. cit.*) considers it "after Bruegel"

43 🖼 🔵 $^{77 \times 104,5}_{*1565*?}$ 🗒 ⦂

Peasants dancing in front of a Tavern
Paris, Baroness Bentinck Collection
(Netherlands Embassy)
The composition is not unlike a

detail (see p. 96) in the two engravings connected with the *St George's Kermis*. It was at one time in the Thyssen Collection, Lugano, and before that in the collection of the Vicomte d'Angers. It was exhibited at Munich in 1930; subsequently the clumsy overpainting was removed and the picture was found to be in a bad state. Friedländer attributed it to the elder Bruegel and dated it about 1565; Van Puyvelde accepts the attribution, but maintains that the work is only a fragment; Denis and Michel also agree with the attribution and the latter thinks that it might be a youthful work. Tolnay and Jedlicka definitely reject it, while Genaille believes that it is a variant of the Detroit painting (41).

Michel mentions another version (same format), which appeared on the Berlin art

market and was purchased by Paul Cassirer of that city. Michel also draws attention to a partial replica (limited to the doorway of the tavern), which was acquired by the Delaroff Gallery, Gatsc'ina (Leningrad), from the Salomonsohns Collection, Berlin, but he states that it is not a genuine Bruegel.

44 🖼 🔵 $^{61,5 \times 114,5}_{*1566*}$ 🗒 ⦂

Wedding Procession
Brussels, Musée Municipal
The procession, on its way to the church which can be seen through the trees, on the left, is divided into two groups, each led by a piper; in the foreground, towards the right, is the group of women accompanying the bride — recognizable by the little crown on her head, by her modest bearing and by the presence of two pages, one on either side of her; further back is a group of men headed by the bridegroom (between the two tree-trunks on the left), who also has a little crown on his head; the dignity of the procession is somewhat impaired by the presence of curious onlookers, gossiping women and men relieving themselves. The landscape is dominated by a windmill; on the right is the village from which the procession started, and we may accept Glück's statement that the covered carts standing nearby are those in which the guests arrived. In the sky we see one of those showers so frequent in Flanders during the summer months.

The first mention of this painting dates from 1830, when it entered the Northwick Park Collection, being described in the 1864 catalogue as by Pieter Bruegel the Elder and Van Scorel; in May 1965 it was sold at Christie's to the Brussels dealer A. Finck. During its long stay at Northwick Park, the critics had few opportunities to

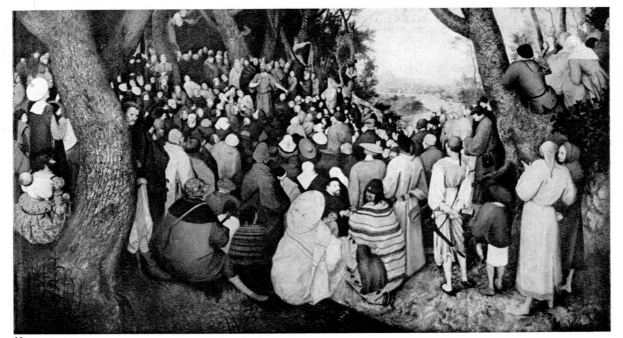

40

works of art left by the well-known French collector Eberhard Jabach, who died in 1695, it is described as follows: "Winter, with many figures; in the foreground [on the left] the three kings adoring Our Lord; snow is falling fast; a little boy [foreground, towards the right] is propelling himself across the ice on a sleigh; by the elder Bruegel." More recently, the painting belonged to Count Saurma of Schleswig, who sold it to its present owner. Some critics, in view of the uncertainty as to the date, assume that it was not painted by Bruegel himself; Tolnay, in particular, thinks that the master was commissioned to paint it, but that it was finished by others.

As has often been remarked, this is yet another of Bruegel's revolutionary snow-scenes, and yet another of his essays in

study it, but Friedlander drew attention to it in 1913–4 (ZBK); in 1916 he expressed doubts as to its authenticity, but in 1921 he changed his mind and finally, in 1937 expressed his enthusiastic admiration for the work, which he claimed was executed by Bruegel alone. Borenius (1921) accepts the attribution given in the Northwick Park catalogue, and so does Glück (1951). Tolnay, however, attributes the execution to Jan Bruegel, stressing certain affinities with the Brussels *Adoration of the Magi* (7), which according to him is by Jan. The attribution to Jan is also accepted by Grossmann (BM 1957), though, as a supporter of the authenticity of the Brussels *Adoration*, he justifies his assertion by comparing the painting with Jan's *Kermis* in Windsor Castle, signed and dated 1600. After the recent sale, the old varnish

45 ⊕ 108×156 1567

The Conversion of St Paul
Vienna, Kunsthistorisches Museum
Signed and dated, on the rock in the lower right-hand corner, BRVEGEL M.D.LXVII. A completely new interpretation of the theme. The spectator is impressed above all by the steep crags ("those most beautiful rocks," as Van Mander calls them) and the army on the march, ranging from the tiny soldiers on the left seen emerging from a ravine, gradually increasing in size and culminating in the imposing horsemen on the right, while other warriors are disappearing into the distance as they enter a gorge. As so often, the principal event can scarcely be discerned. St Paul's fall to the ground is a tiny distant episode. There is no

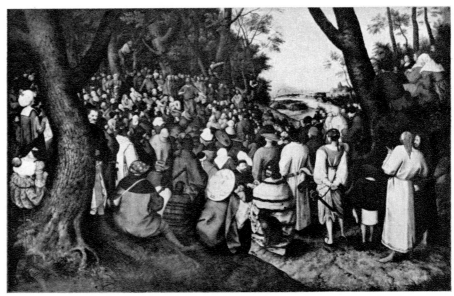

Painted version (on wood, 43 × 72 inches, 109·5 × 182·5 cm; Milan, Vittorio Duca Collection) of 40, included by Van Puyvelde in his catalogue of Bruegel's works.

Version by Pieter Bruegel the Younger of the hypothetical 65 (Douai, Musée des Beaux-Arts).

was removed, revealing a surface untouched by restoration but containing the numerous *pentimenti* so often found in original works. The painting in its present state is much admired by Genaille (private communication), who dates it about 1567; by Marlier, who prefers 1568, and by Denis who – reaffirming his previous opinion (1952) – like Friedländer, discerns points of contact with other works painted about 1565. A replica (29¼ × 48¾ inches, 74 × 124 cm), signed by Pieter the Younger and dated 1630, is in the Koninklijk Museum, Antwerp.

apparition of Christ, nor terrified men and horses. The chief figures, the mounted men in the foreground, whose faces we cannot see (another frequent motif with Bruegel) are given monumental, static poses. As in *The Suicide of Saul* (19), the landscape setting is probably based on reminiscences of the Alps, such as we see in many drawings by Bruegel, especially one now in the Louvre (No. 19,737) probably made during his journey to Italy (Denis); another suggestion is that the contrast between the majesty of the precipitous mountains and the tiny human figures might

have been inspired by Titian's lost *Battle of Cadore* (Grossmann); while other critics (e.g. Glück, LBB, Marlier, SB) believe that the work may be an allusion to the passage of the Alps by the Duke of Alba's armies in 1567, on their way from Lombardy through Savoy to suppress the rising of the iconoclasts (Tolnay and Grossmann reject this hypothesis and the latter interprets this painting as a symbolical rendering of the sufferings of men as they strive to achieve real faith).

It is known that the work was acquired in 1594 by Archduke Ernest, at that time governor of the Netherlands; Van Mander lists it among the works belonging to Emperor Rudolph II; it does not appear in the seventeenth-century inventories. but it figures in those relating to the Hradschin in Prague (1718 and 1737). It was for some time in the Vienna Belvedere, but was then taken back to Prague and was subsequently transferred to the gallery in the Austrian capital. At the *Siècle de Bruegel* exhibition (Brussels, 1963) a replica of this painting was shown (on

canvas, 46¾ × 62¼ inches, 119 × 158 cm), containing a few variants, which later came on to the Brussels art market and is now in a private collection; it was probably painted by Pieter the Younger.

46 ⊕ 35×55 1567?

The Adoration of the Magi in the Snow
Winterthur, Reinhart Collection
Below, on the left, are traces of an inscription which Glück and other critics read as M.D. LXVII BRVEGEL; Tolnay thinks the date should be read as M.D.LXIII. In an inventory of the

rendering sacred subjects in realistic, "ordinary" terms. The fall of snow was depicted in medieval calendars, but otherwise Bruegel was the innovator of this henceforth popular theme (Grossmann). The Adoration is taking place in the extreme left-hand corner; once again, it is not the "real" theme and the picture (cf. *The Carrying of the Cross* and *The Conversion of St Paul*). The theme is the depiction of peasant life in a little Flemish village in midwinter. The village is very like those of *The Numbering* and *The Massacre of the Innocents*.

47 ⊕ 52×78 1567

The Land of Cockaigne or **The Fools' Paradise**
Munich, Alte Pinakothek
Signed and dated, below on the left, M.D.L.XVII BRVEGEL. The painting represents the "*Luilekkerland*" of Flemish popular legends: "*lui*" means lazy, and "*lekker*" means greedy. According to the legend, (which in one form or another, crops up in the folk-lore of almost every country in Europe) *Luilekkerland* could be reached by digging a

42

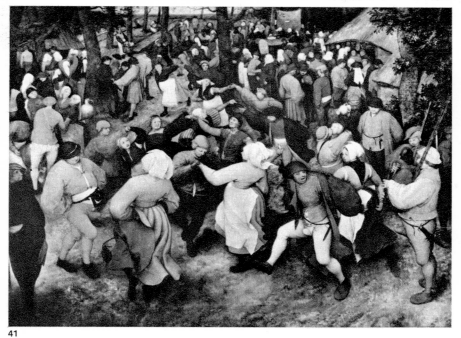

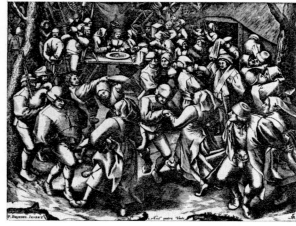

Engraving by Pieter van der Heyden, whose monogram can be seen in the bottom right-hand corner, published by Cock ("P. BRVEGEL INVENT": 14¾ × 16¾ inches, 37·5 × 42·3 cm); related to 41.

41

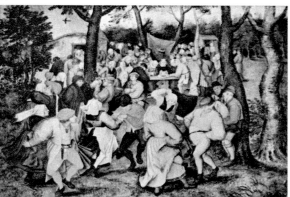

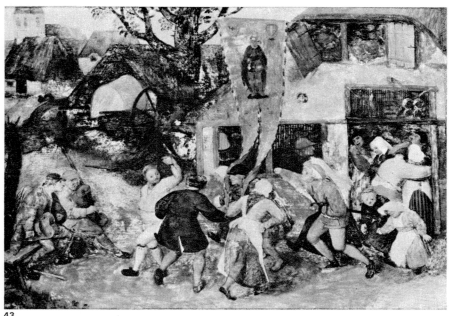

43

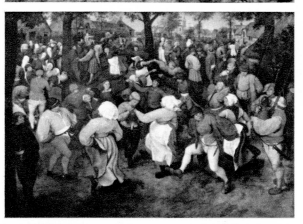

tunnel under a mountain of buckwheat porridge, and in fact, in the right background, we see a successful digger emerging into the promised land, where a tree is waiting to deposit him gently on the ground. It was at this moment that the existence of an idle glutton began, which a Flemish proverb defined as the height of illogicality; a number of dry round cakes await him, stuck together in such a way that they look like a cactus; beside them is the "roast pig arriving with a knife in his belly," as in the legend, and, on a white napkin, a plate with a roast fowl alighting on it; in the foreground a boiled egg, already

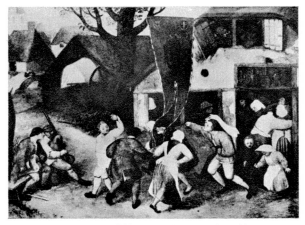

43, as it appeared before 1930, prior to the restoration which removed the clumsy overpaintings. (Below, left) Replica of part of the same composition (formerly [?] in a private collection in Berlin).

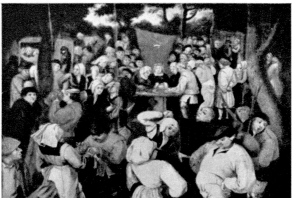

(Above, from top) Three painted versions of 41; the top two are, respectively, in the Musée des Beaux-Arts at Narbonne (attributed to Pieter the Younger and containing numerous variants in the landscape setting) and in the Koninklijk Museum, Antwerp; the third (after A. Venturi had certified that it was a genuine Bruegel) figured in the Costantini sale (Florence, 1952); *location unknown.*

opened by a spoon or knife, runs up to the cleric; "the houses are covered with tarts" (one can be seen on the left) and "the hedges are made of sausages" (as they are in the pleasant little meadow in the background); while the trees (like the one in the center have platforms laden with food round their trunks. To the nobleman in armor, "into

whose mouth a roast pigeon is falling," the artist, with ironical deference, gives a roof (the one covered with tarts), but the soldier — daringly foreshortened — who has thrown away his arms, the peasant, who looks like a fat seal and is sleeping on his flail, and the cleric, who can afford to neglect his breviary, have to be content with the

107

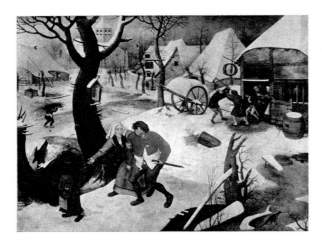

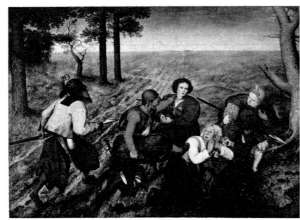

(From top) Painted versions of hypothetical 66 (formerly [?] Antwerp, Grisar Collection) and 67 (Stockholm, University).

shade of a tree, the three "estates" being thus united in a very sensual and – artistically speaking – delightful state of bliss. When we remember that similar eggs are found in the works of Bosch, where they are probably allusions to alchemy or black magic or even to Satan himself (if, in our picture, it is a knife which is stuck into the egg, it might be an allusion to the "philosopher's fire" or the male sex), it is not surprising that certain critics should have tried to interpret this picture in an esoteric manner. For example, we are told that it symbolizes a yearning for Utopia or a promised land of fleshly delights – despite the fact the picture was painted in the very same year in which the Duke of Alba began his savage reprisals; hence the moralistic deduction that "the painter may have wished to satirize his fellow-countrymen, who were too ready to indulge in the pleasures of the table and idleness, and to show that – as coming events were to prove – an excessive preoccupation with physical wellbeing would undermine their moral courage and make them ready to accept oppression and tyranny" (L. Maeterlinck, 1907).

The first mention of the work occurs in the inventories of the Hradschin in Prague for the years 1621 and 1647–8 (Drei schlaffende bauern im schlaraffenlandt von dem alten Prügl); during the sack of the city by the Swedes it was stolen, apparently by a private individual, since it does not figure in inventories of Queen Christina's Collection. The manner of its rediscovery makes a curious story. A Dr Henri Rossier of Vevey bought it for five francs; the picture had been much overpainted, but after the overpainting had been removed, a Parisian expert valued it at several hundred francs. In 1901, however, Rossier sold it to Richard von Kaufmann, a Berlin collector, for ten thousand francs, and when it was auctioned after the latter's death in 1917, the Munich gallery paid 220,000 marks for it. On the whole the state of preservation is good, except for the nobleman under the roof on the left, where, owing to excessively vigorous cleaning, the roast pigeon flying into his mouth can hardly be seen.

48 ⊞ ⊕ 86×85 1568? ▤ ⋮

The Misanthrope or The Perfidy of the World
Naples, Gallerie Nazionali di Capodimonte
Signed BRUEGEL and dated 1568 – Hulin de Loo and Friedländer had read 1565, and Michel adopted that date. Tolnay, Glück, Genaille and Grossmann prefer 1568, chiefly because the later part of his career Bruegel increasingly chose compositions containing few personages. The distich beneath the figures – which Hulin de Loo believes was written by Bruegel himself – reads: Om dat de

Werelt is soe ongetru/Daer om gha ic in den ru (Because the world is so untrustworthy I am wearing mourning), which explains the first and more usual title of the picture, though it does not explain why the misanthrope, having renounced the world and leading a life of hardship (the sacrifices he has to make are symbolized by the thorns on the path in front of him), should have at his belt a fat purse which awakens the interest of the thief. The latter is enclosed in a glass globe, said to symbolize the world. Compare the similar figure in the foreground of The Proverbs (16). According to Jedlicka the picture is a bitter criticism of ecclesiastical greed, but Hulin de Loo points out that the protagonist is not wearing clerical garb, but clothing of the type worn by the mourners (the pleurants) whom we see on Late Gothic tombs. Moreover, Michel believes that the figure of the pickpocket was added later, and when we compare the execution with that of the beautiful landscape – flat and typically Flemish, with a shepherd, his flock and a windmill – this seems a plausible hypothesis (despite the conflicting evidence provided by the print reproduced on p. 110). The picture used to be considered a depiction of heresy and, fifty years ago, its title in the museum catalogue was "L'Eresia."

We do not know where the painting originally came from, but in the early seventeenth century it belonged to Count Masi of Parma; in 1611 it was confiscated by the Farnese family and figures in an inventory (1680) of works in the Palazzo del Giardino in Parma; it was sent to Naples in 1734 together with other works of the Farnese Collection. Hulin de Loo remarked that Breugel chose the round format because he had always used it when illustrating proverbs (cf. 16). On this point compare the tondos by Bosch, nos. 1, 2 and 25 in The Complete Paintings of Bosch.

49 ⊞ ⊕ 86×154 1568 ▤ ⋮

The Parable of the Blind Men
Naples, Gallerie Nazionali di Capodimonte
Signed and dated, below on the left, BRVEGEL M.D.LX.VIII. The inspiration came from the Gospels (Matthew, XV. 14, Luke, VI. 39), "And if the blind lead the blind, both shall fall into the ditch," words which are more literally interpreted in a drawing (1562) by the master now in Berlin, in which there are only two blind men. The episode is also painted by Bruegel as no. 18 of The Proverbs (16), in the far background. The history of the painting is the same as that of The Misanthrope (48) and the technical details are also similar (a Mantuan inventory mentions a work that might appear to be the one we are discussing, but speaks of four men instead of six)

This is one of Bruegel's finest and most impressive

works. The beauty of the coloring, notably of the luminous landscape, and the delicacy of the tones of the mauves, grays, blues, and whites of the figures belong to the very highest art (despite the poor condition of the paint, tempera). And as well as having these painterly qualities, the picture surely gives us one of our deepest insights into the nature of Bruegel's thought. Most scholars have appreciated this point: each has given what seems to him the true meaning of the picture. For Dvořák it was a case of the indifference of nature, the world, to individual human calamity. Tolnay takes this further, arguing that the blind men are caught on an

outcrop of earth that had detached itself from the ground and is about to crumble into the "abyss" (as he describes the ditch of the parable): hence, man is at the mercy of the inflexible laws of Nature.

Glück and Grossmann think that Bruegel had wished to show in the blind men those who are blind to the true faith (symbolized in the firm structure of the church on the horizon), and who stagger to perdition. Genaille rejects these interpretations, and speaks of a more general disenchantment with man and his blind folly, contrasted with the serene harmony of nature. Certainly Bruegel seems to have pointed up more clearly than ever before

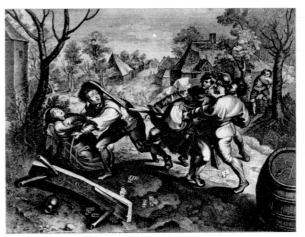

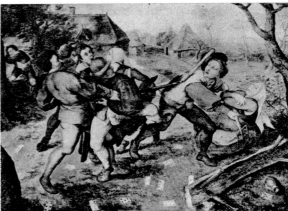

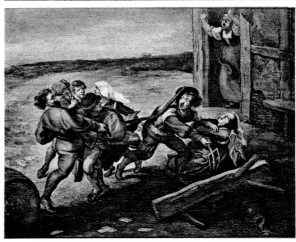

(From top) Engraving by L. Vorsterman ("Pet. Bruegel inuent"; 17×20¾ inches, 43×52·5 cm) possibly connected with 68. Painted version (Vienna, Kunsthistorisches Museum). Copy by Peter Paul Rubens (Brussels, Cavens Collection [1907]).

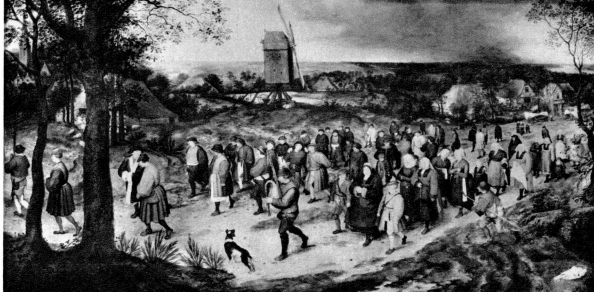

44

The Cripples (The Beggars, The Lepers) Paris, Louvre Signed and dated, below on the left, BRVEGEL M.D.LXVIII. On the back of the panel are two inscriptions, apparently dating from the sixteenth century ; one of them, incomplete and in Flemish, reads : [k]ruepelen, hooch, dat u nering betern moeg (O cripples, may your affairs prosper) ; the other consists of two Latin distichs, which Genaille reads as follows : NATVRAE DEERAT NOSTRAE QVOD DEFVIT ARTI/HAEC DATA PICTORI GRATIA TANTA [FUIT]/ALIVD/HIC NATVRA STVPET PICTIS EXPRESSA FIGVRIS/VISA SVIS CLAVDIS HVNC BRVEGEL ESSE PAREM (Even Nature does not possess that which our art lacks, so great is the privilege granted to the painter ; here Nature, transformed into painted images and seen in her cripples, is amazed to see that Bruegel is her peer. The first inscription tells us what the subject is, while the second must be considered as a normal humanistic homage to the artist who – thanks to the ability granted to him by the gods to rival nature and depict it with his brush in every one of its aspects, whether positive or negative – has succeeded in depicting an astonishing truth ; this is, in substance, what Ortelius said in his Latin verses (cf. above, Critical History), while the humanistic inspiration is confirmed by the fact that the first line is taken word for word from Politian's epitaph for Giotto (1490 ; cf. *The Complete Paintings of Giotto*, p. 10).

A work portraying cripples is

the tragedy and folly (for the blind men are ridiculous as well as pathetic) of human life, and there does seem an intention to contrast these with the calm order of nature. Genaille well reminds us of Bosch's "Wanderer" and "Prodigal Son" both for the type of wretched humanity, and, in the "Wanderer" (outside of the Prado *Hay-Wain*), with the details of the foreground, with the path and the stream. Bosch was in fact the originator of the theme of the "Blind Men" (engraving reproduced in Glück's *Aus drei Jahrhunderten Europäischen Malerei*, Vienna, 1933, p. 8). It was used, with varying numbers of figures by Cornelis Matsys, Jan van Amstel and Herri met de Bles, all before Bruegel. Copies of the Naples painting exist, most of them painted by Pieter the Younger, in the Louvre, in the Parma picture-gallery, in the Liechtenstein gallery at Vaduz.

useless thief, while the brambles and the iris allude to the moral strength of the principal figure.

Michel more simply considers that the young peasant is pointing out the nest to the boy in the tree, so as to be sure that he gets hold of it. Since 1659, when it is known to have belonged to Archduke

Leopold William – though it was attributed to Pieter the Younger (*Original vom jungen Breugel*) – this work has formed part of Vienna's artistic heritage, except between 1809 and 1815, when it was in Paris with the rest of Napoleon's booty. Tolnay notes that the position of the principal figure's legs is the same as in that of Christ in Michelangelo's

Last Judgment, while the bent arm is reminiscent of the Child Jesus in his marble Madonna in Notre-Dame at Bruges.

Vanbeselaer too is reminded of Michelangelo by the heroic proportions of the young man, but we need not follow him in the specific borrowings that he claims to detect. As well as producing the superbly robust young peasant, Bruegel has rendered a wonderful, broad landscape, calm and peaceful beneath a radiant sky. The trunk of the oak-tree, its foliage, the plants on the banks of the brook are all done with perfect art, as is the golden light of a summer day that suffuses the picture.

Unfortunately the right-hand portion of the picture has been damaged by imprudent and excessively vigorous cleaning.

46 [Plate XLVII]

50 ⊞ ⊘ 59×68 1568 ▤ ⦂

The Birdnester Vienna, Kunsthistorisches Museum Signed and dated, below on the left, BRVEGEL MD.LXVIII. Hulin de Loo believes that this work illustrates the Flemish proverb : *Dije den nest weet, dije weeten ; dijen rooft, dije heeten* (He who knows where the nest is, knows that and nothing else ; he who steals the nest, has it), the same proverb that inspired the master's drawing of the beekeepers. Other writers (Jedlicka and Vanbeselaer) prefer a moralistic interpretation and think that, since the young rustic in the foreground seems to be on the point of falling into the stream at his feet, we have here a biblical allusion (Matthew, VII. 3) : "Why beholdest thou the mote that is in thy brother's eye, but considerest not the beam that is in thine own eye?" Kjell Boström (*Konsthistorik Tidskrift*, XVIII, 1949) suggested an analysis of the picture which shows a pessimistic view of man and the world on Bruegel's part. His view is supported by a discussion of the significance of the plants (as understood in the sixteenth century) : the willow stump refers to the bad and

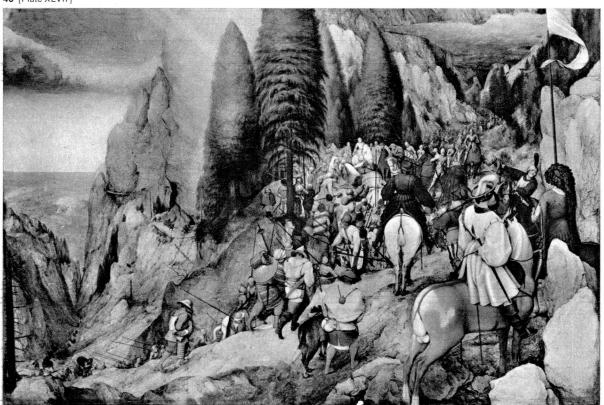

45 [Plate XLVI]

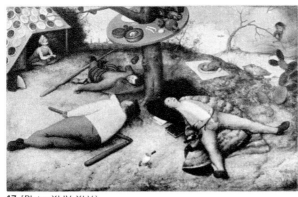

47 [Plates XLIV–XLV]

mentioned in the Hermann de Neyt inventory (1642) and others figure in catalogues of other seventeenth-century collections in Antwerp. Hulin de Loo, however, states that the work we are discussing was stolen by the Swedes during the sack of Prague in 1648; four years later it appears in an inventory of Queen Christina's possessions compiled by the Marquis de Fresne, who describes it as a little picture *représentant des gens estropiez*. In 1892 it was donated to the Louvre by the art critic Paul Mantz. The five cripples, who appear to be dispersing after a conversation (the faces of only two of them are completely visible), have been interpreted by the critics in a variety of

"Back to your sty, you pig!," engraving by J. Wierix ("P. Brueghel inuet"; diameter 7¼ inches, 18·5 cm); see 70.

ways; according to Jedlicka, the painter wanted to depict their vanity; for Delevoy, the picture contains political allusions, the five being representatives of the various social categories — monarch, bishop, soldier, bourgeois and peasant (these identifications are based on the headgear of the beggars); while Stridbeck (1956) believes that they symbolize the degradation and sinfulness of mankind. The foxes' (or martens') tails have been the subject of much speculation — the literature is given in Glück, LBB p. 85. Glück recounts one story, taken from Goethe, that St Philip Neri at about this time told a noble young man who wanted to join his order to walk through the streets of Rome with a fox tail pinned to his back. Evidently disgrace and shame were attached to the symbol, for the young man gave up his application to the order. The explanation accepted by Grossmann (1966) is that given by S. J. Gudlangsson (MRKD

1010

1947). Gudlangsson thinks that the foxes' tails were the emblems worn by lepers in their own processions on the Monday after Twelfth Night and during Carnival (note the beggars thus distinguished in *The Battle between Carnival and Lent* [17])

The picture was exhibited at Brussels, 1963, in *Le Siècle de Bruegel*. The state of preservation of this picture is good.

52 ▦ ✦ 45,9×50,8 1568 ▤ ⦂

The Magpie on the Gallows
Darmstadt, Landesmuseum
Signed and dated, below on the left, BRVEGEL 1568. Van Mander tells us that the painter, at his death, left it by will to his wife; Van Mander suggests that "by the magpie he meant evil tongues, who deserve to end on the gallows." It might also refer to a Flemish saying: *Aan de galg dansen* (dancing beneath the gallows), or again to the proverb *Hij beschiet de galg*, "shitting beneath the gallows" — as the man in the left foreground is doing. Some doubt remains as to the real meaning of the painting, especially as Van Mander's explanation does not seem to fit the case very well. Michel and Genaille think that there is a reference to the tragic execution in 1568 of the Flemish nobles, Counts Egmont and Horn. Grossmann following Bax (in *Nederlands Kunsthistorisch Jaarboek* XIII, 1962 p. 5–9) thinks Bruegel may have meant to say that treacherous gossip will bring about people's death, especially Protestants. The picture remains rather enigmatic, although the central meaning is surely clear: a procession of merrily dancing peasants approaches a gallows which dominates the foreground. A magpie can clearly be seen sitting on it while another, less obvious, perches on a tree-trunk in the foreground. The heedless, jolly humans are in contrast with the somber fact of death, and with the huge and beautiful landscape setting: we have here Bruegel's recurring preoccupation with the folly of man and the dignity of nature.

The landscape is a wonderful piece of painting, the lighting being completely uniform (Hulin de Loo); the plain, intersected by the blue waters of a river, is "bathed in light and full of serenity, like an earthly paradise" (Tolnay); while

Grossman observes that "the jerky rhythm of the peasants' dance is in perfect accord with the outlines of the hills in the foreground and the rhythm marked by the gallows . . . while the treatment of light and the pointillist technique seem to be harbingers of the conquests achieved by nineteenth-century painters."

53 ▦ ✦ 114×164 *1568* ▤ ⦂

Peasants dancing Vienna,
Kunsthistorisches Museum
Signed, below on the right, BRVEGEL. Almost all the critics assign this work, like *The Peasants' Wedding* (54), to the master's last years, or more precisely to 1568, though it could, of course, have been painted in the following year. Exceptions are Jedlicka and Genaille, who suggest 1565–6, while Grossman prefers 1567 Even among those who favor 1568 there seems to be a tendency to date this painting, as well as *The Peasants' Wedding*, before works like *The Birdnester* (50), *The Cripples* (51) and *The Magpie on the Gallows* (52), partly because the positive nature of these paintings would seem to belong before rather than after the feeling of pessimism, even despair, that is expressed in *The Blind Men, The Lepers* and *The Magpie on the Gallows*. It is not

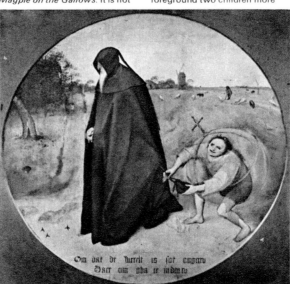

48 [Plate LII]

known whether *The Dancing Peasants* and *The Peasants' Wedding* were intended to be pendants to each other, as stated by Chrétien de Mechel in his well-known catalogue (1783); the fact that the dimensions are almost the same does not necessarily prove this, for several of the master's works have this format (cf. 52). The question as to whether they are companion pieces is discussed by L. Baldass *Les Paysanneries de P. Bruegel* in *Les Arts Plastiques* (Brussels, 1948) pp. 471 – 484. *The Dancing*

Peasants appears in the Vienna catalogues from the beginning of the seventeenth century onwards, being described as *ein*

paurenmusica vom Altenbruegel. In 1748 it was moved from the Weltliche Schatzkammer to the imperial gallery, and later, as we have already said, it figured in Chrétien de Mechel's inventory. In 1809, together with *The Peasants' Wedding*, it was taken to Paris as part of Napoleon's booty, and in 1815 the two paintings were brought back to Vienna.

In this portrayal of a lively rustic dance, Bruegel achieves perfection in the rendering of a subject he had already depicted on other occasions (cf. Van Mander's statement that he and his friend Franckert enjoyed rustic amusements of this kind — kermises, weddings, dances, festivals — where they used to pass themselves off as relatives from afar or inhabitants of the same village, so that they could study from close at hand the energetic caperings and guzzling of the country folk). The figures, fewer in number and larger than in similar compositions painted in earlier years (cf. 41, 43 etc.), are set in accordance with rules of perspective one behind the other in a space bounded by houses and a church, and the horizon is lower. The party is in full swing: the dance is excited, the piper is hard at it, kissing is going on on the left, and a drunken quarrel has broken out at the table. In the left foreground two children more

Print related to 48, from a presumed original drawing, formerly (1907) in the Masson Collection at Amiens.

gently enjoy themselves. Grossmann sees here lechery and anger, made worse by the

presence of church and shrine (on the tree-trunk at the right) which are ignored by all.

54 ▦ ✦ 114×163 *1568* ▤ ⦂

The Peasants' Wedding
Vienna, Kunsthistorisches Museum
The answer to the question, whether this is a pendant to *Peasants dancing* (53), the vicissitudes of which it shared, is that, whatever the original intention may have been, they must at an early period have been considered as "twin" works, for a strip about 2¼ inches wide was added to the work we are now discussing in order to make the dimensions of the two pictures equal. As regards the composition, it should be noted that although the portly bride, looking rather dazed and wearing a crown, stands out against a green cloth hung on the wall, to the left of two figures who are generally supposed to be her parents, the bridegroom is not obviously identified. A number of suggestions have been made (cf. e.g. Glück, Gilbert Highet, *Magazine of Art*, November 1945, pp. 274–6, Baldass, AP 1948) but none is particularly convincing. Scheyer (AQ 1965) has drawn attention to the relative humbleness of the role of groom in Flemish peasant custom. The man with a sword on the right, sitting on an upturned tub and talking to a friar, is generally assumed to be a judge or the local lord of the manor, perhaps he is even the painter himself – disguised as "a relative from afar or an inhabitant of the same village" and anxious to take notes of the scene (Van Mander, cf. Outline Biography, *1557*) – since the features are not unlike those of the man in the Ortelius print. The wedding reception is being held in a barn, to the accompaniment of music provided by two pipers, and the guests are diligently eating and drinking – homely figures who instead of feathers or flowers often have spoons stuck in their hats (spoons and knives were the only articles of tableware then in use, the knife being carried in the belt). The custard pies are being taken around on an unhinged door; the little girl in the foreground eats hers with her fingers. The harvest has been brought in, as can be seen from the two sheaves hung up in decoration: according to J. Borms (cited in Glück, LBB) it was an old tradition to hold the wedding after the harvest.

This is one of Bruegel's most famous paintings, universally admired for the golden coloring, the large, solid, perfectly characterized figures, and above all for the remarkable composition. Scholars have noted the resemblance to Italian *Last Supper* compositions – with the long table and many guests. Hulin de Loo was reminded of Titian's *Last Supper* in Urbino; Vermeylen devoted an article (in *Cahiers de Belgique* 1928 pp. 1–8) to Bruegel's possible Italian sources, considering Tintoretto's

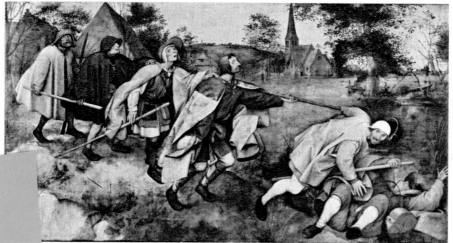

er in Venice a likely
versing the
ip, Genaille suggests
etto (through a print)
drawn inspiration
el's painting for his
r (1594) also in
. Giorgio Maggiore.
we are discussing
istory of art before
pendant, since it is
ve been purchased
Ernest of Austria
0 florins (see
. 90) ; in 1659 it
original von
atalogue of the
tions in Vienna,
mained ever since.
Peasants
t for the brief
Napoleonic times
n Mander

the painter's last years ; Jedlicka,
suggests 1566 ; Genaille,
1566–7 ; Tolnay, 1567, while
Glück and Friedländer both
prefer 1568 and Denis – who
declares that it is "perhaps the
master's last work" – thinks that
it might even have been painted
in 1569. Tolnay, while
reaffirming that it is undoubtedly
authentic, thinks that it is only a
preliminary sketch. Other
writers (Grossmann etc.) feel
that it is an unfinished work
(which would lend support to
Denis' hypothesis).

The subject-matter of the
painting has given rise to a
number of interpretations.
Ludwig Burchard (cf.
Grossmann, p. 205, and Glück,
LBB p. 92) pointed out a passage
in Zedler's *Universal Lecikon*

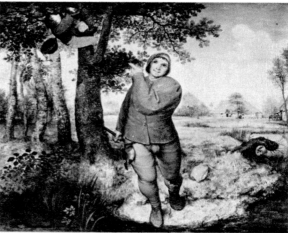

left, BRVEGEL – M.D.XVIII (the
"L" has disappeared). This
grisaille may be a fragment of a
larger work, about which we
know nothing since no
engravings appear to have been
made after it and the master's
descendants painted no copies
of it. As for the "history" of the
fragment, it would appear to be
identical with No. 36 in the
catalogue of King Charles I's
Collection, compiled in 1639 by
Van der Doort : "Item painted in
black and white oyle Cullors
upon a board. Three sweets A
Drummer Affife and a Aunciant
in all over gilded frame." From
the same catalogue we learn
that this little work had been
presented to the king by the
poet Endymion Porter. The mark
CP, with a crown, is burned into
the back of the panel, indicating
that Charles owned it before his
accession in 1625. After the
king's execution the panel was
sold, together with the rest of
his property, but it reappears in
inventories of James II's
Collection and is mentioned for
the last time in 1714, when it
was still Crown property and was
at Somerset House. About 1900
it is known to have been in a
private collection in England and
in 1964 it was sold at Christie's
to the Frick Collection. Edgar
Munhall (*Apollo*, no. 83, May
1966, p. 393) points out that
this painting, at first glance so
unlike Bruegel, should be
considered as belonging with
those other grisailles by the
master, *Christ and the Woman
taken in Adultery* and *The Dor-
mition of the Virgin*. Refinement,
delicacy and poetic feeling
mark all three, even though our
work has a secular subject,
unlike the other two.

*Appendix of pictures which are
known only through later
versions, or whose attribution
to Bruegel is very doubtful*

sixteenth century was already
derided as a charlatan's trick
(Baldass, *H. Bosch*, 1950). The
number of surgeons present is
insufficient and some patients
are waiting to be attended to,
while others are just arriving ; in
front of them the chief surgeon
is extracting the stone from a
patient's forehead ; other stones
have already been extracted and
are lying on a sheet of paper.
Van Lennep detects allusions to
alchemy, pointing out that the
stone of folly is itself akin to the
philosopher's stone (obtainable
from mercury, which in alchemy
was often symbolized by a

madman). The work first became
known through an anonymous
print (*Bruegel inventor 1557*)
entitled *Den Denken van Ronse
in Vlaēderē* (the doyen of Renaix
in Flanders), a reference to the
fact that the inhabitants of
Renaix (cf. Bastelaer) were
reputed to be all mad, or else (if
we suppose that the inscription
was added later, since copies
wihout it exist) because of an
erroneous interpretation of the
picture as a torture scene, since
"chief surgeon" was a popular
nickname for the Inquisitor
Titelmans (Hulin de Loo). Later
there were discovered a painted

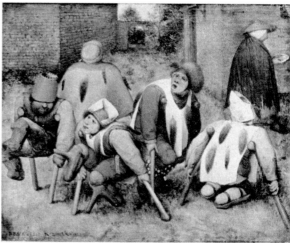

50 [Plate LIV]

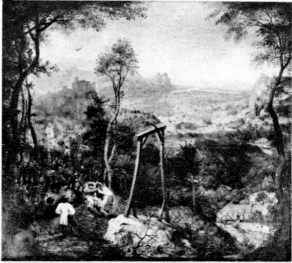

51 [Plate LIII]

ruegel 1562", 7¾ × 12¼ *inches, 19 5× 31cm ;
hkabinett) iconographically related to 49*

ainting of the
h "the faces,
of the peasants
, burned by
h skins, very
e of city
at time
ann Pilgrims
e date 1568 is
nanimously.

0,5×97
1568

nna
Museum
inting was
e Momper
(1904–5)
ruegel has
mous,
(1951 and
d again
r. Glück
(1955) and
opposed
chel
ubts and
be by a later
agreed that
dated from

(1732–50) "If the whale plays
with a barrel that has been
thrown to him and gives the ship
time to escape then he
represents the man who misses
his true good for the sake of
futile trifles." Other passages
have been found (cf. Glück) to
illustrate the figure of the whale
and the barrel, including one
before Bruegel's time, and one
just after. Stridbeck thinks that
the ship is a symbol of man, on
his dangerous journey through
life ; and that the barrel cast into
the sea is a symbol of the
abandonment of material goods
for the sake of salvation. Glück
points out that the sea could
never be ignored by the
inhabitants of the Low
Countries, and that this work is
perhaps the first excellent
sea-piece in Netherlandish art.

56 ⬚ ✦ 20,3×17,8 *1568?* ▤ ⁝

Three Soldiers
New York, Frick Collection
Signed and dated, below on the

57 ⬚ ✦ 74×103 1556*? ▤ °°

Extraction of the Stone of Folly
Formerly in Budapest,
Palugyan Collection
Inscribed P. Brueghel 1556,
which is almost unanimously
considered to be a forgery. The
subject depicted by Bosch in the
celebrated painting now in the
Prado (see *The Complete
Paintings of Bosch* 1) is here
developed and we see the
operating theater of a hospital
specializing in curing the insane
by extracting tne stone of folly,
a practice which in the early

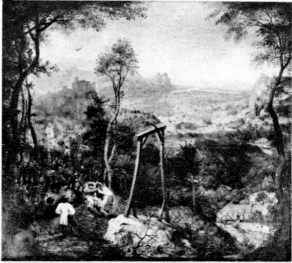

52 [Plate LV]

version at Saint-Omer and another in the De Molène Collection, Paris (1907), each bearing the forged signature *Bruegel*. Finally Friedländer circulated some poor photographs of a version which until 1911 had been in the Gerhardt Collection, Budapest, and subsequently passed to the Palugyan Collection in that city. As regards these photographs, almost indecipherable (we have reproduced one of them here for lack of anything better), Hulin de Loo, after discussing the variants as compared with the above-mentioned engraving – variants which are also found in other painted versions – concluded that an original by Pieter the Elder must have existed, though he would not commit himself as regards the authenticity of the Budapest version. Glück steadfastly maintained that the latter is a copy of a lost original, and the same conclusion is reached by Tolnay and Michel (the latter having first accepted it as authentic).

58 🎴 ⊕ 1556-57? 🎵 ⦂

The Temptations of St Anthony Location unknown
A composition containing numerous elements borrowed from Bosch. On the left, a skeleton transfixed by arrows, with the globe surmounted by a cross, anthropomorphic buildings and, in the foreground, an egg in which alchemists can be seen; in the center, a burning town and a church, above which a dragon carrying a naked man is flying (allusions to pederasty); on the right, an inhabited tree, from which a bellows and other alchemistic objects are hanging, a procession of devils crossing a bridge and, in the foreground, the tempted saint. Grete Ring (OH 1934) attributed this work to Bruegel and dated it 1556–7, but her opinion has not been followed by others.

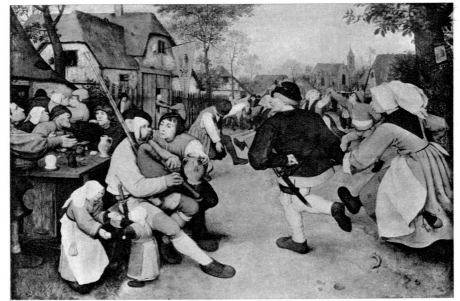

53 [Plates LX-LXIII]

59 🎴 ⊕ 92,5×73,5 *1558? 🎵 ⦂

The Feast of St Martin Vienna, Kunsthistorisches Museum
The complete composition can be seen in a print from an engraving of the seventeenth century by N. Guerard. The subject is the Feast of St Martin (11 November), an important day in the Low Countries, since it coincided with the vintage and the generous knight was also the patron saint of vine-growers, who on that occasion distributed abundant libations of wine free of charge. In the print we see men, women and children crowding round a huge cask from which wine is gushing, trying to collect it in every kind of receptacle; the feast soon degenerates into a general orgy, of which we can discern the first symptoms, accompanied by the first quarrels. The saint has his back to the crowd and is dividing his cloak as he rides away on his white horse. The painting, at that time still intact, is mentioned in an inventory (Vienna, 1659) of the property of Archduke Leopold William of Austria (*Ein grosses Stuckh von Ohlfarb und Leinwaeth, warin das Fösst desz heyl. Martins unter den armen Leuthen ein Fasz Wein zur Almuessen gibt*). It was first exhibited in modern

times in 1915. Guerard's engraving is said to have been published in Rome by Abraham Bruegel, Jan's grandson, and the inscription says that it was derived from a painting by Jan (*I. Bruegel in. et pinx.*). That the print is derived from a painting is confirmed by the fact that the saint is holding his sword in his left hand, whereas in the Vienna fragment it is in his right. Two other paintings (Antwerp, Koninklijk Museum, and Amsterdam, Rijksmuseum) depict *The Feast of St Martin* in a similar way, though with numerous variations compared with the print and also from one to the other; they are both signed PEETER BALTEN. Friedländer and Van Puyvelde include the Vienna fragment in their catalogues of the master's works, dating it about 1558 – Glück (1951), however, believes that the original has been lost (in an earlier study he had agreed with the two critics mentioned above); its authenticity is denied by Michel and Jedlicka (according to the latter the composition is rather lifeless and therefore not by Pieter the Elder); Grossmann is likewise unwilling to admit that it is by the master's own hand, conceding, however, that the conception may have been his.

Tolnay believes that the Vienna fragment was painted by Jan Bruegel in his early years; Marlier [1965] suggests that Jan may have drawn his inspiration from Balten – who, he believes, was responsible for the conception – and that he then executed a painting of which Pieter II made a copy, which would be the mutilated version that has come down to us. In addition to being only a fragment, the Vienna painting is in a poor state of preservation, and it is possible that the original tempera has been over-painted in oil.

60 🎴 ⊕ 12,6×9,2 *1558* 🎵 ⦂

Head of a yawning Man Brussels, Musées Royaux des Beaux-Arts
On the right is a P, the first letter of a monogram, the second having probably

disappeared when this tondo – as it is presumed to have been originally – was cut down at the sides. These suppositions are based on affinities with 61 and 62, together with which and four other works (since lost) it is believed to have formed a series representing seven "Deadly Sins" (L. C. Collins, in Van Camp, AP 1950 and RBAH 1954). If this is the case, the work we are discussing would be a personification of Sloth. It might be the painting (attributed to *Vieux Bruegel*) mentioned as item No. 197 in the Rubens inventory (1640); what we know for certain is that, after being untraced for a long time, it turned up in the Scheikevitch Collection, Moscow, that it was

Version in grisaille of 72 (Antwerp, Koninklijk Museum).

The Triumph of Time. engraving published in 1574 by Ph. Galle ("*Petrus Bruegel inuen*"; 8¼×11¾ inches, 21×30 cm).

sold in Amsterdam in 1907 (F. Muller), belonged successively to A. Maier of Carlsbad and Dr Hönig (1938) of Providence (R.I.), and was acquired by the Brussels museum in 1949. The attribution to Bruegel finds confirmation in an etching by L. Vorsterman and is supported by Hulin de Loo, Glück (1943 and 1952), Van Camp and Marlier (1963); Michel and Grossmann think that it is a copy of a lost original, while Tolnay attributes it to Pieter the Younger and Denis rejects it without making any alternative suggestion.

61 🎴 ⊕ diam. 16 *1558* 🎵 ⦂

Head of a Lansquenet Montpellier, Musée Fabre
On the right, beneath the plume, the monogram P. B. If it belongs to the hypothetical series of seven "Deadly Sins" (cf. 60), it probably represents

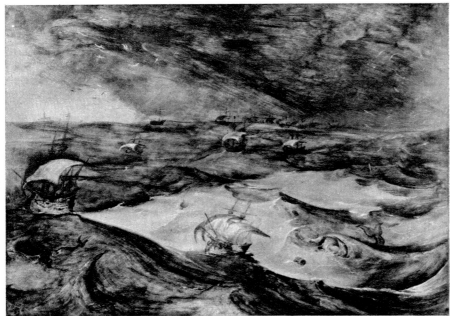

55 [Plate LXIV]

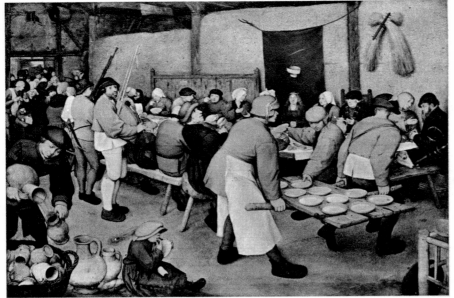

54 [Plates LVI-LIX]
Anger, but J. Claparède (in Marlier, 1963) thinks that it is a personification of one of the "four temperaments." Hulin de Loo believed that he had found a reference to it in the Rubens inventory, but in reality we know its history only since 1864, when it was bequeathed to the museum by Bonnet-Mel. A genuine work according to Hulin de Loo, but Friedländer, after accepting the attribution in 1916, ignored it in his later works; Michel seems doubtful, while Glück and Tolnay attribute it to Pieter the Younger.

62 ▦ ✪ diam. 15 *1558* ▤ ⦂
Head of an Old Man
Bordeaux, Musée des Beaux-Arts
In the series of seven "Deadly Sins," to which 60 and 61 are also supposed to have belonged, this figure would have represented Envy. It came to the Bordeaux museum as part of the Poirson bequest (1900). Formerly attributed to Bosch owing a similarity between it and one of the figures in the celebrated Lisbon triptych (cf. *The Complete Paintings of Bosch* 43). Attributed to Bruegel by L. Jacobos van Merlen (in Marlier, 1963), Van Camp and Marlier; but this attribution to Pieter the Elder is not convincing.

63 ▦ ✪ ⎯1559*? ▤ ⦂
The Nuptials of Mopsus and Nisa
An engraving inscribed MOPSO NISA DATVR, QVID NON SPEREMVS AMANTES, made by Pieter van der Heyden, (whose initials can be seen on the left) for the publisher Cock (*H. Cock, excud. 1570*), apparently derived from a work by Bruegel (*Bruegel-inuentor.*). According to Hulin de Loo, the original was not a drawing, but a painting, and he maintains that this is confirmed by the fact that the same farce is being performed in *The Battle between Carnival and Lent* (17), a further proof being that in the print some of the figures are the wrong way round. The sources make no mention of any such painting. Glück (AQ 1943) showed that the inscription was an addition of Heyden's or Cock's, an example of the fashion for "classicizing" every

subject. Hence the lines from Virgil's Eighth Eclogue. Virgil's story is not shown, and the subject *De Viule Bruid* (The Dirty Bride) belongs to Flemish folklore.

64 ▦ ✪ ⎯1565*? ▤ ⦂
Heathland with Peasants on their Way to Market
A painting of this subject by Bruegel is mentioned in 1668 as one of the eleven works by the master belonging to Peter Stevens of Antwerp: *Une très raisonnable Bruyère, là où des paysans et paysanes vont au marché avec un Chariot et un porché et autres* (a famous picture of a heath, showing peasants and women on their way to market, with a cart, a swineherd and other figures). G. Forchoudt, on 6 December

1669, and C. Huygens, on 10 June 1676, mention it as being still in the hands of Stevens' son, though Huygens describes it as "much less beautiful" than another work by the master (the Berlin *Proverbs* [16]) in the same collection. There is no subsequent mention of any such work, though it is usually believed to have had some connection with two drawings; one of these is particularly interesting – a pen and water-color drawing on canvas (8¼ × 12¾ inches, 21 × 32·5 cm) now in the Staatliche Graphische Sammlung, Munich, to which attention was first drawn by W. Schmidt [*Handzeichnungen alter Meister in der Graphischen Sammlung München*], who describes it as by Bruegel's own

hand, though it is actually by an anonymous seventeenth-century Flemish artist. In addition to this, a reproduction of the lost original can be seen in a *tableau de cabinet* painted by W. Verhaecht and now in the Van den Bergh Collection, New York. Lastly, the lost composition provided inspiration for several paintings by Jan Bruegel, and Glück believes that it may also have influenced Rubens' *Going to Market* now in Windsor. Since the foreground is characteristically close to the spectator, while the other planes, in relation to the foreground, are lowered, Camesasca has suggested that the lost original might have had some connection with "*The Months*" (34), or, if it is not possible to identify it as the missing "piece" in the series (though the subject would be appropriate to the missing spring months), it could at least serve as an aid to the reconstruction of the chronology.

65 ▦ ✪ 1565-66*? ▤ ⦂
Sacking of a Village
The Prague imperial inventories of 1621 mention *Eine dorf blinderung vom alten Prügl* [*sic.*], which reappears in the 1648 inventory as *Eine Dorff-Blünderung*. Since a picture of the same subject by Pieter the Younger (45¾ × 70½ inches, 116 × 179 cm is now in the museum at Douai, some writers (Hulin de Loo etc.) believe that an original painted by the elder Bruegel must have

existed (of which the Douai painting is a copy), similar in style and dimensions to *The Massacre of the Innocents* (39), which would support the theory that there was some connection between the latter and the outrages committed by the Duke of Alba's soldiery.

66 ▦ ✪ ⎯1566*? ▤ ⦂
Drunkard accompanied by his Relatives
A piper (the boy on the left is carrying his bagpipes) is being pulled away by his wife from a group of quarreling peasants at the door of a tavern (background, right). The composition is known through a number of copies, the best of which would seem to be one by Pieter the Younger (on wood, 37½ × 47¾ inches, 95 × 121 cm), which Hulin de Loo mentions as having once belonged to Canon van den Clooster and later to the Grisar Collection in Antwerp. It was this copy that convinced him, as it later did Burchard and Glück, that a prototype by the master must have existed, painted about 1566.

67 ▦ ✪ ⎯1566*? ▤ ⦂
Peasants attacked by Brigands
Three brigands attacking a peasant and his wife. The existence of such a composition is known only because a number of copies by other artists have survived. Of these the best is undoubtedly a painting on wood (37¾ × 50½ inches, 96 × 128 cm) signed by Pieter the Younger, now in the institute of art history in the University of Stockholm. Another good copy is in the Liechtenstein gallery at Vaduz, bearing the forged inscription P. BRVEGHEL 1556, which, according to Romdahl, was painted by Jan Bruegel. Tolnay maintains that the original was painted by the elder Bruegel in 1568, but certain affinities with *The Hireling Shepherd* (36) – noticed by Hulin de Loo, especially in the landscape – justify the assumption that it may have been painted a year or two earlier. Incidentally, Grossmann maintains that no prototype by Pieter the Elder ever existed, but only a skillful pastiche executed by Marten van Cleve, after which Pieter the Younger made his copies.

56

73

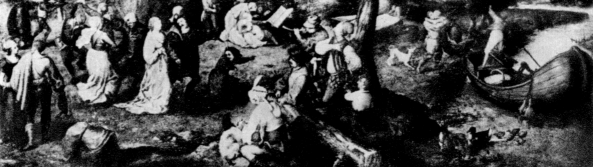

74

68 ⊞ ⊗ ·1566· 🗒 ⊙

Quarreling Card-Players
That the master painted such a picture is proved by a Vorsterman print (*Lucas Vorsterman excud.*) bearing the words *Pet. Bruegel inuent.*, with another inscription below informing us that it was published as an act of homage to the master by his son Jan. Gillis Mostaert may have finished Bruegel's lost composition, probably the landscape, the figures looking as though they were originally executed by Bruegel. The authority for the fact that Bruegel did not complete the picture (thus making it one of his last works, according to Grossmann) is a letter from Lord Arundel (written 1626–30) who acquired it "a peece of painting begunne by Brugels and finished by Mostard; being a squabbling of clowns fallen out at Cardes, which is in stamp by Mr. Lucas Vorsterman..." A number of copies are known, two of them painted by Jan—jn the Kunsthistorisches Museum, Vienna (on canvas, $27\frac{1}{2} \times 36\frac{1}{2}$ inches, 70 × 93 cm) and in the Dresden Gemäldegalerie (on wood, 28 × $39\frac{1}{4}$ inches, 71 × 100 cm, mentioned in the Guarenti inventory compiled before 1753). Another, by Pieter the Younger, is in the Musée Fabre at Montpellier (on wood, $29\frac{1}{2} \times 41\frac{1}{4}$ inches, 75 × 105 cm, signed and dated 1600); another (also signed,

Possible painted version of 75, by Pieter Bruegel the Younger (Antwerp, Koninklijk Museum).

but of uncertain date) is mentioned by Romdahl as having been sold in 1895 by the Berlin dealer Heberle, and there are several others by anonymous artists. In addition to this, in the Rubens inventory (Antwerp, 1640) there is a picture described as *Des Payans qui se battent, fait d'après un dessin du vieux Bruegel.* There are two versions of this picture from Rubens' hand: one, originally in the Cavens Collection, Brussels, was last in the collection of L. Burchard, London. The other, with a landscape by Jan Bruegel the elder, was in the Ebbhardt Collection in Hanover. There is also a spirited chalk and wash sketch by Rubens of the main figures in the Boymans van Beuningen Museum, Rotterdam.

69 ⊞ ⊗ 1568? 🗒 ⦂

Landscape with Hermit
London, A. Seilern Collection Mentioned by Grossmann [1959] as an authentic work, signed and dated 1566, though he gives no further details. When we asked the present owner for the measurements and a photograph, all he told us (letter of 8 January 1967) was that the authorship of his "little" painting, hitherto unpublished, was "quite uncertain."

70 ⊞ ⊗ 1568? 🗒 ⊙

"Back to your sty, you pig !"
There exists a round print bearing the initials of Jan Wierix (IHW), followed by the date 1568 and the words *P. Brueghel inuêt*, illustrating the Flemish proverb : *'t Varken moet in 't Schot,* a free translation of which is given in the heading. As can be seen from the reproduction, it shows the appropriate punishment for a man who behaves like a pig. Hulin de Loo suggests that the engraving may have been made after a lost painting by Bruegel mentioned in an inventory of the property of Gilles van Coninxloo, one of Pieter the Younger's teachers. In this document it is described as *Een stuck waert varcken in 't cot moet* (a picture of a pig being driven into a sty).

71 ⊞ ⊗ ·43×60·? 1568? 🗒 ⊙

Blind Man playing a Hurdy-gurdy
In the catalogue of the N. Selhof sale at The Hague (1759) there is a description of a work by Bruegel, previously (1737) in the Van Huls Collection, depicting a blind man playing a hurdy-gurdy in front of a grocer's shop, followed by small boys, the measurements being given as one foot, three inches high and one foot, ten inches wide, approximately those given in the heading. Nothing more is known about this painting. The date 1568 is deduced from another version (on wood, $15\frac{1}{4} \times 21\frac{3}{4}$ inches, 39 × 55 cm) which appeared at the Löwenfeld sale in Berlin (1906), inscribed BRVEGEL 1568, notwithstanding which Hulin de Loo attributed it to Pieter the Younger, on the assumption that the copyist had placed the date given on the original on his own work. Other replicas, most of them attributed to Pieter the Younger, are mentioned about 1905 as being in the Prince Argutinsky-Dolgorutow and Semenoff collections, in Leningrad, and in the Schulte gallery, Berlin.

72 ⊞ ⊗ ·1568·? 🗒 ⊙

Gentlemen visiting a Farm
A work bearing this title and attributed to the master is mentioned as having been in the former Dellafaille Collection in Antwerp, but its subsequent history is unknown. That an original by Bruegel may have existed is indirectly confirmed by the existence of a number of replicas. One, in grisaille, is in the Musée Municipal at Bergues-Saint-Winoc ; another was acquired in 1865 by the Koninklijk Museum, Antwerp (on wood, 12 × $18\frac{1}{4}$ inches, 30·5 × 46·5 cm) and is rightly considered to be the best, even if we do not accept Romdahl's opinion that it is the original—an opinion rejected by Friedländer, Glück, Hulin de Loo (who attributes it to Jan Bruegel), Tolnay and Denis. Other copies, in color, are to be found in the Kunsthistorisches Museum, Vienna (on copper, $10\frac{1}{2} \times 14\frac{1}{4}$ inches, 27 × 36 cm, perhaps attributable to Pieter the

Pen-drawing in two colors ("bruegel f.," ca. 155[...] 20·3×28·2 cm ; Berlin, Kupferstichkabinett).

Rest on the Flight into Egypt, *engraving ("brueg[...] inches, 31 × 42 cm), possibly connected with 85[...]*

Younger's workshop), and in the Figdor Collection (ca. 1905) in that city (by Pieter the Younger).

73 ⊞ ⊗ 35,5×27 🗒 ⦂

Two Peasants binding Faggots
Birmingham, Barber Institute Friedländer was the first to draw attention to this painting (BM 1935), at a time when it still belonged to Prince Paul of Yugoslavia, and he attributes both the conception and the execution to the master. The attribution is supported by Van Puyvelde, but disputed by Tolnay, who attributes both the conception and the execution to Pieter the Younger, an opinion with which Glück and Genaille agree. According to Grossmann, however, the conception is due to the master, though neither the painting in Birmingham nor any of the other known versions would appear to be authentic.

74 ⊞ ⊗ 72×212 🗒 ⊙

The Worldly Joys of the Magdalen Formerly in a private collection in Berlin Canvas transferred to wood. A rather unusual subject, and one found only in Northern European painting. Attention was first drawn to it by Winkler [P 1928], who believed that it was a genuine Bruegel, a view rejected by Michel, Glück and Tolnay, while other critics do not even mention the work. To judge by the photograph, it would seem to be a work of a later period about 1580.

 Othe[...]
ment[...]
the s[...]

Below w[...]
other work[...]
Mander (1[...]
together w[...]
in sevente[...]
century in[...]
large colle[...]
of which v[...]
attribution[...]
considered[...]
particular,[...]
inventorie[...]
Cardinal C[...]
1607) and[...]
(Antwerp[...]
those cor[...]
art belon[...]
Emperor[...]
1647–8,[...]
1782, a[...]
1750) [...]
William[...]
1659). [...]
The [...]
Granvi[...]
publis[...]
in it, th[...]
interes[...]
excep[...]
attribu[...]
Breug[...]
to "Br[...] in
doubt[...]
might[...]
Youn[...]
desce[...]
Rube[...]
in a f[...]
(Spé[...]
trouve[...]

Pen-drawing ("P. BRVEGEL 1561"; $5\frac{1}{2} \times 7\frac{1}{4}$ inches, 14·3×18·5 cm ; Paris, Louvre), perhaps related iconographically to 78.

de feu Pierre Paul Rubens, 1640) *and in an English one (London, 1839) containing a number of variants. As regards the imperial collections, it would seem that the first inventory of works in the Hradschin Palace at Prague was compiled in 1612 by order of Matthew, the successor of Rudolph II, but the earliest reliable information is contained in the inventory of 1621 (of which there are two editions containing noteworthy discrepancies) compiled at a time when almost all the works by Bruegel which, according to Van Mander, belonged to Rudolph II had already been transferred to Vienna. The vicissitudes of the works which remained in Prague can be reconstructed fairly well from subsequent inventories. As for those in Vienna, there are two catalogues of works at one time in the Schatzkammer and an inventory of works belonging to Archduke Leopold William, all of which have been printed in the Austrian "Jahrbuch" (cf. Bibliography).*

For brevity's sake we have disregarded vague references, such as Van Mander's remark that "it would be difficult to enumerate all the things that he [Pieter the Elder] painted concerning witchcraft, hells, peasant life . . . and, in addition, innumerable proverbs." In the inventories there are frequent references to such subjects, as well as to genre scenes, landscapes etc., and to pictures of which the subject is not given

(often attributed to "Bruegel" without any indication as to which Bruegel is meant). Among these inventories are those concerning the property of Philips van Valckenisse (1614), Nicolaes Cornelisz Cheeus (1621), Jacques Snell (1623), Antoinette Wiael (1627), Carel de la Fossa (1634), Nicolaas Rockox (1640), Herman de Neyt (1642), Sara Schut in van Can veuve Nielis (1644), Cornelis Schut (1645), Abraham Matthys (1649), Jan van Meurs (1652), Jeremias Wildens (1653), Anna de Smidt-Fraryn (1655), Susanna Willemsens veuve Van Borm (1657), Maria de Bodt veuve Kordaens (1659), Anna Colyns veuve Diricxen (1667), Jan Baptista Borrekens (1668), Peter Stevens (1668), Peter Wynants (1669), Jaspar van Havre (1669), Hendrik Bartels (1672), Erasme Quellin (1678), Diego Duarte (1682), Alexander Voet (1685 and 1689), Jan Baptista Anthoine (1691) etc., all of Antwerp, and Cornelis Dusart (1704) of The Hague. To these inventories (on which see the studies by Denucé listed in the Bibliography) must be added the mentions in letters (e.g. one written in Vienna on 20 February 1704 by the merchant Marcus Forchoudt to his brother Justus in Antwerp, in which he mentions an Ecce homo by de ouden Breugel, which would seem to be identical with a painting by Peeter Balten now in the Koninklijk Museum at Antwerp).

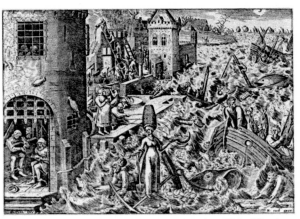

Hope, *engraving ("BRVGEL. INV."; 9 × 11½ inches, 22·5 × 29 cm) from the series of "Seven Virtues" (cf. 89).*

We have made use of all these documents, and also of numerous sales catalogues, whenever the references are to works that can be identified with reasonable certainty, but owing to lack of space we have had to disregard the lost works.

VAN MANDER 1604
75 The Procession to Calvary
The biographer mentions two pictures of "Christ bearing the Cross" by Bruegel, both of which – it would seem – belonged to Emperor Rudolph II, and he describes them as "very vivacious and with many comical figures." One of these pictures can be identified as the painting now in Vienna (30), but nothing is known of the other, though it may have been the prototype of a whole series of versions, most of them by Pieter the Younger or attributed to him. Of these one is now in the Koninklijk Museum at Antwerp (on wood; 42 × 63¼ inches, 106·7 × 161·1 cm), which acquired it in 1898 in exchange for the version mentioned next; one was formerly in the Slingeneyer de Goeswin Collection, Brussels (ca. 1905; on wood; 48 × 66¼ inches, 122 × 168 cm; signed and dated P. BRVEGHEL 1607); others are in the Uffizi in Florence (on wood; 44½ × 51¼ inches, 113 × 130 cm; P. BRVEGHEL 1599); in the castle at Beusdael (ca. 1905; on wood; 48¼ × 65¾ inches, 123 × 167 cm; P. BRVEGHEL; acquired in 1883), and in the museums of Copenhagen, Berlin, Budapest and a number of private collections (cf. Glück).

76 Kermis Mentioned as having once belonged to Wilhelm Jacobs of Amsterdam, together with a painting of a rustic wedding. Both works were apparently painted in tempera on canvas. The second of these works might be the original of our 6 or even the painting in the Johnson Collection, for in a later inventory (of the property of the Antwerp art dealer Diego Duarte [1682]) in which both works are mentioned, only the first is said to be in tempera on canvas, and this, according to Hulin de Loo, entitles us to assume that it has probably disappeared.

77 Peasants' Wedding This work is said to have belonged to

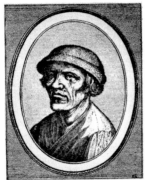

Engraving by J. C. Visscher ("P. Breugel inventor") from the series of thirty-six "pieces" (4¾ × 3½ inches, 11·8 × 9 cm) showing types of peasants (cf. 91).

the collector Herman Pilgrims of Amsterdam and is described as "in oils, very curious; the faces and complexions of the peasants can be seen, brown and yellow, as if burned by the sun, with rough skins, quite different from those of townsfolk." It might be one of the known paintings, our 6 (but cf. 58) or else 41 or 44.

78 The Temptations of Christ The composition is described as "seen from the summit of the Alps; through gaps in the clouds we see villages and towns" (the extensive landscape and the mention of the clouds remind us of a print in the Louvre, signed and dated P. BRVEGEL 1561); Van Mander also says that it belonged to the imperial collections, but this is not certain, and moreover, a *Tentation de notre Seigneur de Breugel* appears in the Rubens inventory (1640). The English edition of this inventory specifies that the work was painted in "water colors" (which in this case would mean tempera), and this might justify the assumption that the work no longer exists.

BESANÇON, 1607
79 Blind Men In the Granvelle inventory a painting in a black frame *de Breughel* is mentioned, showing blind men guiding one another (*des aveugles qui se meinent l'un l'aultre*), the height being given as *un pié et douze poulces et demy* and the width as *deux pieds, quattre polces*, corresponding to about 25¾ ×

32 inches, 65·3 × 81·4 cm. The dimensions, especially if they are inclusive of the frame, as they probably are, make it unlikely that this is the work now in Naples (49), but it might be a medium-sized tempera painting of blind beggars mentioned in the Vienna imperial inventories for 1747–8 and 1750; since, however, the inventories do not say that any of the blind men are on the point of falling and give no further details, we may accept Hulin de Loo's suggestion that the work may have some connection with the autograph drawing in Berlin (dated 1562), showing two blind men followed by a blind woman (cf. reproduction on p. 111), which might be related to some Flemish proverb (cf. 16, saying No. 18).

80 The Flight into Egypt Described as a *Paysage d' une Nostre-Dame allant en Egypte, du vieux Pierre Breughel, haulteur d'un pied quattre polces, large d'un pied treize polces et demy*, in other words about 18 × 27 inches (45·5 × 68·5 cm), dimensions which, since they include the frame (*avec sa moulure dorée*), mean that this might be the work now in the Seilern Collection (but cf. below). A similar painting figures in the Rubens inventory (1640), where it is described as being *à l'huile*, and later (1682) in the Duarte inventory (*Een Lantschapken de Vluchting van Maria en Joseph nyt Egipten vol werckx, heel curieux. Kost gl. 280* (A small landscape, the Flight of Mary and Joseph out of [sic] Egypt, full of details, very curious. Cost 280 florins). It might also be a painting mentioned in a sale catalogue (n.d.) published by Hoet between one dated 1696 and another of 1712. If the words *vol werckx* in the Duarte inventory are to be taken as meaning "full of figures," as Hulin de Loo, for example, believes, then the composition must have been similar to that of *The Numbering of the People at Bethlehem* (38), which would make it less probable that it is our 25. It should be noted that the work we are discussing is the only item in the Granvelle inventory which is explicitly attributed to Pieter the Elder.

81 Ships on a Calm Sea The inventory says that this work (*Navires en mer tranquille, avec petites figures en icelle et paysage lointain*) was *un pied, trois polces [et] deux quarts* high and *un pied, treize polces* wide, i.e. about 17½ × 26½ inches (44·3 × 67·1 cm) and that it had a black frame (*moulure noire*). Hulin de Loo suggests, very cautiously, that it might have been a painted version of the *Strait of Messina* engraved in 1561 by F. Huys for H. Cock, in which case it must have been a painting from Bruegel's early period. The Rubens inventory also mentions a painting by the *Vieux Bregel*, in tempera, *de petits bateaux*, and Hulin de Loo suggests that this might have some connection with a print showing sixteen ships, continued on p. 119

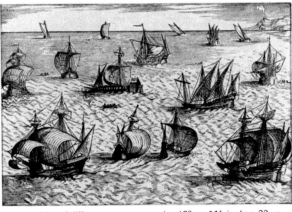

Sixteen ships of different types, *engraving (8¾ × 11½ inches, 22 × 29 cm), possibly connected with 81.*

Ship between two galleys, with the Fall of Phaëton, *engraving (8¾ × 11 inches, 22·3 × 27·8 cm), possibly connected with 81.*

Appendix

Bruegel's drawings

From what we have said above (cf. Outline Biography) the reader will have gathered that no study of Pieter Bruegel's career would be complete without some reference to his activity as a graphic artist. We have already mentioned his long connection with H. Cock, the well-known publisher of prints, pointing out that in his early years, at least down to 1563. Bruegel devoted himself mainly to the production of drawings, a form of art which he never abandoned completely. The series of "Large Landscapes" (ca. 1553; each "piece" has different dimensions), from which we reproduce three out of a total of twelve, all bear the name of Cock together with that of Bruegel; since no engraver is mentioned, it has been assumed that the engraving was done by Pieter himself, but the only engraving known to have been made by him several years after the series of landscapes (cf. p. 117) reveals such a lack of experience as to make this assumption seem rather suspect. The two other prints reproduced here are etchings from the first series (*Multifariarum casularum*) of a cycle consisting of fifty-one "pieces," each measuring $5\frac{3}{4} \times 7\frac{3}{4}$ inches (14·5 × 19·5 cm), all representing views of Brabant and the Campine district. These, too, were published by Cock, in 1559 and 1561, the actual engraving being done by an anonymous artist after drawings provided by Bruegel. The series mentioned above are only among the many important engravings which Bruegel designed for Cock, and some of the others will be mentioned below. Here we would only remind the reader of the "suite" of eleven plates representing *Vaisseaux de mer*, two of which are reproduced on p.115. After his move to Brussels, which affected, but did not completely interrupt, his connection with Cock, Bruegel's graphic activity was concentrated mainly on religious themes and on the illustration of Flemish proverbs, which the aging publisher also caused to be engraved. At the time of his death, Bruegel left unfinished a series of four drawings of "Seasons" commissioned by Cock, of which only the "Spring" and the "Autumn" were subsequently engraved. (For other engravings after drawings by the master, see *Catalogue*.)

(On right, from top) The Penitent Magdalen (*"MAGDALENA POENITENS"*); engraving ($12\frac{3}{4} \times 17$ inches, 32·5 × 42·8 cm), inscribed below on left, "bruegel inuen" and "n. cock eécud." St Jerome in the Desert (*"S. HIERONYMUS IN DESERTO"*); in the bottom right-hand corner of this print ($12\frac{1}{4} \times 16\frac{3}{4}$ inches, 31 × 42·5 cm) are the words "bruegel inuë" and "n. cock eécu."

Two prints from the *"Multifariarum casularum"* series (see above), published by H. Cock in 1559 and perhaps engraved by him.

(Above) Landscape with Hunter (*"INSIDIOSVS AVCEPS,"* $12\frac{3}{4} \times 16\frac{3}{4}$ inches, 32·5 × 42·5 cm); inscribed in bottom right-hand corner, beneath the fowler and his dog, *"BRVEGHEL INVE"* and "n. cock eécudeb."

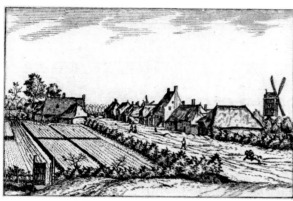

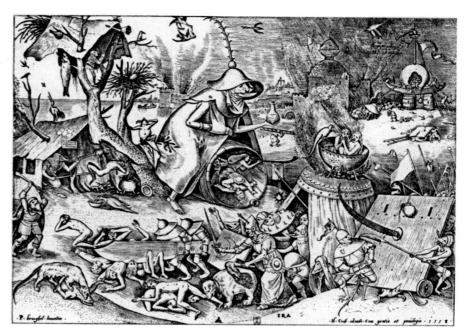

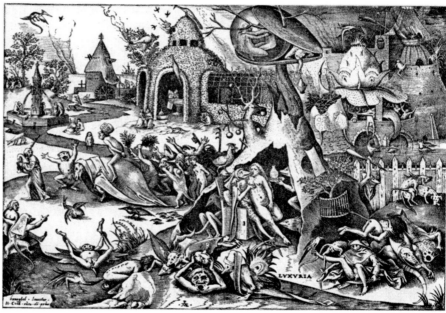

(Above) Two "pieces" from the second series (1561) of wood-cuts (Praediorum villarum et rusticorum icones elegantissimae [sic] ad vivum in aere deformate – Libro secundo, 1561. Hieronymus Cock excudebat cum gratia et privilegio) in the cycle of views of Brabant and the Campine. In both these series the little human figures seem to have been drawn, not by Bruegel, but by some other draftsman, perhaps Cock himself, who probably made the engravings as well as publishing the series. The cycle was very successful and various impressions of it are known, some of these being published, not by Cock, but by Galle and others, down to 1612 and later. In fact, it is in a new edition by J. C. Visscher that we find the only definite statement that the conception was due to Bruegel (Bruegel in. 1561), there being no other evidence that this was the case, as R. Van Bastelaer [1908] pointed out, the stylistic affinity between these engravings and drawings made by the master in the early 1560s leaves no room for doubt as to the truth of Visscher's claim that the former were designed by him. Moreover, certain landscape elements in this series are found again in paintings by Pieter the Elder, where they reveal the same appreciation of atmospheric values and the same keen penetration. The dimensions of the woodcuts vary from $5\frac{1}{4}$ to $7\frac{3}{4}$ inches (13·4 to 19·7 cm) in height and from $5\frac{1}{2}$ to 8 inches (13·8 × 20·4 cm) in width. Attempts to identify the landscapes shown have not been satisfactory.

(Above) Two prints from the series of seven "pieces" representing the capital sins, published by Cock in 1558 and engraved by Pieter van der Heyden, whose monogram can be seen below in the center. The conception is due to Bruegel, obviously inspired by Bosch, as testified by the inscription P. brueghel Inventor. The top print represents Wrath (IRA; $8\frac{3}{4} \times 11\frac{1}{2}$ inches, 22·4 × 29·5 cm); the lower one, Lust (LVXVRIA; $8\frac{3}{4} \times 11\frac{1}{2}$ inches, 22·5 × 29·5 cm). To the same series belong Sloth (DESIDIA), Pride (SVPERBIA), Gluttony (GVLA) and Envy (INVIDIA). The same characteristics (though the influence of Bosch is somewhat less obvious) can be seen in the series of "Seven Virtues," which may have been engraved either by Van der Heyden or by Ph. Galle; it is, however, certain that the series was published by Cock (Cock exc.), and that the conception was due to Bruegel (Brugel [sic] Inv). (See, on p. 115, the reproduction of the Hope, which forms part of this series together with Faith, Charity, Justice, Prudence, Fortitude and Temperance.)

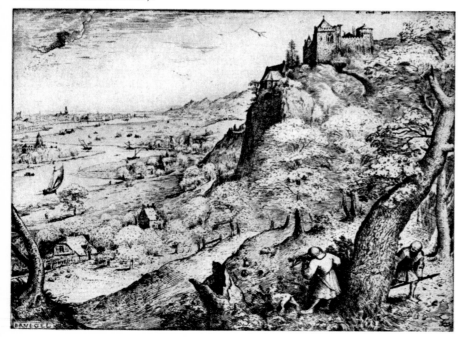

(Left) The Rabbit-hunt, etching retouched with the burin ($8\frac{1}{2} \times 9$ inches, 22 × 22·9 cm); the cartouche, in the bottom left-hand corner, contains, in addition to the signature BRVEGEL, the date 1566 in tiny letters. Along the top edge, towards the right, is the publisher's imprint: H. cock excu. The landscape comprises numerous motifs typical of the master and frequently found in the backgrounds of his pictures. This is the only engraving of which we can be sure that it was executed by Bruegel himself; the lack of experience shown in the handling of the burin is in contrast with the vigorous conception revealing a desire to achieve a perfectly balanced composition and with the superb way in which the effects of light and atmosphere are rendered.

117

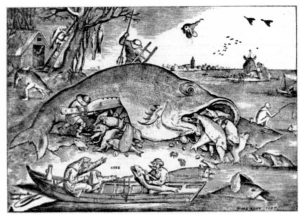

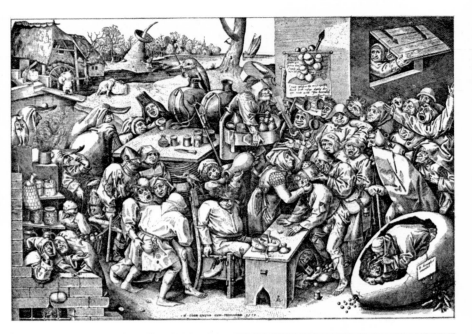

Big fish eat little ones (GRANDIBVS EXIGVI SVNT PISCES ESCA; *9 × 11½ inches, 23 × 29·5 cm*). *Reproduction, in reverse, of a drawing now in the Albertina, Vienna, dated and signed* 1556 brueghel, *based on an original work by Bosch, as indicated on the print:* Hieronymus BOS inuentor. *The derivation from Bosch is also clearly shown by the presence of a flying fish (above, towards the right), another fish with legs (on the left) and the man cutting up the big fish with a huge saw-toothed knife and wearing a large and characteristic broad-brimmed helmet. In addition, there are various points of contact with the triptych of the* Last Judgment *in the Akademie der bildenden Künste in Vienna (cf. The Complete Paintings of Bosch pp. 109–9 and, in particular, Nos. 50 D and E). The actual engraving was done by Pieter van der Heyden (whose monogram can be seen) and the print was published in Antwerp by Cock (COCK EXCV. 1557).*

(*On right, top*) The Witch-doctors of Malleghen (*underneath the lower edge is an inscription:* "Ghy lieden van Mallegem . . . oft loteren v de keyen."*) Engraving (14 × 19 inches, 35·5 × 48 cm) of which a number of states are known; the earlier states contain the monogram of the engraver, Van der Heyden, together with the signature "P. brueghel inuentor" and the publisher's imprint ("H. COCK EXCVD. . . . 1559"). The subject is the extraction of the stone of ·folly (cf. Catalogue, 57). Here, too, perhaps to an even greater extent than in the preceding composition, numerous borrowings from Bosch can be detected; in particular, the curious conical edifice in the background, the freaks borrowed from his repertory of "whimsies" but with the addition of typical motifs of Flemish folklore (like the big wooden spoon stuck in the beak of the strange bird in the center), and lastly, the human figures, e.g. the pickpocket in the foreground towards the left, the thief emerging from underneath the table in the center, and the two men in the huge egg on the right. On the other hand, certain details are typical of Bruegel, for example, the sailing-boat at the top in the center, and they can be found again in paintings like the* Flemish Proverbs (Catalogue, 16).

Vignette (5 × 6¼ inches, 13 × 16 cm) showing two pipers, on the title-page of a series of four plates depicting a pilgrimage of epileptics to the church at Molenbeeck ("Vertooninge hoe de Pelgerimmen op Sint Jansdagh buyten Brussels tot Meulenbeeck dansen moeten . . ."), published by H. Hondius the Younger (1642) and derived from drawings by Bruegel ("P. Bruegel inv.") now in the Albertina, Vienna.

(*On right, middle*) Spring, *pen-drawing by Bruegel (8¾ × 11½ inches, 22·3 × 28·9 cm), signed and dated, below on the right, "M.D.LXV BRVEGEL." (Below) Engraving (9 × 11½ inches, 22·5 × 29 cm) after the above drawing, made by Van der Heyden (whose monogram can be seen) and published by Cock ("HW Cock exc. 1570"). That the conception is due to the master is shown by the words "Bruegel invent," below on the left.*

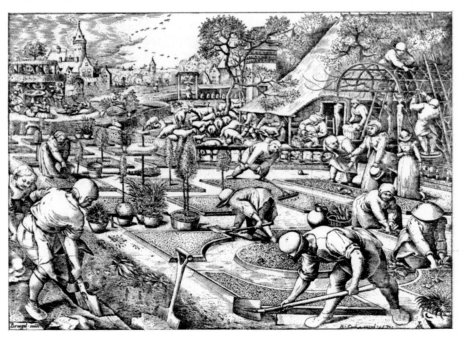

continued from p. 115,
after a drawing by Bruegel, though in it the sea can hardly be described as *tranquille*, as it is in another print from the series, the one showing a ship adrift between two galleys (in which, however, the coastline is not visible). The first state of the latter print bears the monogram F.H., while the second state is inscribed *Theodorus Galle excudit* (in other engravings from the same series the ships — in a dead calm — appear to be at anchor and cannot therefore be described as *en mer*). Both the paintings just mentioned (Hulin de Loo maintains that they cannot be one and the same) remind us of a *Seascape* (30 × 56¼ inches, 76 × 143 cm) formerly in the F. Pauwels Collection at Aachen, where it was attributed to the elder Bruegel, though Tolnay rejects this attribution and later critics make no mention of it.

82 Landscape Described as a work by *Pierre Breughel* on copper (*sur planche de cuivre*), *quatorze polces* high and *un pied, trois polces et un tiers* wide, i.e. about 13¼ × 17¼ inches (33·6 × 43·9 cm), in a walnut frame. No such work by the elder Bruegel is known, though landscapes were favorite subjects at that time, despite the fact that Bruegel's sons never painted any.

83 The Story of Jonah Described as a *Paysage d'un Jonas de Breughel, un pied et un polce* high and *un pied, dix polces et un quart* wide, i.e. about 15 × 23¾ inches (38·3 × 60·4 cm). These measurements make it impossible that this can have been *The Storm at Sea* now in the Kunsthistorisches Museum in Vienna, even more so if they include the *sa moulure dorée*). It might, however, have been the prototype for Jan Bruegel's painting, also in the Vienna museum (on wood, No. 914 ; 15 × 22 inches, 38 × 56 cm), showing Jonah and the whale in a stormy sea.

PRAGUE, 1621

84 Three Masquerades Described respectively as *Eine selsame mascarada vom Prügl* [*sic*], *Eine selzame mascara vom Prügl* and *Eine mascara vom Prügl*. All three reappear in the imperial inventories of 1647–8, but without any further details, so that we can only suppose they represented processions of masked personages (perhaps on the lines of *The Dirty Bride* [63] and *The Encounter between Orson and Valentino* [cf. 17]). In any case, none of the three can be identified as *The Battle between Carnival and Lent* (17), while the name *Prügl* given in the inventory does not exclude the possibility that they may have been painted by one of the master's descendants.

85 Soldiers in a Tavern Attributed simply to *Brügl*, which justifies the supposition that the painter may have been a descendant of Pieter the Elder.

ANTWERP, 1640

86 Battle Between Turks and Christians The title, *Une bataille des turcs et des chrétiens*, might lead one to suppose that this could be *The Suicide of Saul* (19), owing to a slip made by the compiler of the inventory, but the English edition specifies that it was "in water colors," i.e. in tempera, which dispels all doubts.

87 Landscape with (?) Fire From the title, *Un paysage avec feu*, it is impossible to deduce what the painting really represented. Hulin de Loo thought it might have been a study for the background of *The Triumph of Death* (23) or of *"Dulle Griet"* (27), and it should also be remembered that several engravings of "Vices" and "Virtues," after drawings by the master, show burning houses, in particular those of *Avarice*, *Gluttony* and *Hope* (as well as *Pride*, *Wrath* and *Patience*).

88 Portrait The inventory describes it as *Un Portrait* without giving any further details. Similar documents of later date mention portraits of Peter Coecke's wife (Bruegel's mother-in-law), of Frans Floris and his wife, and of another woman, who might have been Bruegel's own wife (though if this were so, it seems strange that the Rubens inventory does not mention it).

89 Head of a Beggar Described as *Un Visage d'un gueux en rond*. The title excludes the possibility that it might be one of the tondos discussed under 60, 61 and 62. It should be borne in mind that numerous oval "peasants' heads" were engraved by A. Brouwer and above all by C. Visscher, after drawings by the master (*P. Breugel inventor*), which probably resembled this head.

90 Heads (?) It is not clear whether the title refers to one painting (a tondo) or to two, since the wording — *Deux petits visages, en rond* — is ambiguous. If we take this as meaning "two small tondos containing heads," then they might be identified as any two of our 60, 61 and 62.

VIENNA, 1659

91 Massacre of the Innocents Described as an oil painting on wood, *hoch 2 Spann 6 Finger, und braidt 3 Spann 7 Finger*, i.e. about 21¼ × 30¼ inches (54 × 77 cm) including the frame. These measurements exclude the possibility that it might be the well-known painting now in Vienna (39).

92 Piper Described in some detail as "A small night-piece, in oils on wood, with a piper in the open air, clad in gray with a black hood, a black belt round his waist and a pipe [of his instrument] in his hand. In a smooth black frame, the inner edge gilded, 1 Spann 2 Finger high and 1 Spann 3 Finger wide (i.e. about 9¾ × 10½ inches, 25 × 27 cm). Original by the elder Bruegel." A similar painting (*Le joueur de cornemuse*), attributed to the master, figures in the catalogue of the Haro sale (Paris, 1897), where it was sold for "205 francs."

PRAGUE, 1718

93 Two Peasants dancing From 1718 on this work is regularly mentioned in the imperial inventories, but on the first occasion the attribution is uncertain : *Alt Briegl* [*sic*], *sub dubio original*. In the next inventory (1737) the attribution is definite and is followed by the word *Leinwand* (canvas), which led Hulin de Loo to suppose that it was painted in tempera and would be therefore liable to deteriorate quickly. The dimensions given : *H. 3 el. 2 zoll* ; *Br. 2 el. 14 zoll* (3 ells 2 inches high, 2 ells 14 inches wide) are equivalent to about 156 × 118 inches (400 × 300 cm), pointing to the figures having been lifesize (Hulin de Loo). The work is mentioned again in the inventory of 1763.

94 Figures in Antique Costume Described as a painting *worauf etliche figuren in alten trachten* and as a genuine work by *Alt Briegel*, it reappears in the 1737 inventory with the additional information that it was on *Leinwand* (canvas) and measured *H. 1 el. 18 zoll* ; *Br. 1 el. 5 zoll* (1 ell 18 inches high, 1 ell 5 inches wide) ; the 1763 inventory gives the width as *15 zoll*, so that its actual dimensions must have been about 78 × 59 inches (200 × 150 cm).

PRAGUE, 1737

95 The Conversion of St Paul Described as an original work, on wood, *H. 14 zoll, Br. 1 el. 15 zoll*, i.e. about 16 × 59 inches (40 × 150 cm).

96 Two Peasants Described as an original work, on wood, measuring about 12 × 13 inches (31 × 34 cm : *H. 12 zoll, Br. 13 zoll*). The fact that it was on wood and the dimensions mean that it cannot possibly be our 93. Hulin de Loo believes that it may have been an illustration of a proverb.

VIENNA, 1747–8

97 Old Peasant Couple Mentioned again in the inventory of 1750, where it is described as being of fairly large dimensions, which means that it cannot be our 96.

98 View of the Scheldt Hymans suggested that there might be some connection between Van Mander's statement that Bruegel was commissioned to paint pictures commemorating the opening of the Brussels-Antwerp canal (cf. Outline Biography *1569*) and a picture sold at Amsterdam in 1716, which in the catalogue of the sale (Hoet, *Catalogus of Naamlijst*, 1752, I, p. 197) is described as follows : *De Heu gelade met volk, zeylende in de Schelde na Brussel, van Breugel* (the vessel full of people, sailing on the Scheldt to Brussels, by Bruegel).

Indexes

Index of Subjects

Adoration of the Magi 7, 31, 46
Adultery, Christ and the woman taken in 33
Anthony, St 58
"Back to your sty, you pig !" 70
Battle between Carnival and Lent 17
Battle (between Turks and Christians) 86 ; (between Philistines and Israelites) 19
Beggars 51 (cf. Cripples)
Birdtrap 35
Blind man playing a hurdy-gurdy 71
Blind men 49, 79
Burning city 4
Calling of the Apostles 5
Carnival 17
Catherine of Alexandria, St 2
Children's games 18
Christ 8, 21, 30, 33, 75 (cf. Jesus)
Christopher, St 24
Conversion of St Paul 45, 95
Cripples 51 (cf. Beggars)
Dancing peasants 53
Day, the dark (or cloudy or gloomy) 34 A
Death 23
Dormition of Virgin 32
Drunkard accompanied by his relatives 66
"Dulle Griet" 27 (cf. "Mad Meg")
End of the world, the 4 (cf. Ships and burning city)
Estuary 10 (cf. Parable of the Sower)
Expulsion of the money-changers from the Temple 6
Extraction of the stone of folly 57
Fall (of Rebel Angels 22 ; (of Icarus) 13
Fat man (attacked by thin couple) 14
Feast of St Martin 69
Figures in antique costume 94
Flemish proverbs 15, 16
Flight into Egypt 25, 80
Galilee, Sea of 5
Gentlemen visiting a farm 72
Harbor at Naples 12
Harvest 34 C
Haymaking or Reaping 34 B
Head (of beggar) 89 ; (of old woman) 26
Heads 90
Heathland with peasants on their way to market 64
Hermit 3, 69

Hunters in the snow 34 E
Icarus 13
Israelites 19
Jesus, the Child 7, 24, 25, 31, 46 (cf. Christ)
John the Baptist 40
John the Evangelist 30
Jonah 83
Joseph, St 7, 25, 31, 38
Kermis 76
Land of Cockaigne 47
Landscape 1, 2, 3, 4, 5, 10, 11, 13, 24, 25, 35, 69, 82, 87
Lansquenet 61
Lent 17
Lepers (cf. Cripples) 51
"Mad Meg" 27 (cf. "Dulle Griet")
Magdalen 74
Magi 7, 31, 46
Magpie on the gallows 52
Martyrdom of St Catherine of Alexandria 2
Masquerades 84
Massacre of the Innocents 39, 91
Michael, Archangel 22 ; (vanquishing Satan) 9
Misanthrope 48 (cf. Perfidy of the world)
Monkeys 20
Months 34 A–E
Mopsus 63
Nisa 63
Nocturnal landscape 3
Numbering of the people at Bethlehem 38 (cf. Payment of the tax)
Parable (of the blind men) 49 ; (of the sower) 10
Paul, St 45
Payment of the tax 38 (cf. Numbering of the people at Bethlehem)
Peasants (attacked) 67 ; (dancing) 42, 93 ; (binding faggots) 73 ; (on the way to market) 64
Peasants dancing in front of tavern 43
Peasants' wedding 54
Perfidy of the world 48 (cf. Misanthrope)
Philistines 19
Piper 92
Portrait 88
Preaching (John the Baptist) 40
Procession to Calvary 30, 75
Quarreling card-players 68
Resurrection 21
Return of the herd 34 D
Satan 9, 27
Saul 19
Shepherd (the good) 37 ; (hireling) 36
Ships and burning city 4 (cf End of the world)
Ships on a calm sea 81
Simon of Cyrene 30
Skaters 35
Sketcher 1
Soldiers (playing drum etc.) 56 ; (in tavern) 85
Sower 10
Storm at sea 55
Story of Jonah 83
Suicide of Saul 19 (cf. Battle between Philistines and Israelites)
Temptations (of Christ) 78 ; (of St Anthony) 11, 58
Thief 48 ; (birdnester) 50
Tower of Babel 28, 29
Triumph (of Death) 23
View (of the Scheldt) 98
Virgin Mary 7, 25, 30, 31, 32, 38, 46
Wedding dance (in open air) 41 ; (indoors) 6
Wedding (of peasants 77 ; (of Mopsus and Nisa) 63 ; (rustic) 6
Wedding procession 44
Wordly joys of the Magdalen 74
Yawning man 60

Index of Titles

An asterisk after the number
denotes the existence of replicas
or copies of the same subject,
mentioned in the text of the item
to which the number refers.

Adoration of the Magi 7, 31
Adoration of the Magi in the
 Snow 46
Archangel Michael vanquishing
 Satan 9
"Back to your sty, you pig!" 70
Battle between Carnival and
 Lent 17 *
Battle between Philistines and
 Israelites (cf. Suicide of Saul
 19
Battle between Turks and
 Christians 86
Birdnester, the 50
Blind Man playing a Hurdy-
 gurdy 71
Blind Men 79
Children's Games 18
Christ and the Woman taken in
 Adultery 33
Conversion of St Paul 45 *, 95
Cripples (or Beggars, or Lepers)
 51
Dancing Peasant 42
Dark Day, the (or Cloudy,
 Gloomy Day) 34 A
Dormition of the Virgin Mary 32
Three Masquerades 84
Drunkard accompanied by his
 Relatives 96 *
"Dulle Griet" ("Mad Meg") 27
Expulsion of the Money-changers
 from the Temple 8 *
Extraction of the Stone of
 Folly 57 *
Fall of the Rebel Angels 22
Feast of St Martin 59 *
Figures in Antique Costumes 94
Flemish Proverbs 16
Flight into Egypt 80
Gentlemen visiting a Farm 72
Good Shepherd, the 37 *
Harbor at Naples, the 12
Harvest 34 C
Haymaking (or Reaping) 34 B
Head of a Beggar 89
Head of a Lansquenet 61
Head of a yawning Man 60
Head of an Old Man 62
Head of an Old Woman 26
Heads (?) 90
Heathland with Peasants on their
 Way to Market 64
Herd, Return of the 34 D
Hireling Shepherd, the 36 *
Hunters in the Snow 34 E
John the Baptist preaching 40 *
Kermis 76
Land of Cockaigne, The 47
Landscape 82
Landscape with (?) Fire 87
Landscape with Hermit 69
Landscape with Man sketching 1
Landscape with Ships and a
 burning City (or The End of the
 World) 4
Landscape with St Christopher
 24
Landscape with the Calling of the
 Apostles 5
Landscape with the Fall of
 Icarus 13
Landscape with the Flight into
 Egypt 25
Landscape with the Martyrdom
 of St Catherine of Alexandria 2
Landscape with the Temptations
 of St Anthony 11
Large Tower of Babel 28
Magpie on the Gallows 52
Massacre of the Innocents 39 *,
 91
Misanthrope (or Perfidy of the
 World) 48
"Months," 34 A–E
Nocturnal Landscape with

Hermit 3
Numbering of the People at
 Bethlehem (or Payment of the
 Tax) 38 *
Nuptials of Mopsus and Nisa 63
Parable of the Blind Men 49 *
Peasants attacked by Brigands
 67 *
Peasants dancing 53
Peasants dancing in front of a
 Tavern 43 *
Peasants' Wedding 54, 77
Piper 92
Portrait 88
Procession to Calvary 30, 75
Quarreling Card-players 68
Resurrection 21
River Landscape with the
 Parable of the Sower (or The
 Estuary) 10
Rustic Wedding or Indoor
 Wedding Dance 6 *
Sacking of a Village 65
Ships on a Calm Sea 81
Small Tower of Babel 29
Soldiers in a Tavern 85
Storm at Sea 55
Story of Jonah 83
Suicide of Saul (or Battle
 between the Philistines and
 the Israelites) 19
Temptations of Christ 78
Temptations of St Anthony 58
Thin Couple attacking a Fat
 Man 14
Three Masquerades 84
Three Soldiers 56
Triumph of Death 23
Twelve Flemish Proverbs 15
Two Monkeys 20
Two Peasants 96
Two Peasants binding Faggots
 73
Two Peasants dancing 93
View of the Scheldt 98
Wedding Dance in the Open Air
 41 *
Wedding Procession 44 *
Winter Landscape with Skaters
 and Birdtrap 35
Worldly Joys of the Magdalen 74

Topographical Index

An asterisk before the number
denotes a replica or a copy
mentioned in the text of the item
to which the number refers.

ANSBACH
Peter von Pölnitz Collection
Landscape with the Calling of
 the Apostles 5

ANTWERP
Koninklijk Museum
Wedding Dance in the Open Air
 *41
Mayer van den Bergh
Museum
"Dulle Griet" ("Mad Meg") 27
Twelve Flemish Proverbs 15

BERLIN
Paul Cassirer Collection
Peasants dancing in front of a
 Tavern *43
Staatliche Museen,
Gemäldegalerie, Dahlem
Flemish Proverbs 16
Two Monkeys 20

BERLIN (formerly)
Private Collection
Worldly Joys of the Magdalen 74

BIRMINGHAM
Barber Institute
Two Peasants binding Faggots
 73

BORDEAUX
Musée des Beaux-Arts
Head of an Old Man 62

BRUSSELS
Baron Descamps Collection
Massacre of the Innocents *39
F. Delporte Collection
Winter Landscape with Skaters
 and Birdtrap 35
Joly Collection
Battle between Carnival and
 Lent *17
Kronacker Collection
The Good Shepherd 37
Musée Municipal
Wedding Procession 44
Musées Royaux des
Beaux-Arts
Adoration of the Magi 7
Fall of the Rebel Angels 22
Head of a yawning Man 60
Landscape with the Fall of
 Icarus 13
Numbering of the People at
 Bethlehem or Payment of the
 Tax 38

BUDAPEST
Szépmüvészeti Museum
John the Baptist preaching 40

Budapest (formerly)
Palugyan Collection
Extraction of the Stone of
 Folly 57

COPENHAGEN
Statens Museum for Kunst
Expulsion of the Money-
 changers from the Temple 8
Thin Couple attacking a Fat
 Man 14

DARMSTADT
Landesmuseum
The Magpie on the Gallows 52

DETROIT
Institute of Arts
Wedding Dance in the Open
 Air 41

DORTMUND
Becker Collection
Landscape with Ships and a
 burning City or The End of the
 World 4

EDGEHILL, Upton House
(National Trust)
Dormition of the Virgin 32

EINDHOVEN (Holland)
Philips de Jongh Collection
The Archangel Michael van-
 quishing Satan 9

HAMBURG
Weber Collection
Wedding Dance in the Open Air
 *41

HAMPTON COURT
Massacre of the Innocents *39

INDIANAPOLIS
Clowes Fund
Nocturnal Landscape with
 Hermit 3

LAREN (Holland)
Van Valkenburg Collection
Dancing Peasant 42

LOCATION UNKNOWN
The Temptations of St Anthony
 58

LONDON
A. Hassid Collection
Winter Landscape with Skaters
 and Birdtrap *35
A. Seilern Collection
Christ and the Woman taken in
 Adultery 33
Landscape with Hermit 69
Landscape with the Flight into
 Egypt 25
National Gallery
Adoration of the Magi 31
Landscape with Man sketching 1

MADRID
Museo del Prado
Triumph of Death 23

MERY-SUR-SEINE
Béague Collection
The Hireling Shepherd *36

MILAN
Vittorio Duca Collection
John the Baptist preaching *40

MONTPELLIER
Musée Fabre
Head of a Lansquenet 61

MUNICH
Alte Pinakothek
Head of an Old Woman 26
The Land of Cockaigne 47

NAPLES
Gallerie Nazionali
di Capodimonte
Parable of the Blind Men 49
The Misanthrope or The Perfidy
 of the World 48

NEW YORK
Frick Collection
Three Soldiers 56

Metropolitan Museum
The Harvest 34 C–D

PARIS
Baroness Bentinck Collection
(Netherlands Embassy)
Peasants dancing in front of a
 Tavern 43
Louvre
Cripples (or Beggars, or Lepers)
 51

PARIS (formerly)
De Molène Collection
Extraction of the Stone of
 Folly *57

PHILADELPHIA
J. G. Johnson Collection
Rustic Wedding or Indoor
 Wedding Dance 6
The Hireling Shepherd 36

PRAGUE
Narodni Gallery
Haymaking or Reaping 34 B

PRIVATE COLLECTIONS
Conversion of St Paul *45
Landscape with St Christopher
 24

ROME
Galleria Doria
The Harbor at Naples 12

ROTTERDAM
Boymans – Van Beuningen
Museum
Resurrection 21
The Small Tower of Babel 29

VIENNA
Kunsthistorisches Museum
Battle between Carnival and
 Lent 17
Children's Games 18
Conversion of St Paul 45
Hunters in the Snow 34 E
Massacre of the Innocents 39
Peasants dancing 53
Procession to Calvary 30
Return of the Herd 34 D–E
Storm at Sea 55
Suicide of Saul or Battle between
 the Philistines and the
 Israelites 19
The Birdnester 50
The Dark Day (or The Cloudy, or
 Gloomy Day) 34 A–B
The Feast of St Martin 59
The Large Tower of Babel 28
The Peasants' Wedding 54

WASHINGTON
National Gallery
Landscape with Martyrdom of
 St Catherine of Alexandria 2
Landscape with the Temptations
 of St Anthony 11
River Landscape with the Parable
 of the Sower or The Estuary 10

WINTERTHUR
Reinhart Collection
Adoration of the Magi in the
 Snow 46